EARLY CHILDHOOD ART

TRENDS IN ART EDUCATION

Consulting Editor: **Earl Linderman**
Arizona State University

ART FOR EXCEPTIONAL CHILDREN—DONALD UHLIN,
California State University, Sacramento

ALTERNATIVES FOR ART EDUCATION RESEARCH—KENNETH R. BEITTEL,
The Pennsylvania State University

**CHILDREN'S ART JUDGMENT: A CURRICULUM FOR ELEMENTARY ART
APPRECIATION**—GORDON S. PLUMMER,
Murray State University

**ART IN THE ELEMENTARY SCHOOL: DRAWING, PAINTING, AND
CREATING FOR THE CLASSROOM**—MARLENE LINDERMAN,
Arizona State University, Extension Division

EARLY CHILDHOOD ART—BARBARA HERBERHOLZ,
California State University, Sacramento
Extension Division

EARLY CHILDHOOD ART

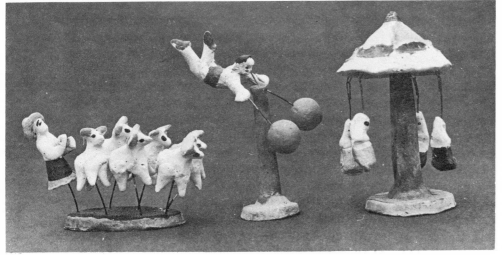

Barbara Herberholz

California State University, Sacramento
Extension Division

WM. C. BROWN COMPANY PUBLISHERS
Dubuque, Iowa

Contents

Preface

The aesthetic tasks described in this book are aimed primarily at developing in young children the beginnings of art skills and attitudes. They are planned to elicit an optimum amount of creative problem-solving and aesthetic responses through heightened perceptual powers, cognitive involvements, and emotional awareness.

It is generally accepted that originality, sensitivity, fluency, and flexibility are involved as important aspects of creative thinking and production in art. Unusual responses and unique configurations show originality and sensitivity and are the result of a child's vivid perceptual experiences and a high level of ability in imagining and building fantasies. A child who is described as fluent in art uses many ideas and symbols to say what he wants to say. The outpouring of his ideas is endless and delightful, and he will create many more visual images than the rigidly oriented child within the same time span. The young child who is flexible changes his symbols and responses easily and confidently and is stimulated and encouraged by a variety of in-depth encounters with art materials. Early childhood years are formative ones, and the education program is remiss if it is not rich in input and conducive to the development of the child's creative powers.

By using the types of art tasks described in this book, children are both free to and encouraged to hazard guesses, test their ideas, and enjoy the surprises and delights of discovery. While aimed at fostering specific cognitive and expressive skills, these tasks appeal to the child's natural curiosities, his desire to explore, experiment, and communicate ideas in a beautiful visual way.

It is estimated that less than ten percent of all students study any kind of visual art in high school. It therefore becomes urgent that the elementary art program be one that not only contributes significantly to opening avenues to the child's enjoyment of his own art production, but also leads the child to an awareness of the rich heritage of the world of art. Herein described are ways and means of introducing the very young child to artists, galleries, original works of art, and fine reproductions.

The adult in charge of structuring and facilitating the child's artistic encounters will be the richer for it if he is able to glimpse the world once again through a child's eyes and relish with him the intellectual, emotional, and aesthetic involvement of finding out what he and the world are all about. This ongoing, never-ending process is indeed one of self-awareness, fulfillment, and renewal which enables us all to stay "young in art."

Acknowledgments

Very special thank-you's are in order for a number of educators without whose efforts, talents, and cooperation I would have been unable to gather the material for this book. Among these teachers are Nancy Remington, Leila Vertrees, Marchetta Schneider, Jill Rellis, Joyce Witt, Betsy Miller, Kay Mills, Jan Mellon, Phyllis Walline, Jan Thompson, Marjorie Whitten, Neda Gray, Mae Belle Myers, and Dorothy Donnelly, Lyn Livingston, and LaVerle Slater. Many eager and enthusiastic youngsters also helped by participating in the various art tasks, and I am indebted to them for their readiness to be in my photographs and to let me use their finished work for illustrative purposes, and to their parents as well.

And of course a special bouquet of roses to my family—husband Don and children Amy, Eric, and Heidi, who tolerated the long hours I spent in classrooms, in the darkroom, and at the typewriter.

Barbara Herberholz

Components of Art in Early Childhood

In a society tending more and more to be technological, complex, and mass-oriented, the arts have the function, responsibility, and opportunity of fostering and preserving an individual's human identity, uniqueness, esteem, and accomplishment. Young children reflect the ensuing trend and get caught up in it, so that when they engage in art production and when they view works of art by others, they come to a better understanding of themselves and the world around them.

Aesthetic education is basic and is designed to enrich a person's life by increasing his capacity to use his senses joyfully in experiencing his environment. Such aesthetic encounters are for all children, and the values of an educational format such as this are best transmitted through the schools since these are the institutions that provide for personal development and the transmission of cultural heritage. The outcomes of aesthetic education will enable students to make personal choices relative to life and to be responsible for what they reject or prize in our society.[1]

The National Art Education Association has stated that art in school is a body of knowledge, as well as a series of activities, organized to provide experiences that are related to specific goals—the sequence and depth of these experiences being determined by the nature of the art discipline, the objectives desired, and by the interests, abilities, and needs of children at different levels of growth.

An art program of quality should begin in preschool and sequentially progress through the educational levels with experiences provided that are compatible with the intellectual, social, and aesthetic maturity of each student. The art program should provide experiences in

1. examining intensively both natural and man-made objects from many sources,
2. expressing individual ideas and feelings through use of a variety of art media suited to the manipulative abilities and expressive needs of the student,
3. experimenting in depth with art materials and processes to determine their effectiveness in achieving personal expressive form,
4. working with tools appropriate to the students' abilities in order to develop manipulative skills needed for satisfying aesthetic expression,
5. organizing, evaluating, and reorganizing work-in-process to gain an understanding of the formal structuring of line, form, color, and texture in space,

1. Aesthetic Education Program, *Aesthetic Education: A Social and Individual Need* (St. Louis, Mo.: CEMREL, Inc., 1973), pp. 4-5.

6. looking at, reading about, and discussing works of art—painting, sculpture, constructions, architecture, industrial and handcrafted products—using a variety of educational media and community resources,
7. evaluating art of both students and mature artists, industrial products, home and community design,
8. seeing artists produce works of art in their studios, in the classroom, or on film,
9. engaging in activities which provide opportunities to apply art knowledge and aesthetic judgment to personal life, home, or community planning.[2]

Educational programs are currently concerned with the accountability of art within the total curriculum, with the result that some art programs are being structured upon behavioral objectives. These objectives are stated in terms of behaviors that a child will exhibit as a result of having interacted in a learning situation. They are not an educational philosophy or a curricular theory. The approach is a procedure or format for organizing the teaching-learning situation. The teacher clearly states what he wants the children to learn, what the conditions are in which the learning will take place, and what overt behavior will be manifested as evidence of that learning.

Behavioral objectives facilitate both the identification of the content of instruction and the setting up of specifications for the teaching and learning environment, and they provide clear data for the sequence and structure of instructional modules. They furnish a means of evaluating whether student learning has taken place. Their use makes it more likely that the child's behavior will not be assessed solely by intuitive, subjective, and chance processes. If carefully structured experiences that are geared to individual interests and attainment result in demonstrated behavior which becomes increasingly complex, the art curriculum is on its way to acceptance and validity. Such a behaviorally oriented program in visual arts places its emphasis upon the development of a child who is creative, sensitive, and visually literate—one who not only produces art but enjoys, values, and is beginning to be knowledgeable of the language, heritage, and range of art. Such a program in early childhood is dynamic and growth-promoting (behavior-changing) and opens up avenues to explore rather than being a terminating point.[3]

When Bloom developed his taxonomy of educational objectives, he collected lists from leading educators of things that they felt children should learn. He then classified these into three domains: the cognitive domain covering verbal association, concepts, principles, and problem-solving; the affective domain relating to attitudes and values; and the psychomotor domain having to do with skills.[4] These can serve as frameworks for ascertaining and describing the terminal behavior desired in children in a given area.

Boys and girls in the awakening formative years of early childhood have special developmental needs that include perceptual, emotional, aesthetic, and creative implications which can best be fostered through an art program which incorporates four principal components or behavioral categories: (1) visual and tactile perceptual encounters, (2) production of art, (3) aesthetic judgment and valuing of art, and (4) heritage of art.[5]

2. *The Essentials of a Quality Art Program: A Position Statement* (Washington, D.C.: National Art Education Association, 1972), pp. 6-7.
3. *Art Education: Elementary* (Washington, D.C.: National Art Education Association, 1972), pp. 6-7.
4. Benjamin S. Bloom, *Taxonomy of Educational Objectives, Handbook I: Cognitive Domain* (New York: McKay Publishing Co., 1956), pp. 6-21.
5. *Art Education Framework for California Public Schools, Kindergarten Through Grade Twelve* (Sacramento, Calif.: California State Board of Education, 1971), pp. 14-18.

Visual and Tactile Perceptual Encounters

What we know of the world we take in through our senses. The refinement and sharpening of the senses then become paramount in the development of the individual. Young children are enthusiastic, curious, and eager participators interested in exploring everything around them. The quality and quantity of that exploration must not be left solely to chance. Rather, the teacher should lead, guide, and direct the child and whet his appetite for perceptual experiences so as to aid him in becoming better able to recognize and discriminate art elements in both natural and man-made objects, more skillful in recalling observations, and more able to understand, describe, and make use of colors, textures, lines, and shapes.

If perception is basic to all learning, if selective viewing is a desirable kind of behavior, and if conceptualization comes after sensory experiences, then it becomes imperative and mandatory that the teacher set the stage so as to keep all the young child's senses alive and free from atrophy. While we cannot always decipher when an aesthetic experience has occurred or cannot always cause one to happen, we can provide the paths for numerous visual and tactile experiences that a child, left to his own devices, is not apt to discover by himself.

Creative people are perceptually very aware of their environment. They are visually observant of the world, and they know how things feel to the touch. They listen to sounds and have a sensitivity for the ways things smell and taste. They are able to take in information without prejudging it; they delay structuring it, trying to take in much information and to look at things from several points of view.[6]

Attempts have been made to analyze the thought processes of famous people who have made great discoveries with the idea that their mode of operation might be taught to others. Wallas has described the discovery process as having four stages: first, preparation in which knowledge is acquired and awareness gained as to how different ideas fit together; second, the incubation in which ideas are sorted, perhaps in an unconscious way; third, illumination or the moment when the solution dawns; and fourth, the verification or the testing of the tentative solution.[7]

As children mature they are able to perceive, with more complexity and subtlety, the quality of this desirable behavior being affected by the amount and types of perceptual experiences to which they have been exposed. As it relates to artistic expression in early childhood, visual and tactile perception is twofold. It has to do with (1) the extent to which the child has developed the capacity to perceive and select, as each occasion demands, that which is significant, unusual, similar, contrasting, has more details, or is differentiated from a myriad scene or from a total encounter with his environment, (2) the extent to which the child focuses on one part of his own picture or on the work of art by another person at a time and does or does not perceive the more complex contextual relations within the entire configuration.

The child's visual and tactile awareness is nurtured with two kinds of encounters since nature shares with man-made art objects many of the same terms, properties, and characteristics. Thus through closely viewing, studying, and discussing leaves, seed pods, shells, clouds, and insects, as well as paintings, sculpture, pots, prints, and woven things, the teacher can direct the young child's attention to the elements and terminology of art—line, color, shape, texture, repetition, pattern, larger than, curving, straight, balance, proportion, unity, rough, variety, and blended.

6. Earl W. Linderman and Donald W. Herberholz, *Developing Artistic and Perceptual Awareness,* 2nd ed. (Dubuque, Ia.: Wm. C. Brown Company Publishers, 1969), pp. 5-6.
7. G. Wallas, *The Art of Thought* (New York: Brace and World, 1926), pp. 79-107.

Through heightened perceptual experiences the child often discovers in both new and familiar things a beauty and honesty that one whose senses are dulled might dismiss or overlook. Sensory encounters give wings to the child's imagination and at the same time enable him to relate and react to the real world around him.

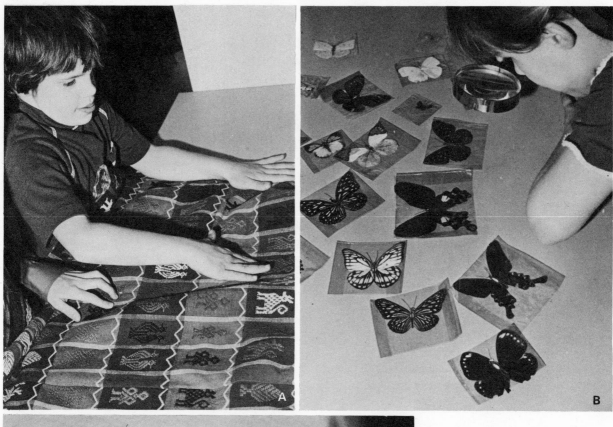

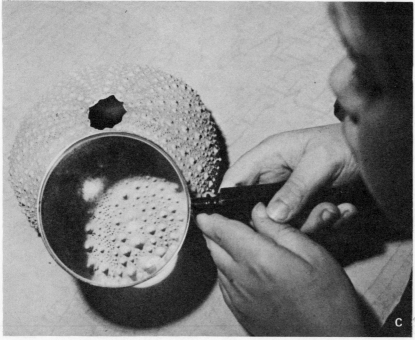

A, B, and C. The child's visual language expands if he is surrounded with materials and an encouraging and many-faceted atmosphere. "Come touch, come see" should be bywords in the early years.

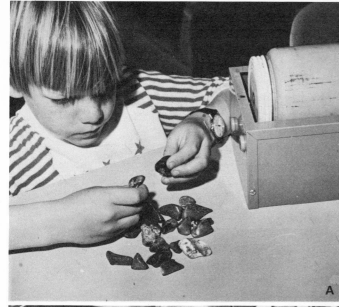

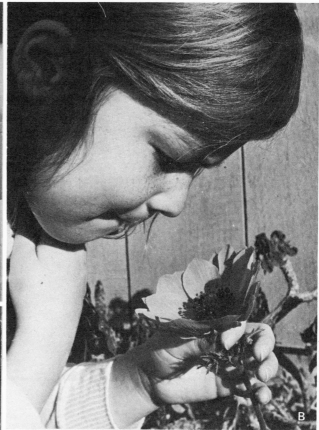

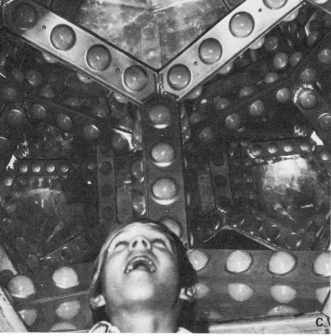

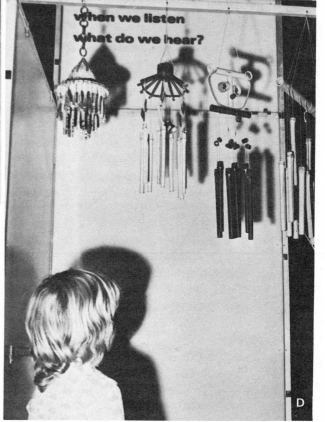

A. Rock polisher produces smooth sculpture-like forms from ordinary pebbles. The colors, patterns, shapes, and surface qualities invite the child to examine them.

B. Early childhood is a time for many intake experiences, and art is a means of activating the child's sensibilities.

C. Created by a sculptor, this "limbic system" installed in the San Francisco Exploratorium is in the shape of a multicolored bubble and reflects a child's image into infinity.

D. Exhibits in the Exploratorium are designed for sensory discovery, enjoyment, and learning, and include numerous audio and visual surprises. Separate tactile gallery is a labyrinth which a child passes through in total darkness.

Production of Art

Art production is a creative process for the child; it is an avenue through which all kinds of experiences are expressed in a nonverbal way. An involvement with art tasks provides marvelous experiences for young children that can be derived in no other way. When the very youngest child picks up a crayon or brush, he has taken one of the first steps involved in the creative act, that of selecting and making a decision. As he matures he will make meaningful artistic expressions involving his personal feelings, his cognitive awareness, and his sensory impressions to convey and communicate. If the environment is warm, supportive, and receptive, he will enjoy and freely incorporate moods and original concepts in all sorts of subject matter by using many kinds of art materials.

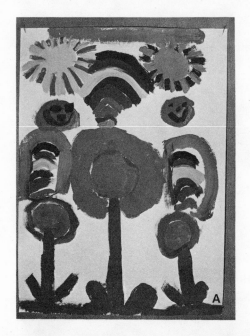

A. Through art the child takes from his world the ordinary and heightens his awareness by using it for subject matter. He accents its essence and finds delight in the sensuous beauty of paint. He communicates to others.

B. Children paint what they know and see around them. The entire length of the playground in this San Francisco school is bright with paneled murals painted by the children in the primary grades.

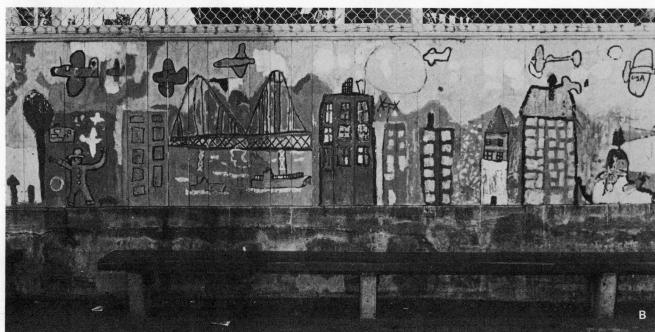

Two of the leading specialists on Piaget, who is an outstanding authority on the general intellectual development of children, believe that the leading implication for teaching Piaget's theory is that young children learn best from concrete activities.[8] Since Piaget feels that it is advisable to permit children to absorb experiences in their own ways and at their own rates, teachers must provide a rich environment that will permit a maximum number of concrete activities, but they must keep at a minimum those situations in which the children are shown exactly how to structure those experiences.

Situations in which children are unable to fall back on preconceived ideas and in which they explore in previously undiscovered areas are of enormous educational value.[9] The art program in early childhood should be so designed as to promote the child's own personal production of concepts and develop his skills in painting, drawing, cutting, gluing, modeling, constructing, weaving, printmaking, and so on. Art productions in both two and three dimensions are important and closely related, and they reinforce each other. Each makes its own valuable contribution to the artistic growth of the child.

Very young children need exceedingly little stimulation to begin art production. They are eager to respond to the sensuous attraction of brightly colored paint and paper and to the tactile appeal of modeling materials. They delight in cutting paper for the sake of cutting and pounding and squeezing pliable materials for the kinesthetic enjoyment it gives them. They may not always choose to recount an experience, but in the exploration of materials they will learn the skills that they will need when they do wish to communicate or tell a story about something that is important to them.

Aesthetic Judgment and Valuing of Art

If a child's life is devoid of the knowledge of art and its value as an important human endeavor, he is culturally handicapped. Becoming literate is one of the main goals of education, and if children are encouraged to speak of their attitudes, feelings, and perceptions relative to a work of art, their educational landscape is not left bereft of a body of enriching and ennobling ideas which are related to the artistic contributions of mankind. Acquiring and using art terminology with an easy fluency is an important part of the child's visual learning. He responds to each aesthetic encounter with attitudes, judgments, and nonverbal feelings, and words can help in sharpening and directing his perceptions in regard to his own work and the works of others.

When children encounter a new work of art, verbalizing about it with familiar words can make for a nonthreatening starting point. Preschool and kindergarten children can begin to use elementary art terms and add to their basic vocabulary every time they handle art materials or look closely at natural and man-made objects. They can talk about which works of art they like best and how the colors and images evoke in them feelings of happiness or anger. Even preprimary children can become consciously and critically aware of works of art that evidence pleasing relationships and well-developed elements or organization and richness. Through handling art materials and seeing original and reproduced items of fine art they can come to identify a variety of art forms such as painting, sculpture, ceramics, prints, and architecture.

8. Herbert Ginsburg and Sylvia Opper, *Piaget's Theory of Intellectual Development: An Introduction* (Englewood Cliffs, N.J.: Prentice-Hall, Inc., 1969), p. 221.
9. John M. Pickering, *Visual Education in the Primary School* (New York: Watson-Guptill Publications, 1971), p. 8.

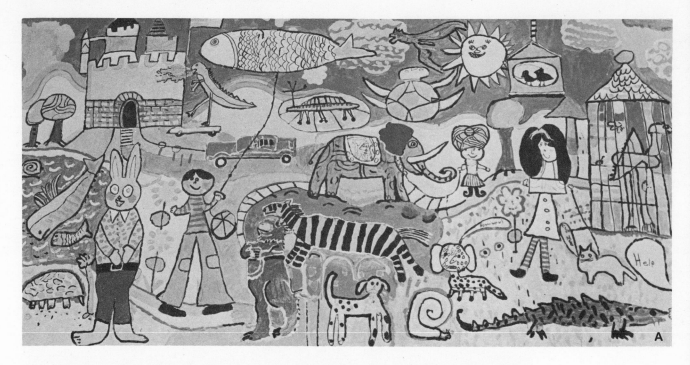

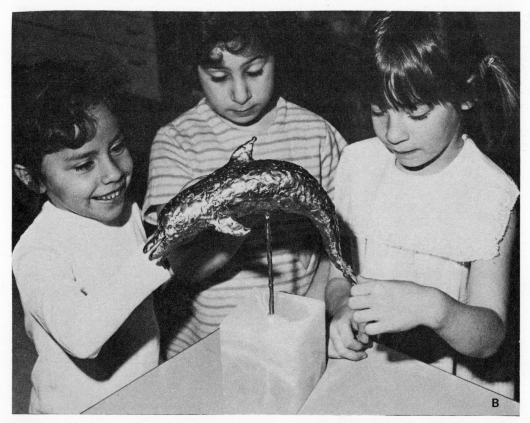

A. Many painting experiences and follow-up discussions on aesthetic concepts increase children's skills and self-judgment for future productions. This large mural was painted by second- and third-grade children for the Bryant Elementary School Library in San Francisco.

B. Bronze dolphin by a contemporary sculptor is being explored as to its curving, leaping form and its touch-inviting surface. Six-year-old children learned how metal was melted like wax with a very hot torch to form the undulating texture that they loved to feel.

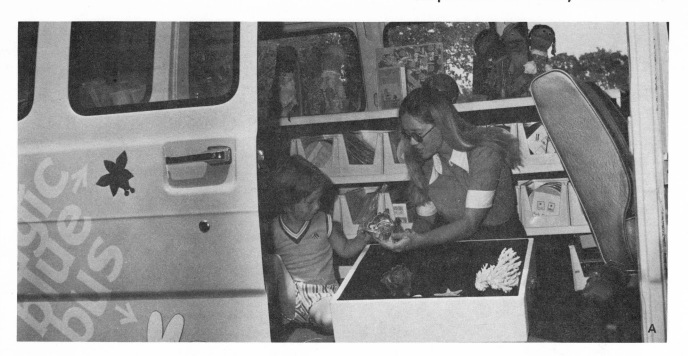

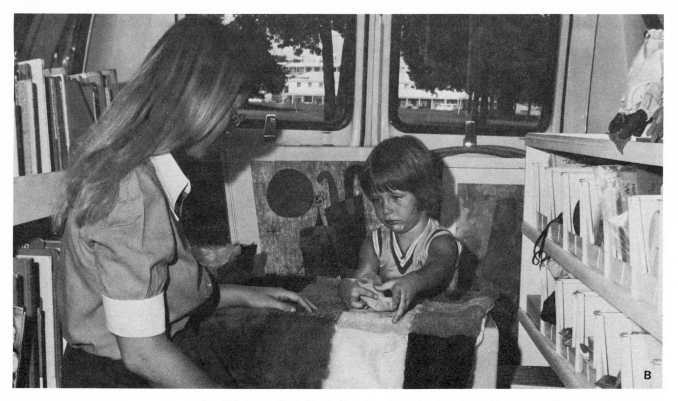

A. Oklahoma City's Magic Blue Bus from the Arts Council's Rainbow fleet provides continuous support and stimulation to that city's early childhood education programs. It offers in-service training for adults who are in charge of young children, and it enriches the youngsters' environment by lending materials on a regularly scheduled basis. Here a boy sees and touches a shell collection. (Photograph by LeClede A. Arnn)

B. All sorts of materials for increasing and broadening sensory awareness are lent from the Magic Blue Bus, as are art materials, games, and puppets for imaginative play, and fine reproductions for an early introduction to the world's great works of art. (Photograph by LeClede A. Arnn)

If art is to be elevated to its rightful place in the educational program and not be made to serve as a mere handmaiden to other subject areas, or if art materials are available only when each holiday rolls around and room decorations are needed, then the child will never come to know art as the communicator of mankind's visions and aspirations. If the art period is held only sporadically when the teacher can find a few minutes for it after the "real" work of math and reading is done, the child will receive the wrong message as to the importance of art and its relationship to life. Art must not be placed low on the scale of educational values by its neglect and misuse in the school program. Through frequent and regular encounters, young children should be brought to an awareness of the expressive qualities in visual forms and, at the same time, come to accept and respect the range of interests and abilities of their peers.

Aesthetic judgment involves an awareness of our environment. Humanities stress the relation and relevance of art to society. We are concerned not only with clean air and water, green spaces, and protecting nature's balance, but with guarding against visual pollutants as well. A visually literate populace demands an aesthetic environment which includes good design qualities in homes and home furnishings, schools, city planning, highways and transportation, television and films.

Early childhood is the time for aesthetic beginnings and foundations.

Art Heritage

Through the visual arts, schools can provide behavioral experiences that will lead to changes in which each child's ultimate potential is more likely to be reached. It is the responsibility of the school to foster in the children a feeling of pride and appreciation as to the art heritage of all groups that participate in our society and that contribute to its art.

While early childhood is a difficult period to teach the concept of historical time, children can view original works of art as well as reproductions. They can begin to know that art has a long history and that mankind has always been engaged in the creation of visual images. If the teacher will expose the children to art from some of the major periods of art history, the idea will be born that there is no one single art form that is "correct" for all human beings. The children in these early years can come to know that at different periods of time art has taken different forms and served different purposes.[10] Within the contextual study of other cultures and times, some of the important artistic contributions of ethnic groups can be introduced and studied as to their similarities and differences and the purposes that prompted the artists to create them.

10. Kenneth M. Lansing, *Art, Artists, and Education* (New York: McGraw-Hill Book Co., 1969), pp. 357-59.

2 Reaching Out

It is through early contact with arts and artists that the child's attitudes and concepts form. The young child is ready to find and enjoy art in his community. This discovery can be facilitated in several ways.

Museums and Galleries

Most of the larger cities and towns in our country have a number of small galleries and a larger museum or two that offer exciting viewing potentials for field trips. Some museums have specially designed rooms or galleries for elementary school children. Many have docents or tour leaders who are particularly trained in helping children view with sensitivity and awareness and respond

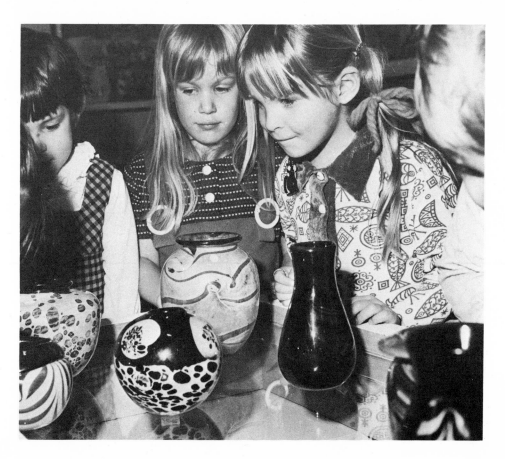

Preschoolers visited an art gallery and studied the swirling, contrasting patterns that the ceramist created on these pots.

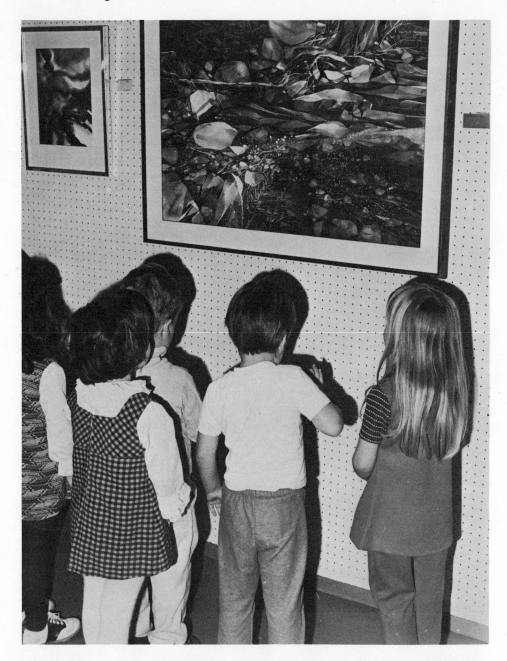

Early introduction to the many forms of art starts very young children on the road to openness and discovery. Here four-year-olds endeavor to find which paintings they like best in a small gallery.

aesthetically and with imagination.[1] The youngest child will enjoy exploring and discovering with only a little instruction on the part of the teacher. He will respond emotionally and vigorously to colorful paintings, huge sculptures, and decorative prints. Older children will benefit by some pretrip discussion and direction as to what things they are likely to see, how they were made, by whom, and so forth.

Many galleries have a rental room where a class may browse and collectively vote on which work of art they would like to borrow for a month or two. The rental fees on these paintings, prints, and drawings are minimal, and the children will profit by participating in the selection as well as in living with their choice for the allotted time.

1. *Art Education: Elementary* (Washington, D.C.: National Art Education Association, 1972), pp. 184-90.

Contacts with Artists—at Their Studios

A visit to the studio of a working artist has much to offer the young child. He comes into contact with an adult whose life is devoted to his art, and he sees him at work—producing paintings, sculpture, prints, or crafts in his own studio. He sees the artist using fascinating equipment, and listens and watches as the artist explains the sequence of steps it takes to complete an object. Most artists' studios abound in finished objects as well as works in the making and are intriguing places for youngsters to visit. They can come to know and identify art as something that is a natural and vital part of adult endeavor and of a community's life. A unit on the "Community and Its Helpers" often includes visits to fire stations, post offices, and factories. What better time than this to arrange a visit to the studio of an artist? To see a potter throwing a pot on a fast-spinning wheel, to watch a sculptor chisel a lump of stone or wood and see a beautiful form emerge, to see a craftsman create jewelry with metal and heat, to watch a weaver make a shuttle fly back and forth on a loom, or a printmaker work on a silk screen—all these are "ah-inspiring" experiences indeed for the young child.

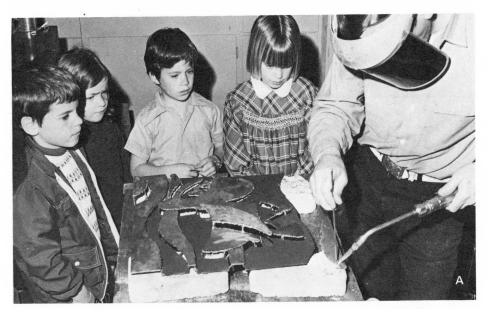

A. A trip to the studio of a metal sculptor introduces children to the beauty inherent in steel, copper, and brass when these materials are touched by the torch of a skilled and sensitive craftsman.

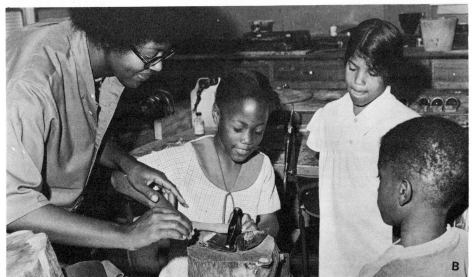

B. Visiting youngsters watched to see how jewelry can be made, and then they were given the opportunity to pound copper in a wooden mold.

Contacts with Artists—at School Visits

Not only is it feasible and stimulating to take the child to art galleries and artists' studios, but it is also highly recommended that artists be invited to come to the school. The teacher can enlist the help of guilds, leagues, museums, galleries, local Arts Councils and artist-in-residence programs to recruit resource people who are able to visit the classroom. The photographs below show a woman from the Weaver's Guild who brought her spindle, fleece, and spinning wheel to a preschool and not only demonstrated her skill but let the children work at carding wool and try their hands at spinning. They watched with keen attention as she showed them how yarn may be spun on such a simple device as a stick inserted in an onion. She told them of the many sources of fleece and brought along samples from a number of animals for them to touch.

In a similar manner, an enamelist, linoleum block printer, painter, jewelry maker, or any number of kinds of artists could touch the children's lives in a memorable way through a classroom visit.

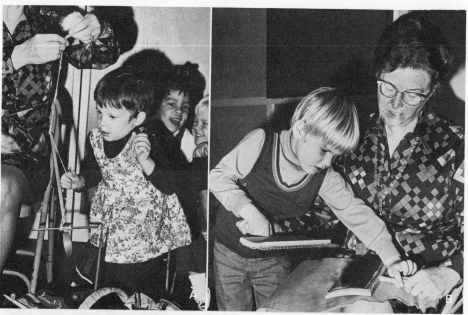

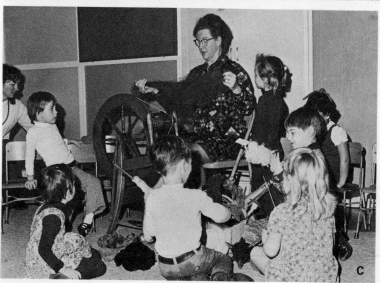

A. Three-year-old girl gives the demonstrator an assist and actually sees fibers become spun yarn on a drop spindle.

B. The ancient task of carding wool is experienced firsthand by this young boy.

C. Preschoolers examine several kinds of fleece used for spinning yarn on the wheel.

Folk Art: An Ethnic and Cultural Emphasis

Above the entrance to the International Museum of Folk Art in Santa Fe, New Mexico, are inscribed the words: "The art of the craftsman is a bond between the peoples of the world." Folk art comes to us from many ethnic and cultural groups. The people who have produced it were and are the common people of a nation or region. They modeled, constructed, carved, wove, stitched, and otherwise made objects for both utilitarian and nonutilitarian purposes. These visual arts are part of the record of mankind's achievements. They embody the values and beliefs of

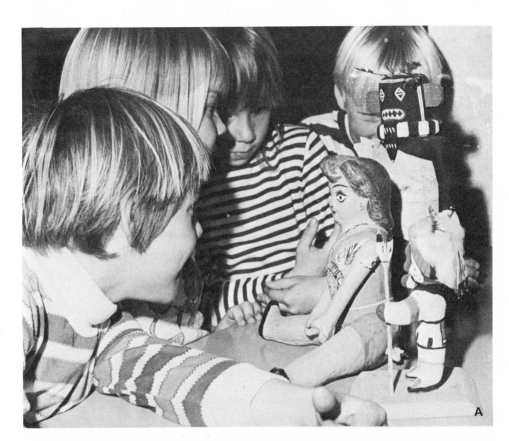

A. Papier-mâché doll from Mexico and Kachina dolls from the Southwest use familiar materials and arouse the interest of children everywhere. Through respect is born the desire to handle fine things with care.

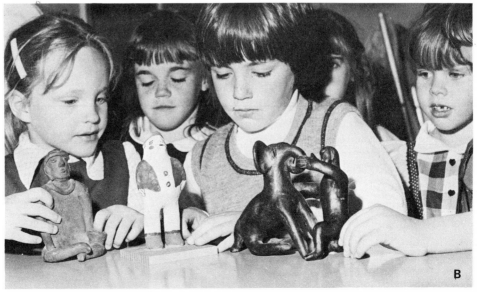

B. Mexican and Indian figures, both human and animal, are modeled from clay. Six-year-old children are fascinated with their simplicity and tactile appeal. Folk art in the classroom inspires, stimulates, and conveys historical and cultural concepts.

different cultures. Through examining them the child can begin to have a feeling of the past as well as for the present. Folk art can involve children in learning something of our origins and of ourselves. Some of the ancient artifacts that we find in original, reproduced, or photographed form tell us of human necessities, beliefs, scenes, and customs of a vanishing way of life, a way of life that nourished man's soul and from which he felt the need to fashion beautiful things. Folk art celebrates the creative spirit of a people and preserves evidence of cultural traditions.

Alexander Girard in speaking about the Collection of Folk Art from the Girard Foundation makes a plea for the present-day evolving of customs and the shaping, in our own way, of contemporary objects of equivalent value using new methods and materials. Folk art, he feels, should not be sentimentally imitated, but its creative spirit should nourish the human productive attitude of the present.[2]

Very young children can be introduced to the artistic heritage of many countries, peoples, and times through seeing a number of items that have their origin in ethnic and cultural groups. They can come to know that art has always been an important and beautiful aspect of life for young and old alike. Folk literature, folk music, folk dance, and folk costumes have long been meaningful areas of exploration in the educational program. Children respond readily to the directness and simplicity of folk art and to its sometimes humorous and whimsical notes. In the early childhood classroom, folk art can serve to motivate an art production, be the focal point for a discussion of aesthetic considerations, or provide information about the way of life of another people.

Though the roots of various cultures differ widely, there is a pervasive similarity in most folk art, and at the same time there is a good deal of relatedness to child art. Its materials and subject matter are often familiar to children. Carved and modeled figures, both human and animal, masks, baskets, pots, dolls, toys, jewelry, and textiles and metal pieces usually portray an individual craftsman's response to a need—whether it be for beauty, function, or just plain delight. Such ethnic and cultural art, when brought into the classroom, seen in galleries or books, or viewed in films, brings to the children's eyes and hearts insight into the proud roots of many cultures which throughout time have given a high priority for fine craftsmanship and good design to all sorts of objects—whether they were made for everyday use, for religious or ceremonial purposes, or even for play.

Almost all art of ethnic origin makes use of a great deal of overall decoration, whether it is applied to a fabric, carved on an animal, painted on a clay pot, or hammered on a tin mask. While the motif is usually uncomplicated, it is often repeated over and over because the folk artist delights in rhythmic design rather than in the natural appearance of things. Many folk groups use their own legends, stories, religion, and everyday events as a basis for their craft work, and in a similar manner children model and construct characters from their own favorite tales and from their immediate environment. Folk artists everywhere love to carve, model, and make small figures of both humans and animals, and children respond instinctively to this sort of sculpture with delight and interest.

While industrial growth and the emergence of city life have brought about a decline in this valuable art form, the last few years have seen a new and revitalized interest in crafts and folk art. It appears from this trend that the need for being involved in craft and art production as well as for owning objects made by someone's hand is a very natural and human one—one that can be fostered and nourished by introducing and enjoying folk art in the early childhood educational program.

2. Alexander Girard, *The Magic of a People* (New York: Viking Press, 1968), Introduction.

Children as Collectors

If art is to be an integral part of a child's life now, and later as an adult, it must have its beginnings in early childhood. It must be something that is lived with, respected, and loved from day to day. A feeling for good design—in utilitarian objects as well as for fine paintings and works of art that enrich our lives and improve the quality of the environment—cannot wait until the child is grown to have its beginnings. Children need to have good examples of art in their surroundings daily, to talk about them, and to know that there exists a wide range of art expression.

To aid in the development of attitudes and taste formation, the school can initiate a permanent art collection that becomes a part of the library. From the collection, items may be checked out by a classroom for a period of time before being exchanged for another piece. An art exhibit center in a common area of the school such as the entrance hall, reception room, or library could be initiated and maintained with fine reproductions and original works of art on display. These should then be changed frequently to keep the children's interest at a high level and develop their insight into many styles, differences, and possibilities in the world of art.

Funds may be made available from the general budget or from the PTA, or civic clubs may be encouraged to give portions from their treasury. Special fund-raising events may be held to build and add to the collection on a regular basis.

The children themselves should serve on the purchasing and selection committee, along with several teachers and interested parents. The committee should choose representative items from all fields of art and crafts—from painting, drawing, prints, sculpture, ceramics, fiber, wood, glass, leather, and plastic areas. Selections may be found in local and regional galleries and shops or purchased directly from artists and suppliers of fine reproductions and replicas.

The school art collection enables the children to have both original and fine reproductions of works of art in the classroom and the school. They learn to respect and care for fine craftsmanship, good design, and expressive qualities. They become familiar with the wide range of materials that are used by artists and become acquainted as well with the many different ways individual artists communicate. Preferences, tastes, vocabulary, and judgmental attitudes as to the value of art as a part of life find a place early in the child's experiences through the expedient of a school art collection.

Avenues to Aesthetic Growth 3

Aesthetic Discussions

When young children view a work of art, whether it is contemporary or historical, original or reproduced in print form or on film, they should be given by the teacher some appropriate background information which is within their level of comprehension. Knowing about different kinds of art and artists, what artists think about and what they do, and how art is a part of everyday life should be taken into account as important aspects of this sort of aesthetic discussion in early childhood. In order to make such discussions meaningful, stress should be placed on the enjoyment of a work of art, the uniqueness of each piece, and the presentation of many kinds of art.

Children respond to works of art with a natural enthusiasm. However, the visual language that some artists use needs a degree of interpretation or decoding for fuller understanding. The data given the children should be brief and may refer to the process and materials used in making a work of art, the subject matter depicted, the country of its origin, or a few interesting facts about the artist's life. Reference should be made to a few of the structural and design elements that make a work of art especially interesting. Such considerations as repeated shapes and colors, eye-leading lines and centers of interest, ways in which texture and pattern were created, and so on, may be mentioned by using simple art terms and vocabulary. The expressive component of the work should be stressed also—what emotions the artist may have been trying to convey and how they relate to the child's own feelings.

We should encourage young children to delay making a judgment about a work of art until they have considered several basic questions. These issues have to do with describing what they see, observing how the work of art was composed or put together, and thinking about what it was the artist was trying to say.[1] The following questions may be presented to the children for consideration:

1. What is this work of art—a drawing, painting, print, stone sculpture, wood carving, woven object, architecture, etc.?
2. Can you tell us what you see when you look at this work of art?
3. How does this picture or work of art look like or differ from some other piece?
4. Why do you think the artist made it? What was he trying to say?
5. What is the most interesting or important thing about this work of art?
6. How does this work of art make you feel—angry, happy, sad, frightened, excited—or what?

1. Charles D. Gaitskell and Al Hurwitz, *Children and Their Art,* 2nd ed. (New York: Harcourt, Brace and World, Inc., 1970), pp. 422-24.

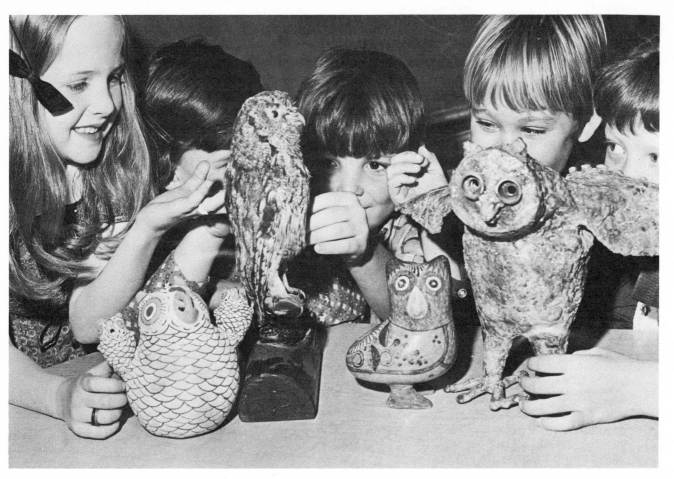

First-grade children compare expressive and visual/tactile differences between a real stuffed owl and three counterparts—one with owlets on its shoulders by a Southwestern Indian artist; a highly decorated version from Mexico; and a copper one with outspread wings by a contemporary metal sculptor.

7. What is in the work of art that makes you feel this way—textures, shapes, colors, etc.?
8. Do you like this work of art? Why or why not?

Sources for Teaching Art Heritage and Aesthetic Awareness

From the following list of materials for teaching art heritage and aesthetic awareness, all teachers, regardless of their familiarity with or specialization in the area, will find complete packaged programs, units and resources to use in taking young children on exciting ventures into the study of our cultural background in art. Included below are organizations to which one may send for catalogs for films, filmstrips, slides, fine reproductions and small study prints, three-dimensional replicas, postcards of great works of art and, of course, books.

SHOREWOOD REPRODUCTIONS, INC., 724 Fifth Ave., New York, N.Y. 10019. Catalog lists a number of comprehensive collections of reproductions of the world's greatest masterpieces coordinated with reference guides and display equipment. Prints, slides, films, and correlated study guides that integrate the study of art into every area of the school curriculum are available—as are small study prints for the child's own collection. Materials for creating an art gallery within the school are described.

BARTON COTTON, 1405 Parker Rd., Baltimore, Md. 21227. "Guidelines for Learning through Art" is a complete program in a comprehensive series for grades one through eight. Each set in the program contains ten six-by-nine-inch student prints for the child's collection, lesson guidelines and procedures, information, bibliographies, and correlative prints for comparing and contrasting the prints with other subjects and artists. Edited by Clyde M. McGeary and William M. Dallam.

AMERICAN BOOK COMPANY, 300 Pike Street, Cincinnati, Ohio 45202. "Teaching through Art," a multipurpose art print program designed by Robert J. Saunders for the elementary school. Series A, B, and C each contains twenty prints and a teacher's manual on how to extend the lesson. Lesson plans for each print give description and interpretation of the painting and background information on the artists. "Looking Exercises" guide the child's first encounter with a painting; "Learning Exercises" develop concepts and cognitive skills; and "Extension Activities" use the painting as a point of departure for developing ideas and skills. Also from the American Book Company is *History of Art for Young People* by H. W. Janson, an excellent source book for teacher's reference.

NATIONAL GALLERY OF ART, Washington, D.C. 20565. Through the Extension Service loan program listed in their catalog, slides, records, films, special publications, and traveling exhibits are available to any school free of charge except for transportation costs. In the *Catalogue of Color Reproductions* from the Publications Fund may be found listings of purchasable items including reproductions, color postcards, sculpture and jewelry replicas, and a number of materials especially designed for school use, such as slides and filmstrips.

WARREN SCHLOAT PRODUCTIONS, INC., Pleasantville, N.Y. 10470. Color filmstrips with sound on discs or cassettes. Catalog lists very wide range of subject matter including "Little Adventures in Art" in which primary children will recognize the imaginative forms that familiar animals have taken in works of art from prehistoric cave paintings to contemporary works by Picasso and Calder and creatures made of coconuts, soapstone, and such, by Africans, Eskimos, Mayans, Indians, and American colonists. Filmstrips on UNICEF art introduce the child to lands and peoples of the world as they have been interpreted both by native and visiting artists. "The Art of Seeing" series of filmstrips introduces the student to the language of visual perception and expression and stimulates him to make his own discoveries about painting, sculpture, architecture, and other media.

SANDAK, 4 East 48th St., New York, N.Y. 10017. "Visual Sources for Learning," ninety color slides depicting works by famous artists are structured to serve as points of departure for developing thirty study themes. A teacher's manual discusses slides and suggests group or individual activities in art, creative writing, drama, movement, language arts, mathematics, social studies, and science. Planned by Flora and Jerome Hausman.

BENEFIC PRESS, 10300 W. Roosevelt Rd., Westchester, Ill. 60153. For grades one through six, a series of books for students, with special teacher editions called "Meaning, Method, and Media." Each book is organized in six learning task areas and is a comprehensive art program for learning to perceive, learning the language of art, learning about artists, criticizing and judging art, learning to use art tools and materials, and building artistic abilities. The authors are Guy Hubbard and Mary J. Rouse.

BOWMAR, P. O. Box 5225, Glendale, Calif. 91201. Catalog lists Bowmar "Artworlds," a series of programs including filmstrips, records or audio cassettes, large color posters, child art reproductions, and an illustrated teacher's guide for commentary and classroom activities. Each Artworld media program involves the student in such learning behaviors as seeing, describing, knowing, creating, evalu-

ating, and valuing. Twelve sets are listed under Visual Awareness, Self Awareness, and Visual Expression. Designed by Dotty and Harvey Mandlin.

PROTHMANN ASSOCIATES, INC., 650 Thomas Ave., Baldwin, N.Y. 11510. "Art Is Everywhere" and "The Eyes Have It" series of slides with text, for second grade and up.

GROLIER EDUCATION CORPORATION, New York, N.Y. *The Book of Art*, ten volumes, a pictorial encyclopedia of painting, drawing, and sculpture. Excellent resource material.

EDUCATIONAL DIMENSIONS CORPORATION, P.O. Box 488, Great Neck, N.Y. 11022. Catalog lists collections of filmstrips on painting, sculpture, American artists, masks, etc. Also lists a Crafts Collection of color sound filmstrips presenting the major crafts and their place in the history of man.

ART EDUCATION INC., Blauvelt, N.Y. 10913. An art-appreciation print program consisting of sixty-four mounted and varnished prints and one adjustable frame has a complete kit of teacher commentaries and materials. Prepared by Olive Riley and Eileen Lomasney. Also available are Multivisuals—twenty-four color reproductions of exciting images from various sources and subject matter, mounted on heavy card stock.

CEMREL, INC., Aesthetic Education Programs, The Viking Press, 625 Madison Ave., New York, N.Y. 10022. Available in forty packages for the program, each representing ten hours of instruction in the following areas: Aesthetics in the Physical World, Aesthetics and Art Elements, and Aesthetics and the Creative Process.

FILMS INC., 1144 Wilmette Ave., Wilmette, Ill. 60091. "The Art of Seeing" series bridges the gulf between the child's everyday experiences and the world of museum paintings and statues. The series aims to develop and train visual perception by heightening awareness of art and the environment. Produced by the American Federation of the Arts with Rudolph Arnheim as project advisor. Each unit of the "Art of Seeing" film series is accompanied by a teacher's resource manual.

Games for Aesthetic and Perceptual Growth

The following games are examples of play activities that are designed to sharpen the child's perceptions and familiarize him with great works of art.

1. *Match It:* Collect two or three postcards or small reproductions of works by each of about five to ten artists. Mix them all up and place them in a box or in a fabric drawstring bag. The child takes them out of the box or bag and spreads them all out on a table. Then he is to pair or match up the two or three that are by the same artist. Two Van Gogh's have similar characteristics, colors, and style, and the child should be able to separate and differentiate them from two Rembrandt's, two Gaugin's, etc.

2. *Puzzles:* Collect small fine-art reproductions or postcards and mount them on small pieces of poster board before making a number of very simple puzzles. For the youngest child, about three or four postcards or prints may each be cut in half and all the cut halves mixed up and placed in a small box. Have him take out the pieces and put them together, matching top with bottom half. More complicated puzzles may be made by cutting the post cards in quarters or in four horizontal strips to be mixed up and reassembled.

3. *Paintbrush:* Collect four different reproductions or postcards for each of four famous artists and mount them on cardboard pieces of equal size.

Mix them up and deal out four to each of four children. At a signal each child selects one card he doesn't need and places it face down near the player to his left. When all the players have done this, the players pick up the cards on their right. This play continues until one child has accumulated four Picasso's or four of any one artist (or four landscapes, four portraits, four abstractions, or four still lifes). He then grabs one of the three paintbrushes from the center of the table, and then each player tries to grab one. The player left with no brush loses. Variation: Make a set of sixteen cards to which have been glued four different sets of eyes, mouths, noses, and feet clipped from magazines, or four sets of matching textures—rough, smooth, shiny, dull.

4. *Tell About It:* Have a number of reproductions of fine paintings, drawings, or pieces of sculpture. Have three children leave the room. The first one to return is told which is the secret picture. He then must describe it to the second child when he returns, using descriptive art words that do not refer to its subject matter. The second child must remember what he has been told and repeat the description to the third child who must try to guess which is the secret picture. Many modifications of this game may be made according to the number and kinds of reproductions available and to the interests and maturity of the children.

5. *Museum:* You will need at least twelve sets of four cards each. Each set should consist of works of art by one artist. Shuffle and deal seven cards to each player and place the remainder in the center pile, called the "Museum." The first player asks the player to his left for all the cards he has by one artist. If he has some, he must give them to the first player who then may ask the same player for more cards of a set. If this player has none, the first player draws a card from the Museum. If he draws the card he asked for, he may ask the second player for cards again. The next player repeats play. When a player collects a set of four, he places the set in front of him. Winner is the first player to place all the cards in his hand in sets of four in front of him.

6. *See, Touch, and Tell:* A natural object such as a seed pod, flower, or shell is passed from one child to another in a circle, with each child adding a word or phrase to describe it. A seashell, for instance, might be called "big" by the first child, "big and bumpy" by the second, "big, bumpy, and pink" by the third, "big, bumpy, pink, and curving" by the fourth, and so on. This causes the child to observe and feel the object carefully, to use a word to describe it, and to remember the other descriptive words that have been used.

7. *Art Words:* Using a group of photographs of zoo, farm, or jungle animals, have one child be "it" and secretly choose one animal and describe it to the group as to its color, the shape of its ears, the size of its feet, the placement of its nose, and so on. This causes the child to look carefully at the animal and select its significant and characteristic details. He may then say, "I have four thick legs. My skin is wrinkled and rough. My ears are flat and roundish. Which animal am I?"

8. *Touch and Guess:* Players sit in a circle with one child blindfolded in the center. Other children take turns selecting an object from a tray for the child in the center to hold and guess what it is. Objects should include such things as a feather, a piece of sandpaper, a cube, a cylinder of wood, a nail, a bit of fur, a scrap of soft satin, a button, a paintbrush, a rock, a wooden spoon, etc. If the blindfolded child guesses correctly on the first attempt, the child who selected the item gets to become "it."

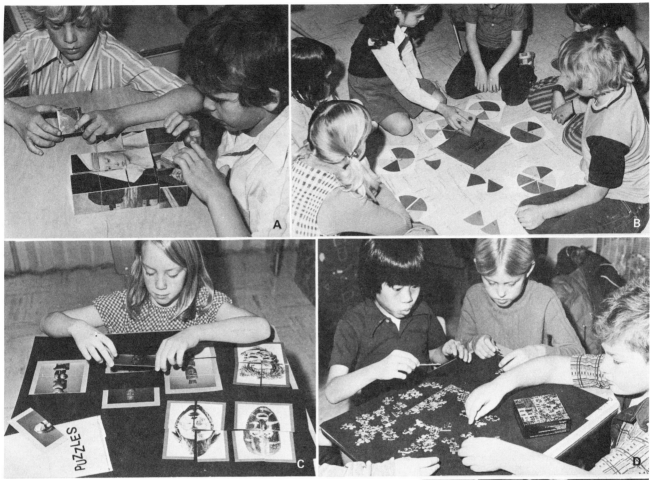

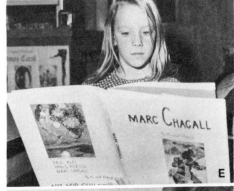

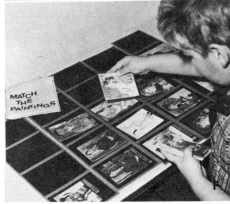

A. A three-dimensional jigsaw puzzle may be made from small, square blocks of wood by mounting six different reproductions of famous paintings to the six sides of the cubes.

B. Children are highly motivated to learn the primary and secondary colors when they play "Color Wheel." Each child has a blank cardboard wheel and tries to be the first to cover the sections with color chips, the chips being numbered in sequential order. Red is 1, yellow is 2, blue is 3, orange is 4, green is 5, and violet is 6. He must take turns throwing a die. If he throws the desired number, he may have another turn before passing the die to the next player.

C. Museum postcards are mounted on colored poster board and cut apart for simple puzzles. The vinyl envelope was stitched on the sewing machine and makes a sturdy and protective case for storage.

D. Pieter Brueghel's well-known and much loved painting of "Children's Games" is one selected from a commercial series of small jigsaw puzzles featuring famous works of art.

E. Books on art for children help them understand and delight in the symbols and imagery the painters may have used and also give them biographical information about the artists.

F. When playing "Match the Paintings," the child must perceive similarities and differences in various artists' styles and techniques. In order to group all the pictures by one artist together on the play board, he matches them with the key picture mounted on the left.

9. *Perceptual Recall:* Have a tray of a number of small objects. Let the child look at the objects for a few minutes. Cover the tray. See how many of the objects the child can name. Vary the task by asking the child to name all the brown objects, or all the hard objects, or all the round ones. Or, have one child leave the circle and then remove one or two objects; see if he can remember which ones are missing. In all of these memory/perception games, start with just a few objects and increase the number as the children become more skilled.

10. *Secret Guessing:* Pass a small object around a circle with everyone blindfolded and have each child in turn feel it and silently guess what it is. When all the children have examined it, the teacher may call on them to see how many children guessed correctly.

11. *Art Collector:* Make a set of twelve pairs (or more) of cards, each pair consisting of two different prints by the same artist. Shuffle and spread all 24 cards face down. The first child turns one card over and tries to find its mate by turning over one more card. If he does so, he gets to keep the pair. If not, he replaces both cards, face down, and the next child turns over one card and then tries to find its mate in one more turn. Play continues until all cards are paired up, the winner having the most sets. Add more pairs for older children. Variation: Make cards with matching pairs of textures, shapes, lines, or colors.

12. *Match the Paintings:* Arrange into units three or four small reproductions for each of six or more artists about like this: on a large poster board paste down three Klee's in a row, three Renoir's, three El Greco's, etc. Then give the child one print by each of the artists whose examples are on the board. His task is to place each reproduction with its proper grouping, the behavioral objective being for the child to demonstrate ability to discriminate between the various artists' styles and to relate like works.

13. *Old Master:* Make seven sets of four cards each, using four small reproductions by seven different artists. Also make one card that says, "Old Master." Shuffle and deal all the cards to four players. Dealer then places on the table all the matching pairs in his hand if he has any. He then takes a card from the player's hand on his right. If it matches a card in his hand, he puts the pair on the table. The player to his left then does the same, and the game proceeds until all the cards are matched, leaving the "Old Master" card in the winning player's hand.

4 Artistic Behavior and Development in the Early Years

Very young children all over the world begin at an extremely early age to indicate certain developmental characteristics in their art products. General stages such as this appear to be quite universal and need to be identified so that an environment for maximum growth can be designed. The adult's task is to provide the means through which the child's motor, affective, perceptual, cognitive, and aesthetic development will reach its fullest potential.[1]

Children who have had paper, pens, crayons, scissors, paint, and modeling materials available at home will come to the preschool or kindergarten more advanced in their artistic development than those who have not. Mental, emotional, and physical handicaps and social and cultural influences also have a bearing upon a child's visual image development. Some children will pass quickly through the stages of growth in art, but the characteristic pattern of their artistic behavior remains very similar. It is of paramount importance that this early period of development be encouraged to its fullest in order for the stage to be set for future growth and development. Without basic and supportive experiences with art materials the child will tend to be retarded in his artistic expression and will not acquire a language of nonverbal symbols that will enable him to express his personalized vision of the world in an artistic form.

The first marks the child makes, usually between his first and second year, are random scribbles and are most likely derived from the kinesthetic and visual enjoyment of moving the arm and hand and noticing that the motion the hand makes with the crayon, finger, or pencil leaves a mark on paper, sidewalk, or sand. After some time with this pleasant activity he will develop some control and be able to repeat certain lines and marks at will. Soon the scribbles become more organized and are made in a repeated circular or longitudinal direction. If at this time adults encourage children to do copy-work and forbid spontaneous scribbling, harm may be done to the child's development in learning as well as in art.[2] The child may sometimes name his scribbling and tell a story about it, either during the process of scribbling or afterward, without actually portraying any of the visual elements of the subject matter.

From this circular or oval shape the child one day makes a remarkable discovery—that he has the motor coordination to repeat the shape at will and that in the circle he sees a symbol that he can use to stand for a number of objects that are close-by and are of emotional significance to him. He can add two lines and the

1. *Art for the Preprimary Child* (Washington, D.C.: National Art Education Association, 1972), pp. 59-73.
2. Rhoda Kellogg, *Analyzing Children's Art* (Palo Alto, Calif.: National Press Books, 1969), p. 100.

circle becomes his mother. This configuration is sometimes referred to as the "head-feet" symbol[3] or the "big head" symbol.[4] While different children arrive at this stage at different times in their development, most children are using this symbol during their fourth and fifth years. They will repeat it often, modifying it and making it more elaborate and detailed by adding eyes, mouth, ears and so on. They may add a number of radial lines and call it the sun, or four legs and a tail to make it a dog.

The child at this time will do a lot of verbalizing with himself or with an interested adult while he is drawing—recalling, reorganizing, fantasying about some experience. The result in the end may be named something entirely different than it was originally intended to be at the inception. The child will use this rudimentary figure repeatedly to suit his needs and to communicate with himself and others about those experiences that have some important conceptual or emotional meaning to him. He will use it with drawing tools, with paint, and with modeling materials.

At this age the child is self- or ego-centered, and quite naturally the subject matter for his art expression centers around himself, his mother, father, sister, dog, and house. The objects he puts in his pictures are usually isolated and floating in space. He is not aware of or concerned with proportion and representational details. Drawing at this time is a very important activity in that it allows the child to gain motor control and refine his symbols. Painting, too, is important since it gives him a sensual, pleasurable outlet for his emotions and develops his skill in spreading colors on a paper. Modeling is important because it provides him with a three-dimensional avenue for concept formation.

An adult should never "correct" a young child's drawing, or show him "how to draw," or ask him to "copy" another drawing. Such interference is meaningless and damaging to the child's pursuit of self-discovery, to his artistic growth, and to his personality by making him dependent on an adult when he needs to be building confidence in his own visual language and learning to reach out, explore, and communicate his own thoughts.

Bruner states that by the age of three or so and through the primary grades the child is probably functioning at the level of *iconic* representation, that is, he is primarily learning through actions and visual and sensory experiences and organization. He also believes that the emotional aspects concerning learning are begun at this age, and he is in favor of a relaxed and playful attitude and approach on the part of the teacher. Bruner believes that the young child will be more encouraged to attempt things and be less upset by failure if he understands that the outcomes of such activities are not as extreme as he may have hoped or feared that they would be.[5]

After a while, usually during the fourth or fifth year, the child will extend the two feet or legs on the head figure that he has been making and draw one or more lines below for a body. To this body he may add legs or feet and arms. This body is sometimes in a triangular shape, or sometimes the body is another circle or oval with the legs and arms also drawn with ovals. Color and object relationships develop slowly, and we often see blue hair and red eyes, simply because the child likes those colors and is not concerned with strict visual representation.

The house symbol begins to appear, usually around four or five years, and the child's visual language continues to expand. At this time children are usually con-

3. Viktor Lowenfeld and Lambert W. Brittain, *Creative and Mental Growth*, 5th ed. (New York: Macmillan Co., 1970), p. 119.

4. Kenneth Jameson, *Art and the Young Child* (New York: Viking Press, 1968), p. 23.

5. Jerome S. Bruner, *Toward a Theory of Instruction* (Cambridge, Mass.: Belknap Press of Harvard University, 1966), pp. 10-13.

fident and freely draw anything that they have experienced. Occasionally they may ask for help. It is not their drawing skill that the teacher should help—rather their visual perceiving and recall. If Bryon says he can't draw himself jumping rope, the teacher can have him hold a jump rope and go through the actual process himself and then watch a friend while he jumps rope, directing his attention to the hands holding the rope, the feet off the ground, and so on. Studying several photographs or viewing a film on jungle animals can serve to direct the child's attention to details, sizes, and such that he might not have observed before but wishes to review and recall before he engages in art production. With reinforcement soundly based on directing the child's attention to the visual, tactile, or kinesthetic activities involved he will bring to his drawing and painting activities new insight and enthusiasm.

Young children will often exaggerate or enrich with many details those parts of their drawings and paintings that have some emotional significance for them and that are the focal point of their communication. Visual depiction of relative sizes and proportion is not the children's major concern at this time. Rather, they have an honest sense of logic that is naïve and obvious, and which is perhaps quite realistic in the true sense of the word. A long, strong arm is needed to pull a wagon; hence that arm will appear longer in the picture. To depict oneself with a newly lost tooth requires drawing a huge mouth. A stubbed toe feels larger than it looks and may be drawn that way.

Teachers are sometimes disturbed and puzzled by the child who paints over a picture he has just completed. Such behavior is usually of an emotional nature; perhaps the child just happens to like that particular color very much, or in painting over his picture he may be showing some normal aggressive behavior. Unless these actions are part of a larger pattern of overtly abnormal behavior in other areas, they may be regarded as within the range of typical development and will probably soon be outgrown and left behind in lieu of more positive actions.

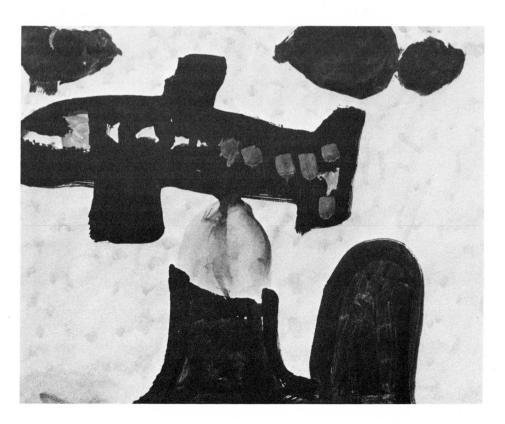

Strong and contrasting forms are visualized concepts of airplane and mountains by a six-year-old child.

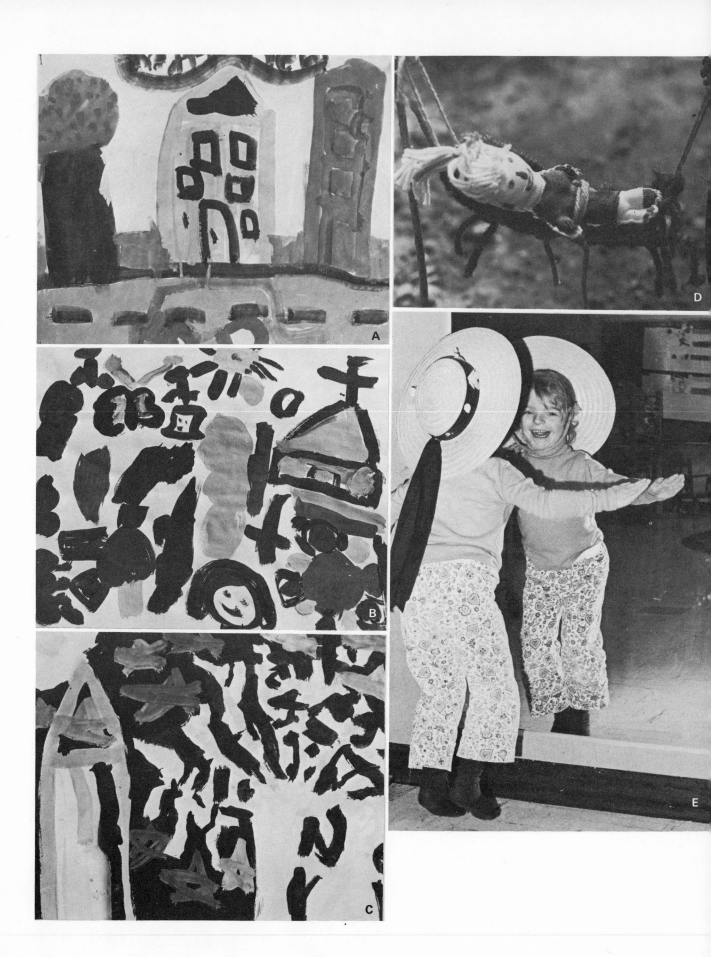

F

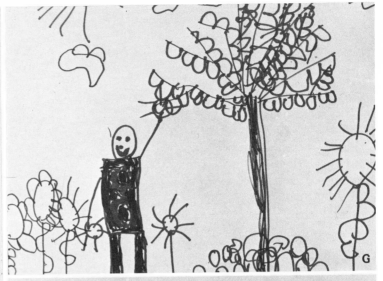

G

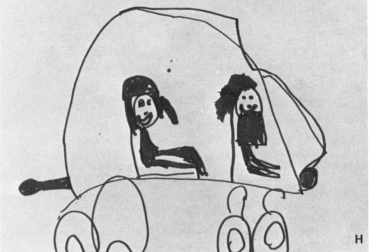

H

I

A. Sensitive feeling for balance and overall composition is readily seen in this painting by a first-grade child.

B. Scattered arrangement and floating patches of color are typical of paintings by five-year-old children.

C. A highly differentiated and aesthetically designed tree was painted by six-year-old child who had many opportunities to handle paint and brushes.

D. Lady in Woven Hammock by eight-year-old child demonstrates resourceful use of materials and makes a whimsical comment on the human form.

E. Good feelings about the self and a conscious awareness of body imagery aid in art production. A mirror in the classroom encourages movement and observation.

F. A flexible schema for the human form can be changed to meet the child's needs. This one was drawn with felt pens and shows a good deal of detail and an awareness of bodily parts.

G and H. Arms aren't very important when one is engaged in sitting in the car, but they are important when cherries need picking. These two drawings were made within a few minutes of each other by a five-year-old girl.

I. A sidewalk and fat pieces of chalk are compatible with each other. Children can enjoy drawing large figures, monsters, animals, birds, and houses on this type of horizontal surface.

Sometimes an adult can carry on a one-to-one flow of conversation while a very young child draws. This drawing-and-talking dialogue is almost on an unconscious level on the part of the very young child, and an adult can question, direct, and so structure this "happening" as to activate what a child already knows about an experience. Jenny was drawing with a felt pen. She told of getting in the car every morning to go to school. The teacher asked her who drove the car. She promptly added her father and the steering wheel to the car symbol. The teacher then asked what her mother did when they left the house. Jenny replied that she always came outside to wave goodbye, and she added her mother with a long arm waving. Then she remembered her dog and her younger sister's presence and added them. In this way the child told a whole story with reactivated feelings and memories. The teacher did not tell her where to place any of the elements in her story, nor did she tell her what things to put in it or how to draw them.

Usually during the fifth or sixth year, the child becomes more aware of his environment. He discovers that the sky is up above and can be represented by a strip across the top of his picture and that the ground is down below and can be shown by a base line along the bottom with people and objects lined up along it. Logically the air is in between. Trees, flowers, and houses appear on the base line. He draws symbolic representations to serve as the vehicles necessary in making a statement.

As the children mature still more, usually at six or seven years, some of them may begin to show evidences of being critical of their own work and becoming dissatisfied when something doesn't look just as they want it to look. This is especially true if they have not had numerous perceptual encounters, have not participated in a variety of experiences with art materials, and if their artistic growth has been interfered with by adult-imposed patterns, coloring books, or highly directed projects. The teacher can help by directing the children's attention to details and similarities, to shapes, to movements, etc., and by encouraging them to look at and explore the environment more carefully and try to relate and remember that which was of artistic and emotional significance. Six- and seven-year-old children are ready to widen the range of their experiences with art materials and explore more challenging and intricate processes. They are eager to develop their skills in handling all sorts of materials, and the teacher will do well not to underestimate their capacities. The child will by now probably tend to be less spontaneous and fluent in his art production, and some children may even tend to repeat the same subject or theme over and over.

At this level the teacher should use many motivational channels to stimulate the children and keep open the doors of creative communication.[6] Through handling a saddle during the motivational preproduction period children will be eager to draw themselves horseback-riding. As an example of behavioral objectives for such an "actual object" motivation, the following might serve. Given a saddle and drawing and painting materials, the child will

1. enjoy sitting on the saddle,
2. act out or pretend to ride horseback,
3. observe other children's body positions when they are sitting on the saddle and will verbalize as to the placement of arms, legs, etc.,
4. discuss various situations and environments where he or other people would ride horses,
5. draw or paint himself or another person engaged in horseback-riding.

6. Donald Herberholz and Barbara Herberholz, *A Child's Pursuit of Art* (Dubuque, Ia.: Wm. C. Brown Company Publishers, 1967), pp. 44-206.

These objective statements are not restrictive to individualized creativity in that they do not preordain or control the child's response nor do they specify how the child must draw or paint. The motivation or stimulus is provided, the main focus being on perception, motor and cognitive awareness, affective involvement, and subsequent art production.

In a similar manner, behavioral objectives may be written for motivations that utilize any number of involvement devices such as taking field trips, acting things out, looking at numerous photographs and films about circuses and fish, hearing humorous songs or listening to image-evoking poems, identifying with unusual and interesting sorts of people, and thinking about topics that have to do with whimsy, fantasy, and humor. Such in-depth activities will recharge the young child's batteries and aid him in pushing forward in his artistic expression. These motivational devices can provide the opportunity for the teacher to ask leading questions that will direct the child to look, feel, and remember, and to engage in art production which subsequently may be evaluated for overt evidence of a behavioral change.

Seven-year-old children having gone through much experimenting will usually arrive at a definite concept of man and his environment which they represent in the form of a schema and which they repeatedly use, deviating from it in response to a need to express a modified or different form. Some children have richer schemata than others, depending upon personality differences, emotional factors, and environmental experiences: to what degree, for example, the teacher has been able to activate their passive knowledge when they were originally forming their concepts. Space, at this age level, evidences definite order, and the child shows that he is consciously aware of being a part of his environment. The base line continues to be a universal way of organizing spatial relationships. He may deviate from it by bending it for a mountain, and then place the trees perpendicularly on it. He may use two base lines and have objects lined up on both as in a fold-over representation. He may mix plane and elevation within one picture.[7]

By eight years the schema for the human figure will have changed somewhat from being a totally geometric symbolic representation to one that shows more specific characterizations. The child will use more details in his art work, including such items as hair, buttons, eyebrows, and clothing patterns. Sometimes he will show both the inside and outside of an object as in an X-ray drawing. Distant objects may be represented by placing them higher on the page. Color now has more relationship to objects than it did before, but the child does not show distinctions between several different shades or tones of one color. By now the child is beginning to use more realistic proportions and may even represent spatial relations through the overlapping of forms. The base line may become the horizon line. Distant objects may be drawn smaller, and some attempt may be made to show figures in action poses.

Evaluating Artistic Behavior in Young Children

If a pattern of growth is recognized as a normal part of the child's artistic development and if changes in his behavior are expected as an outcome of a series of art tasks, evaluation of the artistic process and product becomes a significant area of concern.

In considering what aspects can be evaluated relative to an art production, Elliot Eisner has defined three areas,[8] the first of which is the degree of technical

7. Lowenfeld and Brittain, *Creative and Mental Growth*, pp. 54-162.
8. Elliott W. Eisner, *Educating Artistic Vision* (New York: Macmillan Co., 1972), pp. 212-16.

skill displayed in a child's work. This has to do with determining the extent to which the child has demonstrated skill in handling and controlling a given material, because without the necessary skills, expression is bound to be stifled. If a child's paper has holes in it from being overworked with a brush on its surface or if it has large puddles of paint that were not intended to be there, we can probably conclude that the child is having difficulty in coping with the material. In early childhood we do not expect highly developed mastery or control of materials; however, an increasing amount of capacity to master materials and a desire to develop skills are evidences suitable for evaluation.

The second aspect for evaluation deals with the aesthetic and expressive areas of the child's work. In this, we look at the extent to which the child has organized his work and made the parts function, as well as what sort of expressive characteristics he has displayed. The third focus for Eisner's evaluation in the productive realm has to do with assessing the degree of creative imagination and ingenuity used in the work. Technical skill and an aesthetically pleasing form may be present, and yet imaginative aspects and fresh insight may be at a minimum. Ideally, all three aspects work together and support each other.

For the preschool and kindergarten child, an impromptu and informal discussion as the completed art products are being hung about the room is probably critique enough. "John's painting makes me feel like a sunshiny day—happy and warm. Louise's drawing tells us how strong and furry her brown dog is. Jim loves red and orange, and he has arranged them well."

An attractive display of products in which the child has placed much sincere effort is vital to the extent that this act of exhibiting a child's work says to him that he, as a person, is important and that his individual and unique achievements are respected and valued. All the children's work should be on display at different times during the year, and appropriate reinforcing comments and definitive discussion should be made about them.

As children produce art at a more conscious critical level, usually during the first grade, they may talk with the teacher in small groups or individually, verbalizing about their work and becoming more aware of the art elements and how to integrate them in their artistic configurations. Periodic discussion after art production periods will aid the children in dealing more effectively and expressively with color, shape, line, contrast, rhythm, and all-over composition. In this way future discouragement, apathy, and frustration may be prevented. If teachers neglect to talk about the child's art in art terminology, it should not be assumed that the child will automatically develop in aesthetic language and awareness.

Using a positive and constructive approach that does not single out one child's work as "better" than others, the teacher should ask such directed questions as, "What is the best part of this painting? What shapes in Dan's picture tell us about his boat ride? How did Joe make us feel the coldness of a snowy day in his picture? What shapes are repeated in Helen's work and how does this make us feel?"

Art educators have frequently made statements as to the inadvisability of comparing one child's work to another's, using it as an example for others to copy. While harm can be done if emulation is the objective, it is not to be interpreted that a teacher should never choose one child's work for such positive and directed comments as those that refer to the use of ingenuity and praising it; the use of unique approaches and solutions; the imaginative use of materials; the sensitive observations of things and events; the enriching of drawings and paintings with fine textural qualities and details; fine selection and expressive combination of colors; taking the initiative in suggesting ideas; the manner in which a child showed an emotional feeling in his work; etc. Such evaluative considerations are

specific guideposts for young minds which serve to aid them in the future with added insight and understanding.

Checking on the Process and the Product

Over a period of time each child should be observed and scored by the teacher as to evidence of individual progress and growth in the following areas:

1. Does the child show evidence of being visually aware and sensitive to differences and similarities in color, texture, shape, line, and form?
2. Does the child use art terminology to describe works of art and natural objects?
3. Does the child enjoy experimenting and trying different approaches with each art material?
4. Does he create with ease and fluency?
5. Does he change his symbols and images to suit the demands of the problem, material, or situation?
6. Does he persevere with increasing duration?
7. Does he have unique and imaginative ideas?
8. Does he show resourcefulness in working with a combination of materials?
9. Does he display emotional qualities and feelings in his work?
10. Does he work independently without need to imitate the work of other children?
11. Does he show self-confidence and eagerness in his art production?
12. Is he able to handle a number of tools and materials with an increasing degree of competence?
13. Does he use a variety of subject matter?
14. Does he produce works that show a unity of compositional elements and incorporate a variety of forms?
15. Is he able to cooperate in a group art task?
16. Does he work without bothering other children?
17. Does he enjoy performing art tasks and place value on them?
18. Does he frequently choose to work with art materials in a free-choice situation or outside the school?
19. Is the child significantly retarded or advanced in his art?
20. Does he show respect for art materials and cooperate at cleanup time?

Photography 5
Perception and Production

Setting up an open-ended environment, in which the child's growth in visual discernment and subsequent artistic expression will come about, is one of the tasks facing the teacher who designs activities for early childhood.

Introducing photography early in the year and providing numerous experiences with cameras throughout the ensuing months will enable children to learn and improve upon the skills involved in taking a picture. Moreover, in developing photographic skills the child learns to look selectively and with discrimination at the world about him as a preliminary to art production. Once photography has become a familiar friend—an extension of the child's self—many occasions within the curriculum will be prefaced by the enthusiastic request from the boys and girls—"Let's take some pictures."

With the present-day counterparts of the old box cameras available at relatively low cost (Instamatic, Autopac, Autoload, etc.) only the barest rudiments of picture-taking instruction are necessary, and everyday events and familiar surroundings will be looked upon with a fresh eye as to their picture-making and art-related possibilities.

The photographic process may be used not only to deepen perceptual skills but also to coordinate and unify a total experience. Looking at slides or prints over and over again brings to the child's mind details, points of view, and relationships that might have been missed before. Seeing how other children chose to take their pictures of the same subject matter helps children see, appreciate, and have respect for individual differences and points of view.

Preliminary Planning

Here is a specific example of how photography was introduced in a kindergarten. The class was planning a trip to the zoo, and four Instamatic cameras were available for them to use. The following preparations were made:

1. The children saw and handled the cameras in the classroom, looking through the viewfinders and clicking the shutters at pretend pictures.
2. During a brief demonstration and discussion, the children saw how film was loaded and where important parts of a camera were located, and they learned the proper terminology for these parts—lens, viewfinder, shutter, and film cartridge.
3. Common errors such as holding a finger in front of the lens or moving the camera when clicking the shutter were pointed out.
4. Photographs clipped from magazines were mounted on heavy paper and examined by the entire class with the teacher's guidance. Later they were

scrutinized carefully by smaller groups of youngsters. These examples had been selected to illustrate the following basic points of view which would help the children make decisions when they began taking pictures.

a. close-up pictures
b. faraway pictures
c. not so faraway pictures

d. camera looking straight at a subject
e. camera looking down at a subject
f. camera looking up at a subject.

Increasing Visual Skills

When the children arrived at the zoo, they looked very carefully at the mammals, birds, and reptiles and made their individual choices as to which ones interested them the most for their picture-making possibilities. Then each child decided whether to take a picture of a single duck or a whole flock, of a detail, such as the head of the hippo, or the entire body of the elephant.

The colored transparencies and black-and-white prints were then developed and viewed by the entire class. The slides were projected on a large screen for all the children to discuss and to recall who took which pictures. Later, small groups of children enjoyed seeing the slides again in a small portable viewer. Black-and-white pictures were examined on the table top before being displayed on a bulletin board.

In thus viewing their own work critically, the children discovered for themselves how they might improve their next photographs. They realized that it is important to hold the camera level so that the ground and trees don't look tilted. They saw, in a few blurred images, what happens when the camera is not held steady, and one child had a fine photograph of his finger in front of the lens! Some children decided their photographs would have been better had they taken them from a different point of view, or closer, or farther away.

Art Production

To culminate the photographic trip to the zoo, the children and teacher discussed the photographs and things they had seen, pointing out how the shapes of animal ears differ, the relative sizes of paws and noses, the colors and patterns of fur and feathers, and the different sizes of large and small creatures. Then each child was given a piece of white fabric about eight by ten inches or so in size, and using felt pens, he drew the animal that fascinated him the most. The fabric drawing was then stitched to another piece of fabric on the sewing machine, and each child turned his fabric inside out, stuffed it with a bit of Dacron or nylon stocking, and used a simple whip or running stitch to sew up the opening.

Then on several pieces of butcher paper about eight feet long, the children worked in groups and painted the environments for their stuffed animals. Using tubes of tempera called Rich Art Colors, the children painted cages, trees, ponds, paths, a sun, and even a zoo keeper. When the paint was dry, the stuffed animals were pinned in place, and the mural was complete.

Throughout the year, there are many happenings and experiences in which photography can play a vital and indispensable role in developing a young child's perceptual skills. Units and activities vary from grade level to grade level and from urban to suburban school. A few suitable and typical subjects might be found among the following:

—Playground games
—A trip to a farm or ranch
—Transportation
—All kinds of trees

—City streets
—Best friends
—Pets
—All kinds of houses

—A factory tour
—The Harbor and
 Fisherman's Wharf

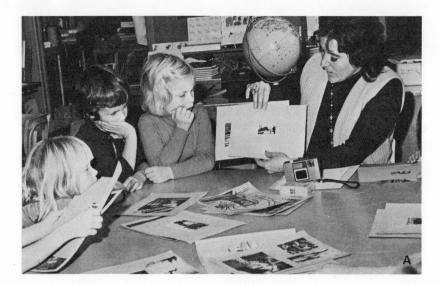

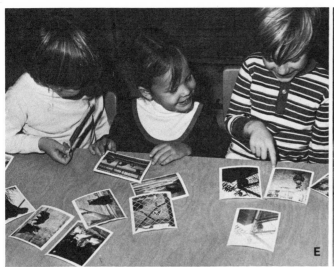

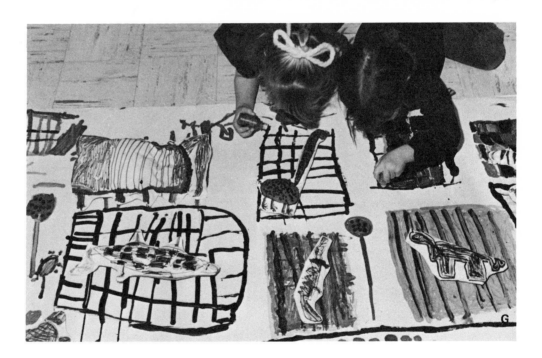

A. Kindergartners study cameras, point of view, and framing devices as preparation for photographic trip.

B. Decision-making is involved when young children handle cameras. Through experiences come the skill and mastery necessary in taking a picture.

C. Closeup point of view was chosen by this boy as he aimed his camera lens down at his subject.

D. This photograph of a bear was taken by a five-year-old child.

E. Children can learn to see another person's point of view and relive a happy experience when they study the class's photographic collection.

F. Colored slides are viewed in a small portable projector after the zoo trip. Children often discover details in photographs that they didn't perceive when they were on the spot.

G. Art production culminated in a mural with stuffed animals and a painted background.

After the pictures have been taken, the children can use the occasion to talk and compose songs and dances based on a particular phase of the experience. They may make notebooks about the happening, write stories and poems, or present their ideas visually in individual or group projects. Such varied tasks as printmaking, modeling, drawing, cut-paper work, chalk or paint murals, puppets, zigzag books, banners, and so on, should be considered as suitable activities.

At the end of the year each child may place his photographs in a small album, a record to keep for many years as well as a visual reminder of the many learning experiences in that year of school.

Children will be handicapped in today's highly visual culture if they have not been given the opportunity to discern, from a myriad of sensory impressions, that which is aesthetic and worthwhile and, subsequently, to record their thoughts and feelings in a creative way. Each encounter the child has with the world about him will contribute in extra measure to his developing sensitivity if he continues to be involved in the exciting world of picture-taking and picture-making.

6 The Teacher as Facilitator
The School Where It Happens

The teacher who is in charge of structuring and designing the young child's artistic encounters must investigate many avenues of skill development, of sensory refinement, of concept formation, and of emotional awareness in order to develop to the fullest each child's inherent and unique potential. The teacher must set the stage, arrange, plan for, and put into orbit many environments for the child's learning, expressing, and communicating. In so doing the teacher will

1. whet the child's curiosity and arouse his imagination,
2. support his enthusiasm and share with him surprise and delight with visual and tactile encounters,
3. show appreciation and respect for his artistic products,
4. reward and reinforce sincere effort, unusual and unique answers, and independent thinking,
5. display, praise, and show genuine appreciation of his art production,
6. structure both two- and three-dimensional art tasks frequently and regularly to provide the trigger for ongoing creative activities and make clear to the students what behaviors are expected of them,
7. never underestimate the child's capabilities or his capacity to understand the world of art,
8. know when it is the opportune time to lead, initiate, suggest, influence, direct, plan, guide, demonstrate, and criticize,
9. introduce him to works of art by other people and foster and respect his appreciation and judgment of them.

Teachers of early childhood classrooms would do well to be advised of the findings of the Goertzels and Torrance. The Goertzels studied the lives of 400 very eminent people of this century. They found that the childhood homes of almost all of these people emphasized a love of learning with a strong drive toward intellectual or creative achievement being present in one or both parents. The family attitude of being "neutral" and "nondirective" was practically nonexistent. Three out of five of these people had disliked school, but the teachers they liked the most had been those who let them progress at their own pace, work in one area of special interest, and had challenged them to think.[1]

Torrance's research pointed to a child's creativity peaking at the second-grade level, then tending to be stifled by demands and pressures "to conform" from curriculum, peers, and teachers; thus a creative thinker is forced to adjust to the

1. Victor Goertzel and Mildred Goertzel, *Cradles of Eminence* (Boston: Little, Brown & Co., 1962), pp. 3-9.

norm. Torrance also found that teachers tend to favor a child with a high IQ but with low creativity. His study described the creative child as one who seems to "play around" in school and is engaged in manipulative and exploratory activities; one who enjoys learning and is intuitive and imaginative, enjoying fantasy; one who is flexible, inventive, original, perceptive, and sensitive to problems. The creative student, he believes, is most often not identified as intellectually gifted.[2]

The influence of the teacher is a major one. By his or her positive attitude and example, the child becomes susceptible to new experiences, receptive to the many forms of art, judgmental in viewing, and skilled in forming tastes and making choices. Books and films having a high quality of illustrative material should be selected for special viewing. Exhibit-corners in the room should display well-chosen and tastefully selected art and craft objects as well as beautiful natural forms. The teacher should endeavor to keep the room attractive and inviting. Live plants, clean fish tanks, brightly colored furniture, and well-designed bulletin boards speak for themselves in contributing to a warm and happy atmosphere.

While a number of experiences in college art classes may aid a teacher in developing skills in his own art production, a lack of extensive formal art training should not be thought of as a deterrent to a teacher's developing a sensitivity for and an understanding of the art of young children. A teacher who comprehends how a young child grows, develops, and expresses art ideas, who provides the child with suitable materials and motivations, who is aware of the importance of perceptual stimuli, and who brings the children in contact with some aspects of historical and cultural art is doing far more for young children than one who is so competently versed in perspective, shading, and depicting realistic landscapes and portraits that he loses sight of the behaviors expected from the very young child. This is not to say that a teacher who experiences artistic production himself is not the richer for it. Getting one's hands into clay, fiber, or paint is a fine way of identifying with the joy and struggle of creation that young children experience.

The teacher will find much value in keeping a folder of each child's work, putting in it from time to time dated drawings and paintings and cut-paper work that show progress, deviations, or regressions in the child's development. If the child has verbalized or named his work, it will be helpful to attach a notation to the drawing. Art is language for the child, and we can learn much about his personality and his ways of perceiving and feeling about the world through this cataloging technique.

The question is often asked as to how much direction or stimulation the teacher should give once the stage has been set and the young child is involved in an art task. Comments and statements that reinforce, encourage, and further the direction of the child's own thinking, that praise, remind, and aid him in recalling pertinent information, and that do not correct proportion or suggest perspective are positive helps. Destructive comments block the child's spontaneous flow of ideas and cause his art production to cease. The discerning teacher moves around the classroom during the work period and gives concrete suggestions when called upon, and he senses design and compositional problems when children need such specific help. Such a teacher is enthusiastically involved with the children's discoveries and is able to evaluate their efforts at critical turning points.[3]

The teacher should not draw for the young child nor ask him to follow a pattern or copy a drawing or prototype because, in so doing, the child's main thrust

2. Robert F. Biehler, *Psychology Applied to Teaching* (Boston: Houghton Mifflin Co., 1971), p. 248.
3. Frank Wachowiak and Theodore Ramsay, *Emphasis: Art* (Scranton, Pa.: International Textbook Co., 1965), pp. 15-21.

becomes that of pleasing the teacher. In attempting to imitate, the child will find the visualization meaningless and beyond his conceptual stage of development, and he will experience failure and frustration if he is unable to imitate. If he does imitate successfully, he is laying the groundwork for a dependent attitude for his future art production. If one child makes a habit of copying another child's art work, it is wise for the teacher to separate the two youngsters and then be alert and quick to praise every sign of initiative on the part of the dependent child.

Contact with Parents

At the beginning of the school year the teacher should find occasion to send a letter home to the parents or meet with them in conference and explain the goals and behaviors to be expected in the child's art production. When drawings and paintings are taken home by the children, they should be received by understanding and appreciative parents if the artistic development at school is to be reinforced. A few words to the parents explaining what normal development is at that particular age level will be helpful.

In addition, a few suggestions as to art materials and home environment for art may be made. Included should be reminders that

1. a place to keep his own collection of interesting objects will encourage the sharpening of the child's visual and tactile sensitivities and nourish his curiosity;
2. a place to work with drawing, modeling, constructing, cutting, and painting materials will encourage the ongoing and spontaneous flow of art production;
3. trips to interesting places in the community will give him experiences that will be reflected in his art work;
4. displaying his work shows the interest and support of the family;
5. coloring books and patterns destroy his ability to think creatively and foster stereotyped and meaningless responses;
6. comparing his work with his brother's or sister's makes for negative feelings and attitudes;
7. correcting his work or drawing for him makes him less independent;
8. encouraging him to be inventive will help him to be resourceful with materials;
9. his art work is an indication of his personality. Respect it and endeavor to see his point of view.

Space: The Classroom as Studio

All of the three prevalent kinds of physical arrangements in a school can be organized to provide a favorable environment for art. First is the self-contained classroom in which all children are in the same grade and one teacher is responsible for all the experiences of the children. The school district often has available the services of an art consultant or resource person to aid the teacher in planning an art program, and many schools have a visiting art teacher. Second is the open or nongraded classroom, with a large number of children of several age groups working at their own levels of accomplishment and regrouping for various subject areas. One teacher is usually responsible for the children's art work. Third is the special school art room to which the children go at specified times during the week for art activities.

In preschool and kindergarten rooms, children usually choose during free activity periods to work in one of several spaces—one of which may be the art

area—in a largely nondirected and independent manner. At other times, art tasks may be structured with small groups or perhaps the entire class working together.

The matter of spatial organization and accessibility of art materials within any type of room setup is related to the frequency and quality of the art program. Easy access to and immediate availability of art materials are imperative to a good art program. When art supplies and work spaces are convenient and neatly organized, the teacher will feel more relaxed and eager to provide a maximum number of art activities, and the children will be more stimulated to innovate, experiment, and participate. Four kinds of space within the classroom should be considered:

—Storage space for materials, tools, and supplies
—Space for projects not completed
—Space for displaying the children's finished work, both two- and three-dimensional
—Space for displaying interesting art-related objects

Paint and brushes should be stored in cabinets or on shelves near the sink. Several large cans should be kept handy for storing brushes of various sizes. Different sizes, colors, and kinds of paper should be on shelves or in drawers within reach of the small child. Shallow plastic trays or dishpans with labels attached can be used to store felt pens, chalk, oil pastels, crayons, colored pencils, scissors, glue, and tape. Cardboard boxes or ice cream cartons should be labeled and filled with such materials as felt, fabric, yarn, feathers, and the like.

Clutter and sloppiness, broken and damaged art materials stuffed into drawers and cabinets, have a very unstimulating effect on both teacher and child. On the other hand, properly maintained art supply areas invite the child to participate in creative tasks.

Time: Regular and Frequent

Preschool and kindergarten children need daily encounters with art production. Often, five or ten minutes is all the time required for them to engage in drawing, modeling, or cutting. As they grow older, their perseverance increases and they may be expected to work for longer periods of time. First-graders should be expected to work twenty or thirty minutes on simple art tasks and for longer periods on more complicated tasks that involve several steps to completion. Kindergartners and first-graders are ready to spend extended time periods working together on such art tasks as mural-making and construction activities. In so doing they spend time learning to respect another's point of view and see their own production contribute to the whole. Primary-grade children should be involved in art activities at least two or three times a week.

Since the creative aspects of art production involve an alert and vigorous mind, teachers would do well to schedule art periods early in the day when the child's ability to attend and remain "on task" are at a high level. Aesthetic sensitivity and art skills develop with use in the same way that skills in reading and mathematics progress—through frequent and regular episodes.

Materials: Suitable and Varied

Small muscles in early childhood are developing motor control rapidly, and art materials that provide the child with experiences in cutting, joining, applying, brushing, twisting, forming, adding, squeezing, rolling, pressing, printing, taping,

and drawing are basic ones. The materials and processes introduced and used in early childhood must be on the child's level if he is expected to perform with minimal assistance from the adult. Small children *can* learn to cut both paper and fabric if they are supplied with good, high-quality scissors. Ball pens, soft lead pencils, small-size crayons, felt pens, oil pastels, small, medium, and large stiff-bristle brushes, glue, tape, clay, salt ceramics, staples, needles and yarn—all provide fertile soil in which the seeds of the young child's imagination may grow. If the very young child ever needs an assist from an adult in manipulating certain materials, the help should serve to prevent a minor frustration and should act to keep the child's imagination in a productive flow. It should not interfere with his own spontaneous and personal expression.

The lack of mastery in handling materials on the part of the young child may sometimes be due to the constant introduction of new materials each week, never allowing the child time to gain competency with any one material. Over a period of time the child will not have had enough in-depth experiences with one material and will not have become involved in seeking his own personal statement in that media. The teacher who feels it is necessary to present a new "gimmick" every Friday afternoon is making the child novelty-oriented and is not providing for individual confrontation and artistic growth in any one area.

This is not to say that variety in materials is not needed. After the initial exploratory and experimental period, the child may find that new material enables him to give form to a latent image. Through working with materials a number of times, a child learns which ones suit him best and what limitations and possibilities are characteristic of each. Through exploration and repeated practice with art materials the child develops self-sufficiency, visual literacy, and an encompassing awareness.

Drawing and Painting 7

Human beings have engaged in drawing activities since the first rock pictographs were made many thousands of years ago. Early man drew on cave walls and on clay pots. Egyptians used limestone tablets and sheets of papyrus. Artists in the Middle Ages drew on parchment made from goatskin or sheepskin.

Drawing is basic to art. Drawings can be valid works of art in themselves or can be made in planning other works of art. Drawings by the old masters are treasured in museum collections, and many contemporary artists make sketches, figure and contour drawings, modeled renderings, and cartoons as their means of expression. They use charcoal, chalk, pastels, Conte crayons, pencils, and pens and ink.

Children begin drawing very early in their existence when they first trace a finger through spilled oatmeal, move a stick on the surface of sand, or make a few crayon or chalk marks on a wall. It is exciting, indeed, to discover that the *kinetic* activity of moving one's hand when it is holding a crayon can leave a mark on a paper!

To draw is to depict forms with lines; it is to pull or move a drawing instrument in a direction that will cause it to make marks. The best tools for children to use are felt pens, crayons, oil pastels, ball-point pens, chalk, and soft lead pencils. Most drawing instruments are small-tipped, and these almost always demand a small piece of paper; conversely, thick chalk is an excellent medium for drawing huge life-size figures, animals, and houses on the sidewalk or on a large piece of paper.

Drawing plays an especially vital role in the young child's artistic development because it is during early childhood that he needs to see very clearly the symbols that he is making and not have them drip or run together as they do when he works only with paint. He can use drawing tools to make outlines and details, and it is at this time that his perceptual explorations are leading him towards finding and recording all sorts of things that are of fundamental importance in his development of concepts. The more details he perceives, the more details he is likely to draw, and the more highly differentiated will become his visual configurations.

Thick round-topped crayons are frustrating for small children to use. At a time when they are seeking symbols and endeavoring to form and refine visual schemata, small crayons will better suit their needs. A thick crayon in the hand of a five-year-old child is equivalent, in proportion, to a broomstick-size crayon in an adult's hand, making it difficult for him to grasp and to control its direction. The child will find it much easier to draw small details such as fingernails, shoelaces, and teeth which he may desire to do but cannot do with thick crayons. While slender crayons may tend to break more easily than fat ones, no child should ever

be so cautioned about the use of his crayons as to cause him to become intimidated and fearful of using them. If one of our objectives in the education of young children is that of having them become more perceptive in relation to visual details and more able to make distinctions and differentiations, we must provide him with the kind of art materials that encourage definitive drawing activities. Small-size crayons, pencils, ball-point pens, and felt pens do just that.

Throughout history painting has been a mirror for man's feelings and ideas about his world. The development of civilization has been recorded by artists for many years, and the many paintings by artists in countries all over the world tell us much about religion, national life, historic events, geography, and famous personages. In early childhood art programs, painting should play a constant and integral part. Tempera is the most functional and popular paint for young children to use. It should be purchased in liquid form (in plastic containers with squeeze tops that make for easy dispensing). If the colors are too thick, they should be thinned by stirring in a little water; however, tempera should be used in a creamy opaque consistency, as too much water makes it transparent and runny. Paper for

A. Play equipment can provide an environment in which children can develop a feeling for good design while they are enjoying kinetic activities.

B. Delightful fantasies and imaginings were drawn with waterproof felt pens on lengths of prehemmed fabric before the teachers gathered them into gay skirts. Supportive role of the teacher is important in fostering the child's artistic production.

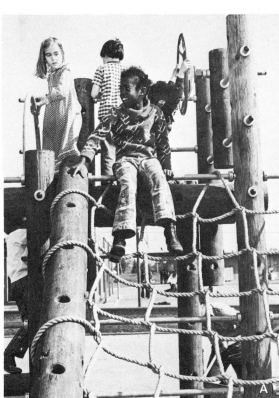

painting activities should be heavy enough so that it does not tear when it becomes wet with paint. Flat and round stiff-bristle brushes in small, medium, and large sizes should be plentiful, since the exclusive use of big, wide brushes encourages the smearing and stroking of paint rather than the making of images and the painting of sensitive forms and details.

A distorted conception, prevalent for a number of years, has been instrumental in forcing the young child to make only large paintings and to use only thick, wide brushes. What benefits are to be reaped when we provide small fingers and hands with only supersize art materials? Children may sometimes feel threatened and overpowered by large blank sheets of paper and find themselves unable to manage, delineate, and control the wide strokes that a large brush forces them to make. Children should be allowed to have a choice as to the size of paper they wish to use, and they should have available to them all sizes of brushes so that they can make a decision and select those which best suit their needs and thus develop skill and mastery in using them.

The child should be comfortably situated for painting and have a supply of brushes, paint, and a container of water in which to place his brushes when he is finished with them. An old shirt worn backwards or a vinyl apronlike smock should be worn to protect his clothing. A damp sponge should be handy for him to use in wiping his fingers.

While most preschools and kindergartens have several easels available for painting activities at all times, their use is more one of convenience than of help for the development of the child's painting skills. Since the paper is attached to the easel at the top and hangs vertically, paint tends to drip and run down and can frustrate and confuse the young painter. Two alternative methods are suggested:

1. Spread newspapers on the floor and have several pie pans of tempera close-by so that the children may sit on the floor in groups and paint on a flat surface. Pie pans are an excellent solution to the problem of what paint containers to use as they do not tip over easily when a brush is left in them, and they are easy to wash. Small amounts of two or three colors in one pan can provide the child with exploratory experiences in mixing colors.
2. Place paper on table tops so that the children may stand up and paint on a flat surface. Small groups of children can paint close together, sharing a half dozen or so containers of paint.

After very young children have had a number of initial exploratory experiences with one or two colors of paint, they should be given some instruction in the handling of brushes and paint. They should know and begin to demonstrate proficiency in

1. putting the brush back in the same color to avoid getting the brush or the paint supply muddy,
2. wiping each side of the brush on the inside edge of the paint container to avoid dripping and having excess paint on the brush,
3. using their fingers, not the fist, to hold the brush and grasp it above the metal part,
4. letting a color dry on the paper before applying more paint on top of it or too close to it, to prevent smearing
5. using a large flat brush for large areas and smaller narrow brushes for details and for painting up close to another painted area,

6. having a few concepts as to mixing colors, such as adding white to a hue to make it lighter, black to make it darker, blending red and yellow to make orange, and so on,
7. using chalk occasionally for a preliminary sketch for a painting,
8. using the tip of the brush and being able to make thick and thin lines and strokes as desired,
9. washing brushes in cool water and storing them, with bristles up, in a tall can, jar, or brush rack; and cleaning up the paint area.

The teacher's guidance in setting up many painting experiences for the children will greatly enhance the variety of approaches that the class may take. For instance, giving the children colored paper to paint on will enable them to see new relationships between colors and the unifying effect of the background. Premixing colors occasionally for the children will encourage them to try mixing colors themselves; pastels, blended tones, grayed colors, gold, silver, magenta, peach, and lime are not used frequently, and their introduction will spark the children's interest and cause them to think of new subject matter to use for picture-making.

Small amounts of unused leftover paint should be poured into either a "warm" color jar or a "cool" color jar, making blended tones for future use. Aluminum foil can be used to cover open containers of paint if they are to be used within a day or two.

Older children will profit from having a piece of scrap paper handy to try out brushstrokes, brush sizes, color mixing, and so on. They can also work together in planning, sketching, and executing a mural on a large piece of paper, with each child painting several items individually.

Glue-it-on Drawings

Most young children produce drawings frequently and with fluency, but a few children show little interest in drawing, probably due to a lack of confidence in their own ability. Both types of youngsters will respond with enthusiasm to the "idea starter" type of drawing motivation. This art task suggests to the child a specific focal point and directs his thinking to the innovative possibilities upon which he may elaborate, may enrich, and even deviate from his schema.

In glue-it-on drawings the basic concept is that of attaching one item to a piece of drawing paper and using that object as a visual clue for the child to begin making a picture.

CLOTHING AND FACES Gluing on cut-out faces or one item of clothing, such as a sweater, slacks, shoes, or hat, which has been clipped from a magazine or catalog is especially inducive to developing the child's concept of the human figure. The teacher or the child may glue the clipped photograph of a single item of clothing to a piece of drawing paper, and the subsequent discussion should deal with what the person who is wearing that particular article of clothing might be doing—running down a hill, walking a dog, playing ball, skiing, pulling a wagon, sweeping a floor, jumping rope, painting a building, and so on. The motivation should then lead the child's thinking to the environmental aspects that would be appropriate, i.e., where the figure might be—on the street, in a garden, at the zoo, on a mountain—and who else might be with the person. Then the children should use crayons, pencils, felt pens, or oil pastels to complete the drawing.

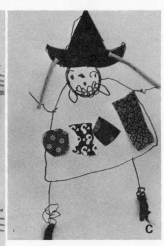

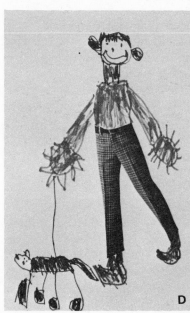

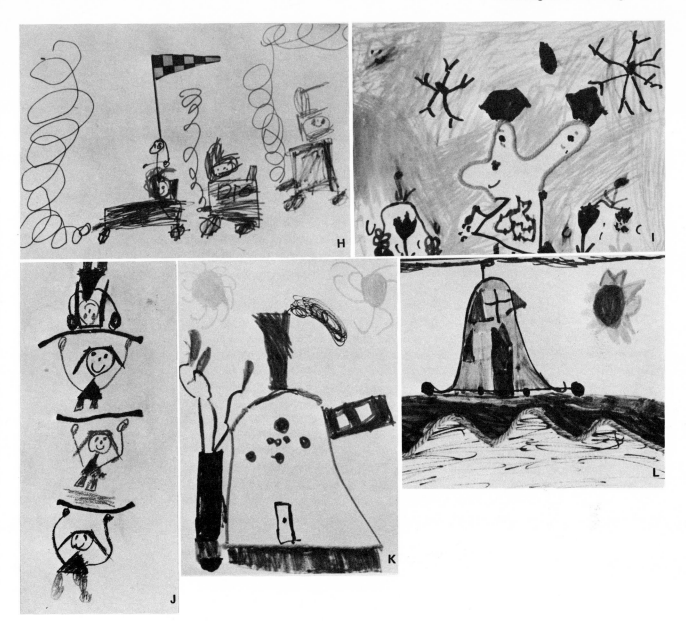

A. Photographs of heads clipped from a catalog were glued to twelve-inch strips of light-weight poster board, and shorter strips were added for arms. The children drew the bodies and clothing with felt pens.

B and C. Five-year-old children showed great diversity of form concept when they drew witches using precut hats as visual starters. Felt pens, yarn, and fabric scraps were used to complete the drawings.

D. A pair of pants was the glued-on starter for this five-year-old boy's drawing of himself walking his dog.

E. Each child in the first grade has a photograph of his own face and was highly motivated to draw himself in this assembled mural.

F. Four seeds glued to the drawing paper motivated this drawing of roots and flowers by a five-year-old child.

G and H. Flags glued to drawing paper suggested soldiers to one kindergarten child, and racing cars to another.

I, J, K, and L. Short pieces of yarn were shaped into a monster by one five-year-old child; shorter pieces into swings for a group of performers by another; the roof of a house by another; and ocean waves near a lighthouse by another.

YARN Each child is given a short length of yarn to place on the paper in a curve, circle, zigzag, line, angle, and so on. The motivational discussion should cause the child to wonder what the yarn suggests to him. Could it be the string of a kite, a fishing pole held by a man in a boat, the outline of an elephant's back, the top of a building, a clown's head, the peak of a mountain, a jump rope, the antennae of a butterfly—or what? Then the children glue the yarn to the paper and complete the picture with drawing materials.

SEEDS The children should each have a paper with four or five flat beans or large seeds glued on it. The motivation should focus on the roots, stems, and parts of plants. Bring in a flower or weed that has been pulled up so that the children can examine it closely and touch its roots, stem, leaves, flowers, and seed pods. Talk about how the shapes of leaves and plants differ, then direct the children's attention to all the colors that flowers take. The children will then be ready to design their own imaginary plants, drawing the roots below the ground, growing down from the glued-on seeds, and the stems, leaves, flowers, and seed pods growing upward above the ground from the seeds.

FLAGS Very small paper flags mounted on short wooden sticks may be purchased in variety stores. They are brightly colored and come in assorted designs. When they are glued to a drawing paper, the children may discuss where they have seen flags flying and who carries flags. One child should demonstrate how a real flag is held—how the elbow is bent—and how the flag flies high above the child's head. The children will remember seeing flags on buildings, on boats, on flagpoles, at fairs, and carried by horseback riders in parades. Then they will be eager to draw a picture with a flag in it, adding appropriate figures and environmental details.

MURALS In the mural "There Was an Old Woman" shown on page 48, first-grade children were given actual photographs, about four inches high, of their own faces. These photographs were cut out and glued to a piece of twelve-by-eighteen-inch drawing paper. Then, using felt pens and scraps of colored paper and fabric, the children drew and cut out the rest of their own bodies and clothing. The completed figures were then cut out of the drawing paper and assembled on a bulletin board, which in this case was covered with a piece of yellow felt. Several children painted and cut out a shoe house, a few flowers, and the title.

Not only did the figure concepts become more detailed and elaborate, but an intense identification with drawing a person was experienced due to the fact that their own faces were serving as the focal points. By grouping the finished figures around a central item and using a unifying theme, the whole group of children enjoyed working together on a class art project.

Here are some related mural topics for a group of young children to create, using either their own portraits or some photos of heads clipped from catalogs and magazines as glued-on starters:

—A castle filled with kings and queens
—An office building where many people work
—A superrocket with space travelers in compartments
—An ocean liner with many tourists in the cabins
—People walking through the jungle on trails
—Children getting on the school bus
—Children playing games on the playground

In all of these motivational topics, each child draws himself and some of the environment that is needed for the completed mural. Each item is individually drawn and cut out, and then all the parts are assembled on the background. For a permanent mural the parts may be glued in place. Pins should be used if the children wish to disassemble the mural later and retain their own individual work.

Tall and Wide, Round and Square

How to provide situations which will help children break through stereotyped expression and move on to less rigid and more sensitive realms is a challenge for teachers. Through appropriate and stimulating motivations, we can endeavor to keep children's thinking dynamic, their schemata enriched, and their imagery varied and flexible.

Paper for drawing and painting that departs from the usual twelve-by-eighteen-inch size challenges the child to make new visual configurations. If crayons, felt pens, or pencils are used instead of paint, the paper should be fairly small. Tall and wide pieces of paper as well as round and square sheets encourage him to adapt his form concepts to that shape of paper and to add details and configurations that fit the new proportions and shapes.

A, B, and C. Drawing tall giants and skinny people requires the child to stretch his concept of the human figure to fit a long, narrow piece of paper.

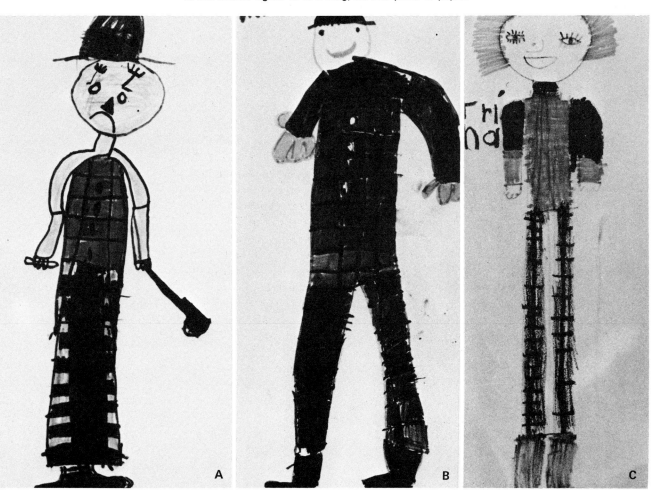

Teachers may suggest to children suitable topics that are adaptable to a particular given shape. Here are some subjects that match unusual paper shapes:

Tall Paper
—High-rise building with people looking out the windows
—Church with steeple
—Clowns on a ladder
—Tree full of squirrels
—Girl in a tree swing

—A castle tower and a princess
—Jake, the Giant
—A spaceship with an astronaut
—A skinny man with boots and hat
—A giraffe or ostrich

Wide Paper
—A submarine, inside
—A long train
—A bus full of people
—People waiting in line for tickets
—Racing horses
—Dancers on a stage

—Chickens on a fence
—An alligator
—The most beautiful caterpillar in the world
—A candy-making machine

Round Paper
—Children playing farmer in the dell
—Swimming in a pool
—Fishing in a round lake
—Children playing jacks or marbles

—A butterfly
—A magic wheel
—A clown's face
—Mother cat nursing kittens
—My friend, the sun
—A coiled snake

Square Paper
—Eating at a picnic table
—Inside a magic box or radio
—A mechanical snail
—A lion's face growling
—A grasshopper or ant

—Sitting in a chair
—Bird in a cage
—Bug on a big flower
—A comet or shooting star
—A very fat man

A

B

A and B. Third-grade class combined efforts for these tall, stuffed paper people. They drew large figures on long pieces of butcher paper, dressed them up with tissue paper, rickrack, and yarn, and then stapled the edges together so they could stuff them with wads of tissue paper. A pole in a wooden platform made it possible for the figures to stand upright and greet visitors at Open House.

C, D, E, and F. Round paper from a dentist's office served for these circular representations by kindergarten children.

G and H. Vigorous drawings of a truck and a train by five-year-old children are aesthetically adapted to long, narrow paper.

I and J. Tall rocket and tall apartment buildings were painted by kindergartners.

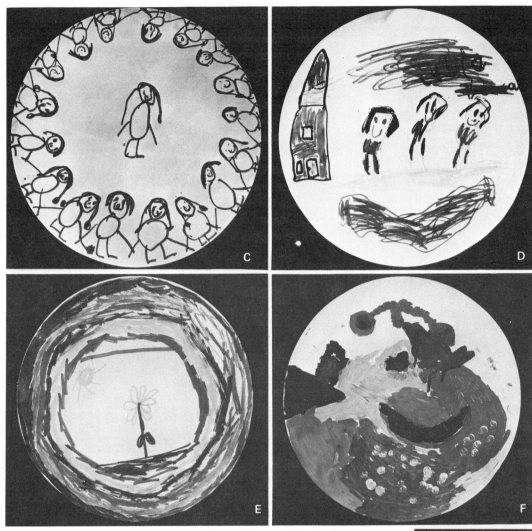

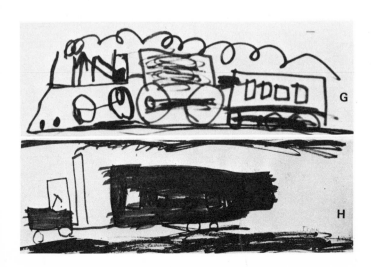

Batik: Plausible, Pleasing, and Painless

Just how the batik process began is not known, but it probably originated in Indonesia and spread to Europe and other countries before finally achieving a high degree of development as an art form in India. Basically, batik is a process whereby wax or paste is applied to fabric in a decorative manner for the purpose of resisting the dye which is applied later. One of the main characteristics of batik is the spiderweb effect achieved when the wax hardens and cracks and the dye penetrates into the fibers in thin lines. In more complicated batiks, the fabric is waxed and dyed several times, creating fantastic color and design patterns due to overlapping and color blending.

In adapting the rather complex batik process for use with young children, teachers will find the three drawing and painting techniques described here to be full of artistic possibilities, yet simple and safe enough to be used in the classroom. The materials may all be purchased in local stores.

PASTE BATIK The first batik to be described is the "paste" method. This technique does not involve using wax or dipping the fabric in a dye bath. It is somewhat related to a Japanese dye process called Sarasa, but it can be greatly simplified for use with young children.

Each child will need a small piece of white fabric such as bleached muslin. This piece of material should be about eight by ten inches or so in size, and it should be taped down to a piece of corrugated cardboard.

Paste is used instead of melted wax for the purpose of protecting the fabric from the dye which is applied later. It should be mixed until there are no lumps. A blender will do the job efficiently and quickly. The proportions are the following:

½ cup of flour
½ cup of water
2 teaspoons of alum

This paste is placed in plastic squeeze bottles such as those used for dispensing mustard and ketchup. A half dozen or so bottles are all that are needed for a class if the children take turns drawing their pictures. The child makes the design by holding the bottle perpendicularly and squeezing it to create and maintain a smooth flow of the paste onto the fabric. He draws his entire picture in this manner, making lines, dots, and solid masses, and then leaves it to dry overnight. The next day the dye is brushed over the entire picture, the dried paste resisting the color and leaving the fabric underneath it white.

Paste food colors should be mixed with water in clean, shallow tin cans such as empty tuna and cat-food cans. These do not tip over as easily as taller cans do. A small amount of this very intense dye should be stirred into the water to make a rich hue because the colors, once on the fabric, dry lighter than they appear to be when they are wet. Several colors may be brushed into separate areas of the same picture, such as applying red for the roof, brown for the tree trunk, yellow for a flower, and blue for the background. The fabric is left to dry thoroughly, and then the paste is chipped and rubbed off with the fingers, revealing the white picture underneath.

The fabric may be trimmed neatly, ironed to press out the wrinkles, and mounted with rubber cement on a piece of colored paper or mat board. Batik pictures also make attractive greeting cards when they are cemented to a folded piece of colored paper.

Paste batiks

A. Paste flows smoothly from squeeze bottle as the child makes a drawing on a taped-down piece of fabric.

B. Food dye contrasts sharply to the white areas that were protected by the paste. Intense watercolor washes may be used in place of the food colors.

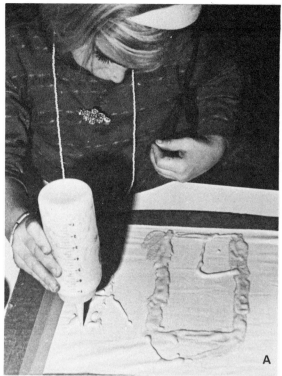

A

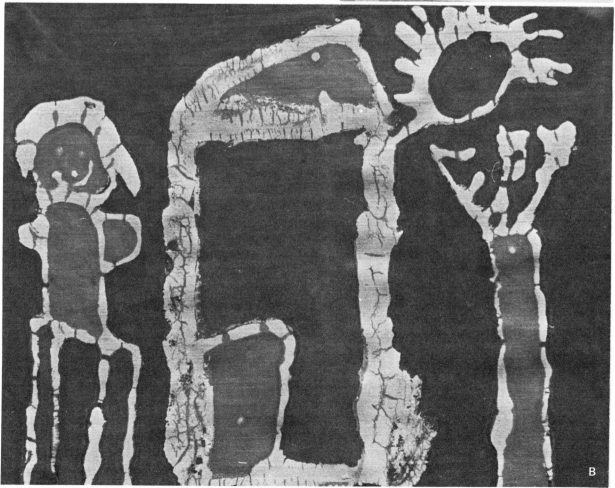

B

DRAWN BATIKS In the second batik variation, the child draws his design with water-soluble felt pens on a piece of white muslin that has been taped to a piece of corrugated cardboard. He may use as many colors and shapes as he wishes. The second step consists of applying melted wax to cover all the outlines of the objects in the drawing.

Wax should be melted and kept at 250 degrees in a deep-fat fryer or in a can standing in a foil-lined electric pan. Dipping a small stiff-bristle brush into the hot wax, the child quickly applies it to his fabric, working rapidly to prevent the wax from cooling on the brush and hardening so much that it does not penetrate and protect the fibers from the dye.

After he has completely covered the edges of everything in his picture with wax, he is ready to brush on the dye, using the same dye bath as previously described for paste batiks. All the background areas that are not colored with felt pens should be covered with dye, and the wax will serve to protect the edges of the drawn forms.

The cloth should then be allowed to dry thoroughly before being ironed between several thicknesses of newspaper to remove the wax.

WAX BATIKS In the more traditional manner of making batiks, a piece of clean muslin or percale is taped to a cardboard or placed on several thicknesses

Drawn batiks

A. Child draws on fabric with felt pens or oil pastels before applying wax.

B. Wax melts in a can that stands in a foil-covered electric pan to make a safe and convenient technique when working with batik. Here a boy covers his felt-pen drawing with wax before he brushes the dye on the unwaxed portions of the fabric.

C. Diluted food coloring is brushed over entire picture.

D. When wax is removed by ironing, the drawn batik is finished.

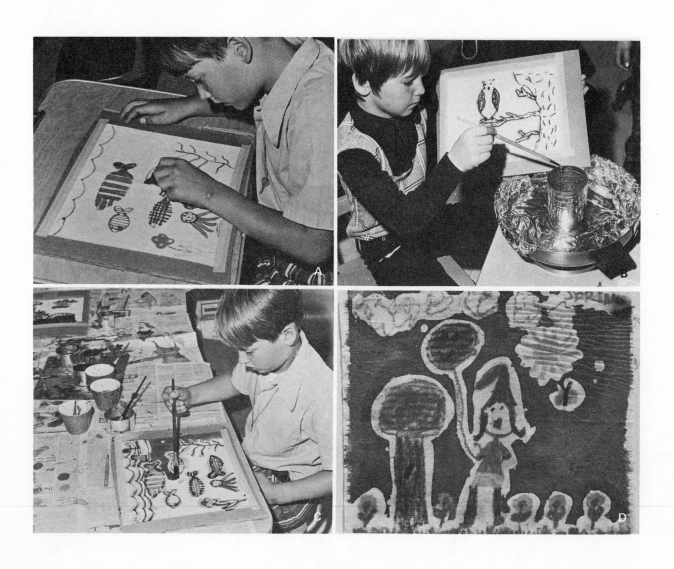

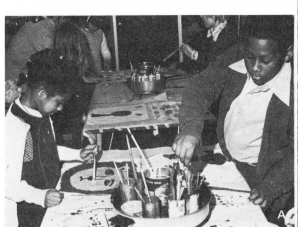

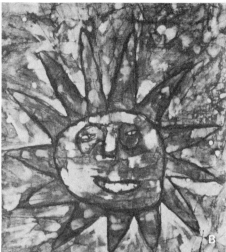

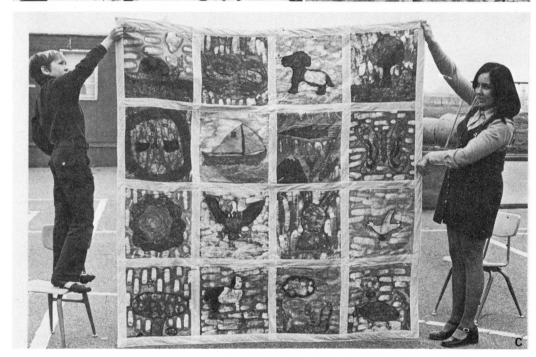

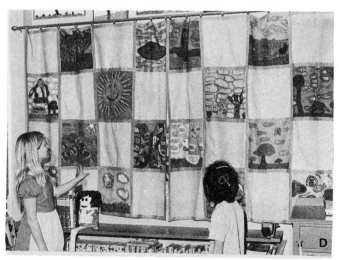

Wax batiks

A. In traditional batik, wax may or may not have color crayons added before the child brushes his design on the fabric.

B. Finished batik by seven-year-old child shows crackle effect that is typical of this technique.

C. Colorful batik banner made by sixteen children shows rich diversity of expression.

D. Batik squares were stitched together and bound with bias tape to make colorful draperies for the classroom.

of newspaper. The child may sketch his design lightly on the cloth with artist's charcoal which may be rubbed off later, or he may brush the melted wax on directly. The wax should be kept very hot and must be applied quickly to the cloth or it will not penetrate the fibers adequately to protect them from the dye. Wherever the child places the wax on the fabric, the fabric will remain its original color.

Colored wax crayons may be mixed in with the paraffin, enabling the children to use several colors in creating their pictures. In this method the waxed areas will appear later as colors rather than white, and the batik will have the appearance of having been dipped in numerous dye baths instead of just one.

After all the wax has been applied, the fabric should be crushed to cause the wax to crackle. Then the fabric should be dipped in the dye bath and left ten minutes or so until the desired amount of dye is absorbed in the fabric. It is necessary to use cold-water dyes because a simmering dye bath would melt away the wax. Rit and Putnam are common dyes that may be used at low temperatures once they have been mixed in hot water and allowed to cool.

After the fabric has soaked in the dye bath and has been rinsed and hung to dry, it should be pressed between layers of newspapers with a hot iron to absorb and remove the wax. The papers will need to be changed frequently as they become saturated with the melted wax.

Children enjoy all of these batik techniques since there is a feel of mastery to be gained and an enjoyable moment of surprise involved. Finished batiks may be fringed, hemmed, matted, hung from rods, made into pillow tops, or sewed together for banners, drapes, and quilts. The results are bright, attractive, and quite dramatic.

Drawing with Yarn

Crayons, pens, and pencils aren't the only tools with which children can draw. When they make pictures with yarn and glue, they can utilize a linear technique to achieve a stitchery-like charm.

Each child will need a plastic bottle of white glue, a varied selection of colored roving (a very thick yarn), and a piece of burlap about twelve by eighteen inches. Heavy cardboard or Masonite will do if burlap is not available. Burlap may be purchased in yardage shops in natural and in colors.

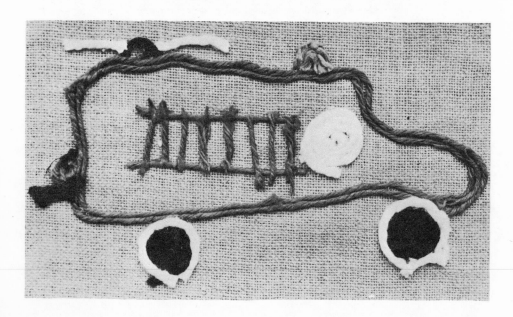

The wheels and window on this fire truck were filled in with coils of yarn.

A. Thick, roving contrasts on either dark or light burlap for drawing colorful pictures. This girl is using several lengths of yarn for hair on her drawing of a face.

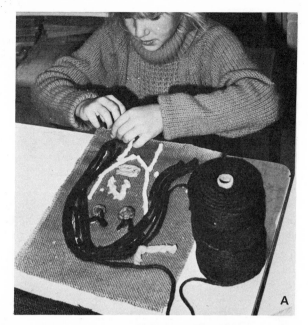

B. For centuries Mexican Indians have used yarn to create all kinds of bright panels and pictures. While it was once the custom to press the yarn into wax, almost the same effect may be attained with glue.

The child should pull the threads until the four sides of his piece of burlap are even. This creates a decorative fringe. The top may be folded over and hemmed to make a slit through which a dowel stick may be inserted for a wall hanging.

The design made by the child may be either realistic or abstract and as detailed as the maturity and interest span of the child will dictate. The children should be encouraged to play with the yarn at first, moving it and arranging it until they have an idea of what configuration they would like to make. Sometimes the yarn itself will fall in such a way as to suggest a motif to the child upon which he can enlarge. When he has arrived at a basic form such as a fish, zebra, or bug, he simply draws the outline in glue, lays the yarn on top of the glue, and presses it in place. He may cut short lengths of yarn for details and for filling in areas.

Painting Christmas Tree Ornaments

Tree decorations at Christmas time can show gaiety and imagination and yet be made with originality from common, inexpensive materials. While books and magazines contain countless ideas for elaborate and intricately made ornaments, the value derived from having children paint their own designs on ornaments far surpasses any activity in which the children follow an adult's preconceived pattern. Thirty Santas, snowflakes, or reindeer, all alike, cut from patterns and sprinkled with glitter dust, are not the result of creative problem-solving on the part of the young child.

A sackful of cardboard tissue tubes that have been cut in half can be the impetus for developing many innovative painting skills by very young children. They can learn how to control small brushes when they embellish the rolls with stripes, dots, faces, or blobs of color, and when all the tubes are hung on the tree, the boys and girls will be very proud of their own individual contributions.

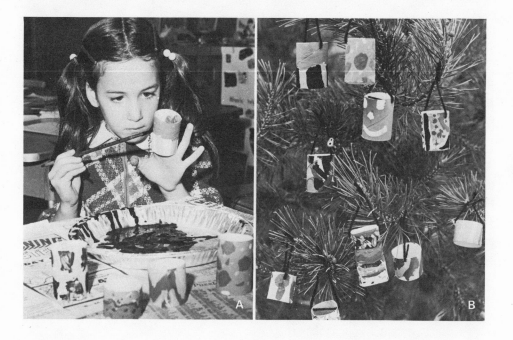

A. By holding her fingers inside the cardboard tube the young child uses the brush without getting paint on her fingers. Shallow pie pans do not tip over easily and may be shared by several children.

B. A short piece of yarn is threaded through two holes in the cardboard tube to make an easy hanging device.

Peepface Figures

Tickle the young child's sense of humor and you have a ready-to-go motivation for painting the human figure. Provide him with huge cardboard panels with cut-out peepholes, and you will stimulate his sense for the dramatic and illusionary. Not only will the children delight in this comical art task, but they will stretch and enrich their cognitive awareness of the human form.

Large pieces of corrugated cardboard are discarded after mattresses and refrigerators have been shipped in them. A single narrow panel is sufficient for one figure, while a longer panel works well for a group of painted characters. Small ovals just the size of a child's face should be cut very close to the top so that the children can peep through them. Two smaller holes cut on both sides either halfway up or near the top can serve as openings for the child's hands. Placing such hand holes up high requires the child to extend the figure's arm up or bend its elbow to reach the opening. He may wish to place a flower or some object near the opening for the hand to pretend to "hold" as it projects through the opening.

A. Three chalk-drawn figures are being painted by these eight-year-old children. Long arm on middle figure is reaching up to catch a bird painted close to the hand hole.

B. Two boys are using tempera tubes rather than brushes to paint their peepface figure. Note whimsical muscles on figure's arms.

C. Girl uses small brush to paint background near her figure's hair.

D. Some panels may have a half circle cut along the top edge where the child may place his chin instead of looking through the oval-shaped hole.

E. When the peepface figures are finished, the children will enjoy taking pictures of each other looking through the openings.

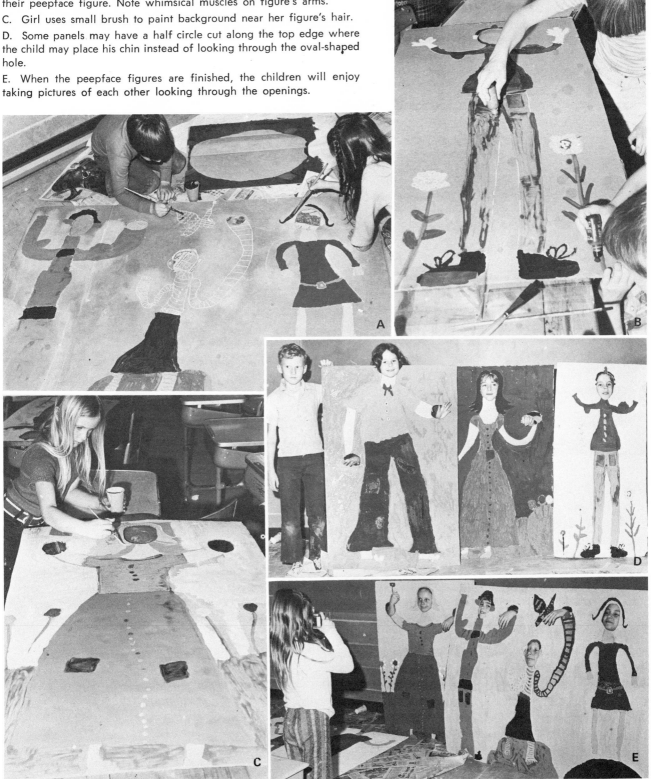

The panels should be placed flat on the floor or on several desks or table tops while the children sketch their figures. Chalk rather than pencil enables the child to draw freely without fear of making a mistake, since he may quickly rub off any area he wishes to change. Chalk is closely related to brushstrokes, and the child will be able to use it to draw details and decorative elements that are easily transposed to paint.

A supply of tempera in both pure and blended colors will enable the child to predetermine which parts of his figures will be which colors. He should be reminded to paint the large areas first, using a large flat brush. Smaller areas, edges, and details should be painted with a one-quarter-inch-wide stiff flat brush. Paint should be dry before a color is placed next to it or a detail painted on top of it. The children will enjoy painting the background on the panel and adding suitable environmental details.

For an imaginative extension of peepface figures, provide the children with horizontal and vertical panels with cutout holes for animal paintings. The silly appeal of having one's own face growling from a lion's body, or one's own mouth pretending to nibble leaves from atop a giraffe's neck would be an irresistible invitation for even the most timid young painter to become involved.

Painting on Light-Sensitive Paper

The magic involved in painting with a clear liquid on white paper and seeing the images that he has created turn black will intrigue and compel the young artist to try many configurations. Young children will never tire of painting pictures with photographic materials.

You will need a package of eight-by-ten-inch printing paper, a small amount of developer such as Kodak's Dektol, some fixer (hypo), and two trays or pans a bit larger than the paper. Mix the developer and hypo according to the directions on the packages. The developer solution used full strength will turn the paper black; diluted 1:2 it will create gray tones. The developer and hypo should be stored in dark airtight bottles. Hypo may be reused many times, but the diluted developer should be discarded when it turns brown.

Printing paper comes in single and double weight and in glossy and mat surfaces. Any of these will be suitable. The sheets may be used full size or cut down to any shape desired. They should be exposed to light and used in a normally lighted room. The children should use brushes, Q-tips, and even little sticks to

This boat was made with full-strength Dektol with a Q-tip on a five-by-eight-inch piece of Kodabromide paper.

Caterpillar and mermaid were painted with brushes and developer on exposed printing paper.

make their pictures. The developer is clear, but as it touches the paper the silver particles in the paper's light-sensitive coating turn black or shades of gray. When the picture is finished, it should be placed in the fixer tray for ten minutes and then rinsed in a tray of running water for twenty minutes.

Another way of working with the miracle of photographic paper is to use hypo as the painting medium rather than the developer, dipping the picture in a tray of developer when it is finished. The areas covered with hypo will remain white, and the unprotected parts will turn black. The paper should then be placed in the hypo for a ten-minute period and then washed in running water for twenty minutes.

The washed pictures should be placed in single layers between blotters or paper towels and weighted down with a book until they are dry. Finished pictures may be mounted on mat board with glue or with dry mount tissue, using a medium-hot iron. This tissue is available from photographic supply stores.

Painting a Mural with Celotex Cutouts

The web of relationships in nature links animal to habitat in a continuous chain of life. Small children feel a closeness to and a love for nature and can understand many fundamental concepts of interdependence and of nature's delicate balance. They are concerned when a species is in danger of no longer existing due to hunters, chemical insecticides, and other life-destroying elements.

To work together in a cooperative venture such as painting a Celotex cutout mural, the children will need to be fully prepared with information from many sources. Books, films, resource speakers, and photographs should be researched and delved into for any clues as to which mammals, birds, reptiles, and fish are to be studied; what size they are; what sort of beaks, claws, teeth, ears, and other features they have; and what purposes all these details serve in preserving the animal's life.

When the class is grounded in information, each child should choose one creature for his own focal point for the mural. A four-by-eight-foot panel of Celotex should be cut into about thirty assorted sizes of rectangular pieces. Then the children should each select one piece according to the shape of the animal they wish to paint on it. They should be strongly encouraged to make their animals fill the entire panel, with the feet touching the bottom, and the head, back, or tail touching the tops and sides. They should draw their animals with chalk first so that they may rub it off for any changes and redraw the outlines and add a few details. Then they should paint them either with colors they mix themselves or by selecting colors from premixed blends of rust, gold, gray, red, white, black, and brown. Small details can be painted on top of dry areas with small-bristle brushes and Q-tips. It is not necessary to paint any background on these small panels because the animals will all be cut out on a band saw later.

After the children decide on a general overall arrangement for the land, sky, and water areas for their mural, they should temporarily place the cutout animals on a four-by-eight-foot Celotex panel which is lying on the floor. (A large piece of heavy corrugated cardboard may be substituted.) The children make drawings near and around their animals, showing appropriate habitats. They should sketch with chalk, remove their animals, and paint the environmental details. For instance, a pelican, whale, and seal need to be in or near the sea with rocks and gulls nearby. The saber-toothed tiger needs a nearby bear nibbling berries from a bush. The eagle may fly near his nest on a craggy cliff, and the owl may be preying on field mice.

When the paint is dry, the animals should be attached to their preplanned positions with one-inch finishing nails. This makes it possible for the mural to be disassembled later so that each child may retain his own Celotex animal.

Many topics are suitable for Celotex cutout murals. It is often feasible to correlate the production with science, social studies, and literary subjects. Or, purely imaginative and fantasy-fun ideas can be used just as well. Here are a few that will direct the children's thinking into new avenues of cooperative exploration:

Seas and skies
Mary, Mary, quite contrary, how
 does your garden grow?
Fun in snow and ice
At the aviary
Inside an ant hill
Insect friends and pests
Gymnastics
Noah's ark

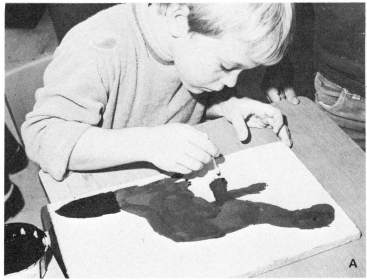

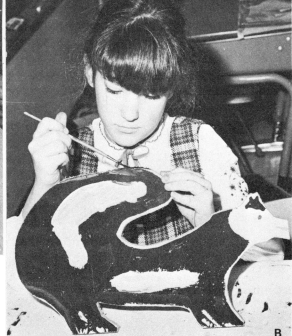

A. A seven-year-old boy uses a Q-tip to add black toes to his brown beaver before it is cut out for the class mural.

B. After the animals were cut out, the children decided to paint the edges black so they would stand out more definitively from the mural's background.

C. These second-grade children had a much richer understanding of nature's needs and of its creatures' interdependence. They became more sensitively aware of each animal's size, color, and proportions through a close study of its life and environment. Appropriate habitats were painted on the panel before adhering the cut-out animal shapes.

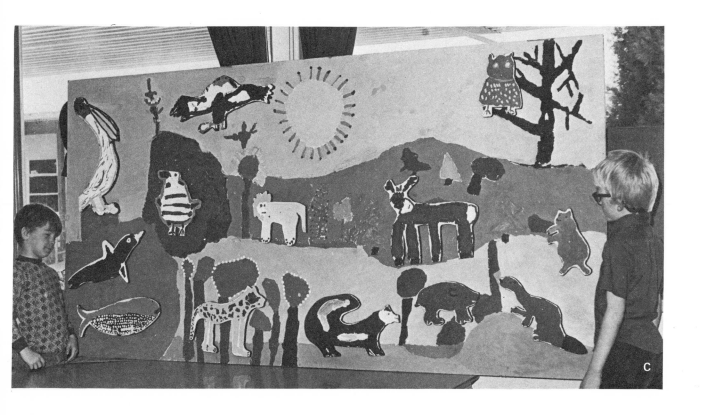

Transparent Drawings in Miniature

Through the medium of projected light, very small drawings of young children may be enlarged to any desired size and viewed by the entire class. The colors in these tiny felt-pen drawings project brilliantly, and the children never tire of making them or seeing their work given new importance and size as it is projected on a large screen.

Write-on slide transparencies offer a multitude of visual experiences for young children through the miracle of projected light.

Some children have difficulty in relating their aesthetic concepts to a super-size drawing or painting surface, yet they are able to draw well-organized and pleasantly arranged compositions when they work very small. Ektagraphic write-on slides provide a small-into-large drawing experience that contains an element of suspense and newness which appeals to very young children.

These two-inch transparent blank mounts are available from photography shops in boxes of 100. They fit both the small table-top viewers and the regular projectors that create enlarged images on a screen. One side of the slide says, "Write on this side," and if this is done the picture is permanent. However, if the picture is drawn on the reverse side, it may be wiped off with a damp cloth and the slide used again.

Children delight in seeing their tiny drawings magically appear as a three-foot-square image on the screen. They are able not only to see their work from a different point of view, but also to see how they might improve it and what new direction they may take in making future drawings.

If a large piece of paper is taped to the wall and the image is projected on it instead of on the screen, the child may draw his own enlarged image on the paper. He must be careful not to stand in the way of the beams emanating from the projector. He may then use his drawing to create a large painting, or he may wish to

project it on a piece of fabric or burlap and use his design for a stitchery project. A long panel of butcher paper taped to the wall can serve for mural-making, with each child projecting his own slide to contribute to the overall effect. Images can be moved around on the paper by moving the projector, in that way facilitating the making of decisions as to the best location for redrawing each child's part.

An auditory-visual presentation may be made by using the write-on slide as a vehicle of expression. Each child may illustrate one episode from a story the class has read or has written, and several children may tell about the pictures as they are projected on the screen. Each child may write a poem and make a slide to supplement his verbalized image. After a field trip to an exciting place or after any pleasant experience, each child may prepare a miniature drawing on a write-on slide to be used in summing up, evaluating, and recalling the class's experience.

Sugar and Chalk Pictures

If thick pieces of colored chalk are soaked for a few minutes in a sugar-and-water solution, they provide young children with a drawing medium that is closely related to paint both in appearance and approach. The thickness of this type of chalk requires large paper and demands a bold approach. One part of sugar should be dissolved in three parts of water and placed in pie pans for soaking the chalk.

Since the chalk is usually dusty, smudgy, and frustrating for young children to handle, this technique will delight them with its rich, velvety, intense tones and its direct and instant application on the paper. They will find that they can draw an object easily, and quickly fill in all the areas. It dries quickly on the paper, and the colors do not tend to run into each other and smear. If the chalk pieces become dry while the children are using them, they may be dipped in the sugar-and-water solution and be reactivated. The finished pictures do not rub off as regular chalk drawings do.

A. Kindergarten girl enjoys seeing vibrant tones of wet chalk on her house-figure picture.
B. Kindergarten boy used bright yellow and warm orange tones for his butterfly-sun picture.

Painting Paper-Bag Costumes

Large-size paper bags from the grocery store can be converted into quick costumes for celebrations and imaginative play activities. At the same time they provide young children with an opportunity to develop their painting and designing skills.

A large hole should be cut in the bottom of the bag for the head opening and small holes in the sides for the arms to go through. The edges of these holes should be covered with masking tape for reinforcement to prevent them from tearing when the child puts on and removes his costume.

Designs and pictures may be applied with paint and brushes or with paint in a tube. The children should be encouraged to make designs on the sides and backs of their costumes after the paint is dry on the front. Older children will enjoy gluing on paper fringe, egg carton bumps, and all sorts of shiny and textured materials in combination with their painted areas and designs.

A. Four-year-old girl uses tempera paint in a tube to design her paper-bag costume.

B. These four preschoolers proudly model their creations.

8 Cutting and Gluing

Children who develop cutting and gluing skills early in their lives will create more exciting and perceptive art products. The teacher must provide the children with good quality scissors in order to prevent initial cutting experiences from being frustrating and failure-oriented. A lack of good scissors and appropriate materials will impede the development of the child's aesthetic growth, and later, when he reaches the symbol stage and is eager to depict the human figure, animals, plants, buildings, and such, his lack of cutting and gluing experiences will have stunted his development of the proper skills. He will tend to be retarded in his ability to communicate visual images in cut paper.

The teacher must be knowledgeable and specific as to what goals and behaviors are to be brought about in regard to cutting and gluing with both paper and fabric. Preschool and kindergarten children should have time, space, and supplies available daily for them to cut and glue. They should know not to run with scissors in their hands and to walk with them holding the tips down.

Children who are still scribbling will probably not cut recognizable objects; rather, they will be content to experiment and cut for the sake of cutting. This is good practice and should be encouraged. They should be shown how to put a small amount of glue on the piece of paper to be glued down, rather than on the paper they are gluing onto, and to put glue on the corners and around the edges of large shapes. The teacher should stress the importance of not using too much glue.

A. Cube-shaped boxes served as bases for the application of decorative shapes cut from fabric and paper.

B. Very young children can begin to learn scissors skills if they are provided with a good pair that readily cuts both paper and fabric.

C. Cutting and taping colored paper into sculptural forms involves skills in forming, joining, and relating three-dimensional shapes.

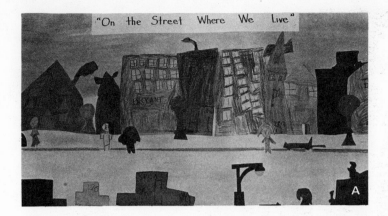

"On the Street Where We Live"

Later the children will begin to cut realistic symbols, usually in parts. The teacher can then show them more scissor skills—how to glue details and smaller parts on top of other things; how to fold the paper over and cut out an interior hole or shape; how to make multiple images by cutting two or three papers at one time; how to make a symmetrical shape by folding and cutting the open edges.

Children should be encouraged to cut freely into paper, never drawing the shapes with pencil ahead of time, as this makes for tiny, cramped details that are difficult to cut out. The teacher should discuss the kinds of shapes the children are cutting, referring to them as straight, curved, thin, jagged, or smooth. The children should be given the opportunity to use shiny paper, dull paper, textured paper, as well as fabric and felt. They should also learn how to tear shapes, holding the fingers close together to control the direction they wish to go, and they should know the difference between a cut and a torn edge.

When the children have developed sufficient scissor skills, they should be given motivational topics for picture-making. They will enjoy combining their efforts to make cut-paper murals, with each child making several figures, flowers, bugs, and buildings and then assembling them with pins on the background until a final arrangement is decided upon. Making stand-up figures from oak tag for dioramas is a skill-building task for young children, too, as is decorating boxes and wood constructions with cut-paper decorations.

Gummed Paper Pictures

Scissor skills are easy to develop when a new material such as colored gummed paper is available to young children. This paper comes in packages of several dozen sheets, and it may be cut into smaller pieces for easy distribution to the children, with each child being given his choice of several colors from which to cut his picture.

Each child will need a small piece of paper, either white or colored, for his background. A size that is not overwhelming in its dimensions for the young child is about six-by-nine inches or no more than nine-by-twelve inches. No glue is needed. A sponge may be used for applying moisture to the sticky side of the paper; however, most children enjoy licking the paper to make it stick. The paper itself is light in weight and easier to cut than construction paper.

Before the children begin to work they will find it helpful to see how paper may be cut in strips, zigzags, and curves; how it may be fringed; how leftover scraps may be used to good advantage. The children should assemble their pictures by using a number of pieces of the gummed paper, adding small bits and shapes for design details on top of the other pieces.

A. Cut-out mural combines drawing and cutting techniques.

B. Felt cut-out train shows highly developed sensitivity to form and design.

A. Kindergarten child used a number of separate parts for his cut-out picture of a sailor and boat.

B. Castle and princess were cut out and put together by a five-year-old girl.

C. This cut-paper design was made in Poland by an adult artist. Children will enjoy seeing its bright colors and the intricate and skillful attention to details.

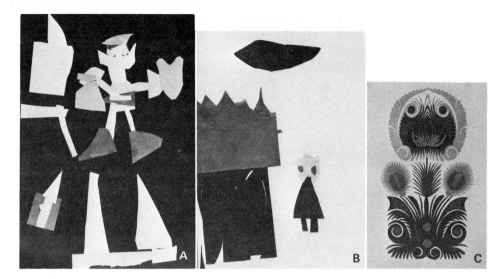

Fantasy City

When children build with blocks—stacking them, moving them, and lining them up—their spatial concepts are given free rein to create an imaginary environment. Preschool children will enjoy making and playing with an imaginary city that they, themselves, create from a large supply of empty cardboard boxes. The boxes in the photograph (below) were salvaged from the trash bin behind a store. The children snipped out and stuck windows and doors, made with colored gummed paper, to the boxes. Older children find it challenging to make more elaborate buildings with stand-up tagboard people and trees to group about on the sidewalk.

These pretend-buildings were placed on the floor, and the children arranged them over and over again along imaginary streets. In playing with their buildings, children find it easy to project themselves into their fantasy city, and teachers can use this play environment scene to encourage the child's verbalization and to extend such concepts as, Where is your car moving? Is your bus in front of the building, behind it, or between two buildings? Is Joe's building taller than Laura's? Is it wider than Henry's? Which is the front and which is the back of your building? What kind of building is yours—factory, warehouse, school, store, apartment, office building, or church? Do you suppose there are several elevators in your building? Can you count how many doors and windows you have made?

A. Preschoolers are fascinated with cutting and gaining control of their scissors.

B. Boxes with windows and doors glued on them become a three-dimensional city for imaginative play activities.

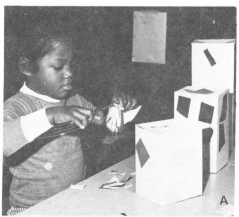

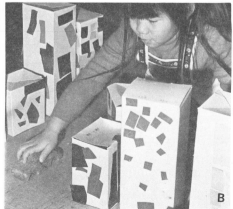

By using more empty boxes and either gummed or construction paper, children can in a similar manner create trains, a harbor full of ships and boats, and runways, hangars, and airplanes. Larger boxes my be substituted for smaller ones and some of the significant parts added with paint and brushes as well as colored paper.

Touch-it Pictures

"Hands off" and "Do not touch" are frequently heard admonitions that run counter to the natural human inclination to explore the world around us through our sense of touch. Smoothly polished wood, shining brass, bumpy fabric, soft fur, gritty sand—all invite the hands to feel, to sense differences, and to enjoy a multitude of aesthetic qualities. Children need to develop their capacity to differentiate between textures and to enjoy the sensory experiences of associating different textures and surfaces with different objects.

When children draw, paint, model, and cut out pictures, they are usually more involved with shapes, colors, and lines than they are with texture. In the art task of making touch-it pictures, the young child is called upon to think primarily of his world in terms of its physical "feel" or surface quality.

The children should all have the opportunity to handle and compare a number of materials and to talk about whether they are soft, rough, smooth, spongy, shiny, slick, furry, and so on. They will begin to think of things that the materials remind them of, and then they are ready to make a touch-it picture.

Velour-surfaced paper may suggest kittens to children. Sheet sponge may suggest undersea plants; shiny foil paper, the flashing colored fish. Sandpaper and felt could be an Indian tent, a tree trunk, or ground. Yarn and fabric may become clothing or hair. Corduroy could be the walls of a house; leather scraps could be a horse or cow.

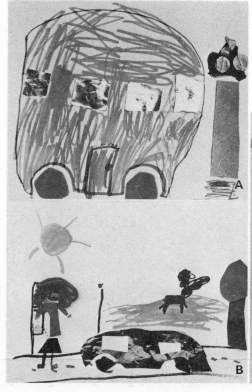

A and B. The children may choose to cut out only some parts of a touch-it picture. They complete the picture with felt pens or crayons.

C. All the parts of a touch-it picture can be cut from textured materials. Children enjoy closing their eyes when they examine each other's touch-it pictures.

Before a child glues down the parts of his picture he should be encouraged to try moving the various parts around and possibly discover a more pleasing arrangement; or perhaps to repeat some shapes to give his picture more unity and to add other textures to enrich the overall quality of the concept he is trying to convey.

Zigzag Books

The pages of a zigzag book flow in a continuous progression from front to back and serve to tell a sequential story, or they become a focus for a cluster of connected concepts. The children should choose a topic and make up their story line together, with each child cutting out one picture for the series of episodes that are needed to tell the tale.

The book which the children are holding in the photographs (below) tells the story of "Silly Dilly the Clown," who had a dog named Billy. Each page of the book tells of one event in which Billy went searching at the circus for his lost master, asking first the balloon man, then the thin man, the popcorn seller, the bareback rider, and so on, if they had seen Silly Dilly. The dog, made of felt, "traveled" from page to page with the aid of the storyteller, creating the necessary suspense leading to the happy ending on the last page.

A blank zigzag book should be made of sturdy cardboard so that it may be folded and unfolded a number of times, as the children will enjoy looking at the pictures over and over and giving a visual and oral presentation to another class. Mat board should be cut in pieces about eight-by-ten or nine-by-twelve inches for the pages. These pieces should be fastened at the sides with masking tape or plastic tape on both front and back so that the pages will fold up in an accordion-like manner from either end.

A. Zigzag books are sturdy receptacles for composite group ideas. They promote sequential thinking about events, or they may unify many concepts having to do with a single theme.

B. Six-year-old children thought about what their life ambitions were and how they would look as adults and then made a zigzag book called "When We Grow Up."

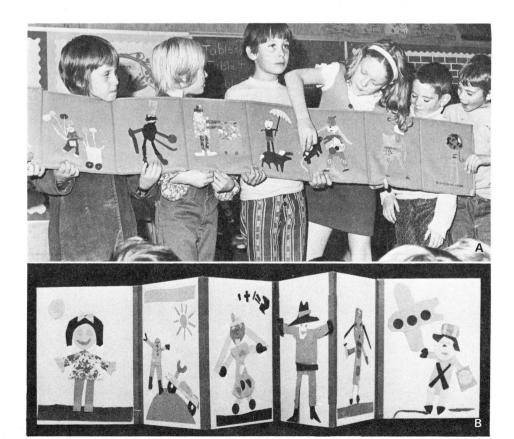

To make a felt-covered zigzag book, you will need two 12-inch-wide strips of felt seventy-two inches long. By sewing these two lengths together along the bottom edge and then in vertical sections about nine and a half inches apart, you will make eight pockets into which 9-by-11½-inch pieces of cardboard may be inserted. Then the top edge should be stitched to complete the book. The felt book has the advantage of being like a flannel board insofar as a felt object may be temporarily placed on a page and then moved from section to section as the story progresses.

After the children have decided on a title and a story, each child chooses an episode that he would like to depict. Fabric, felt, yarn, and all kinds of colored and textured paper may be cut and combined for individual pictures. If each child arranges his cutouts on a piece of background paper the same size and shape as the pages in the book, he will find that they fit the dimensions of the page when he transfers the pieces to the book.

After arranging his pictures he may use rubber cement or glue to fasten down all the cutout pieces. Several children should cut out letters to spell out the title.

Oral communications and creative writing skills may be integrated with the art task of making a zigzag book. The children will be proud of their individual contributions and will enjoy taking turns telling and retelling the stories and looking at the illustrations.

Topics of a type that would suggest story lines for making zigzag books include the following:

> The street where Tom lives
> Things that are round
> The crocodile who couldn't find his dinner
> Where the music is
> An airplane named Harry
> The adventures of a unicorn

Corrugated Paper Crowns

The very young child can be a king or queen for a number of days when he proudly wears a brightly colored and gaily ornamented crown of his own making.

Corrugated paper serves as a sturdy base for these headpieces, and upon them the children may glue, tape, and staple all sorts of decorative materials. This paper comes in rolls in a variety of colors and is available from office and school supply

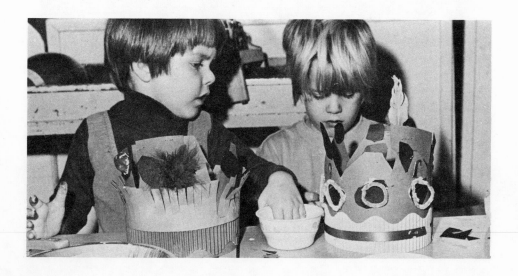

These preschool children are developing their cutting and gluing skills when they add both two- and three-dimensional decorations to their crowns.

houses. A strip about twenty-one inches long may be stapled to a taller piece of colored paper of the same length and then overlapped at the back and stapled to fit the individual child's head. This added piece of construction paper elevates the height of the crown, giving the child more space to decorate. The child may cut the top of his crown in points, curves, fringe, or in whatever manner he may choose.

With a rich supply of such things as discarded gift-wrap ribbons, colored paper and yarn, the children are ready to begin using scissors, glue, tape, and staplers. The child can create projecting decorations by adding feathers, soda straws, and pipe cleaners, and he can make moving parts with fringed paper and crepe-paper streamers. Foil paper, gold and silver stars, and alphabet stick-ons will add sparkle and shine. Folding colored paper and cutting several shapes at the same time will encourage the child to make a repeated motif. Buttons and beads with one side flat enough to hold a bit of glue will add interesting design accents. A pile of egg carton bumps may be painted with tempera and glued on for fake diamonds, emeralds, and rubies.

When they have finished, the new kings and queens may parade in a grand procession or rule their kingdoms seated on thrones. They may happily act out stories and imagine themselves in their new roles as grand monarchs.

Young children love to wear headpieces, and when they can make bright crowns all by themselves, they treasure them highly and wear them for all sorts of pretend play.

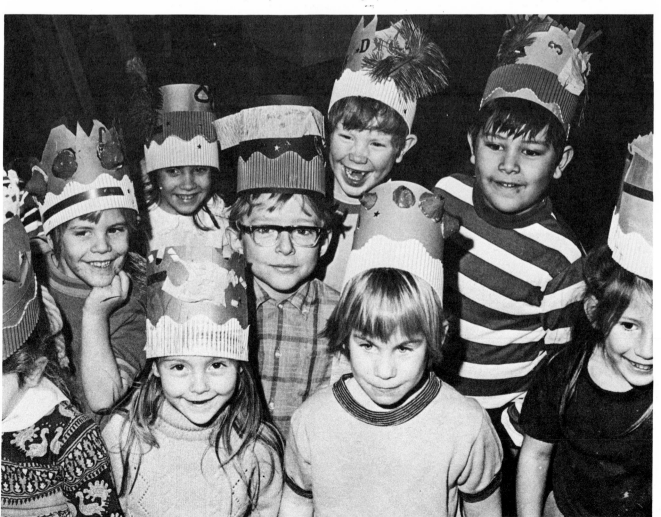

Collages for Valentine's Day

Collage activities are especially appropriate at Valentine's Day. The children will want to help in collecting all sorts of materials ahead of time in anticipation for the task. Each child should have a rather shallow cardboard box or box lid such as the kind hosiery is packaged in to serve as the frame for his creation. He may choose to use the inside or outside of the box for his base, gluing on frilly materials and cutout details. The collages may or may not be symmetrically balanced.

A little instruction in how to fold the red, white, pink, and magenta paper to cut out hearts of different sizes and proportion will be needed. Lace doilies in white, gold, and silver are available in variety stores, as are inexpensive lacy and shiny ribbons, foam sheeting, gift-wrap paper, feathers, paper flowers, and such. The children should look at the doilies with an eye to cutting them apart and using small portions of the delicate circular motifs.

Frilly, colorful valentine collage requires careful cutting and sensitive designing.

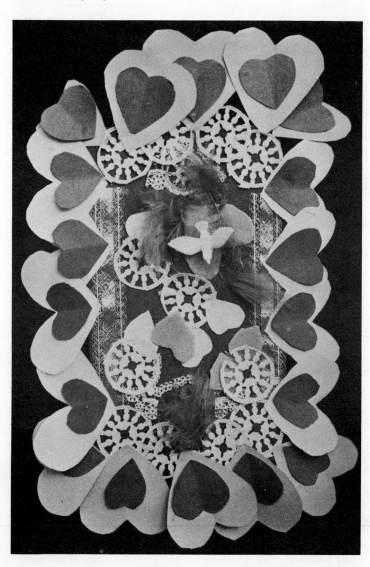

A few printed words cut from magazines and glued together may be used to add a Valentine message to the collage. In like manner, clipped photographs from magazines may be added for design accents.

Pass-it-on Pictures

Gamelike in approach, pass-it-on pictures require the child to be adaptable and quick in his thinking as regards cutting out images freely from colored paper.

Each child should have a piece of white or black construction paper, about nine-by-twelve inches in size, and an assortment of colored paper and glue or gummed colored paper. The class should be instructed in the rules of the game: Each child must cut out one shape from his collection of colored paper, glue it anywhere he chooses to the background, and at a given signal (two minutes is usually sufficient) pass it on to the youngster sitting next to him. At this signal he will also receive a paper from his neighbor. He must quickly decide what the shape that is on it reminds him of, and how he can add to it to make the picture progress. This passing-on continues for about fifteen or so turns, with each child adding a part to each picture for a composite finished arrangement.

The children are quick to find humor and suspense in seeing what happens to the picture that each of them started and seeing how their friends changed and enriched it as the game progressed. They will want to play it several times and will find that practice increases their skill and ability to see novel configurations in shapes. They should make titles for the finished pictures and let their imagination dictate directions for unexpected and whimsical results.

A and B. Pipe-smoking funny man and a motor boat grew piece-by-piece as children each added to the arrangements.

Printmaking Surprises 9

Printmaking is filled with surprises and suspense. One is never quite sure what the finished product will look like until the magic moment when the block is pressed or stamped on the paper. Children are intrigued with the step-by-step process leading up to the moment when their prints are completed. Equally fascinating is the rhythmical element inherent in repeating a single design many times to make all-over patterns as is sometimes done with gadget-printing and small relief prints.[1]

Another valuable characteristic of printmaking is its adaptability to mural projects. Children can use relief techniques such as potato prints, gadgets, and inner tube prints, and they can work in groups, each child making one part or object that will then be repeated several times on the mural surface. Suitable topics for mural-making include the following:

—Flower garden with bugs —Mermaids and sea life
—Cars and trucks on highways and bridges —Astronauts and spaceships
—Herds of animals in a jungle, zoo, or farm

Relief printmaking involves three definite steps before the product is completed. First comes the making of the relief image, whether it is cut on a potato, from an inner tube, on an art gum eraser, on a flat piece of Styrofoam, or on a piece of linoleum. This block or plate is then inked with a brayer or brushed with tempera, and finally it is stamped onto a piece of paper, or a piece of paper may be pressed on the top of the block.

Throughout the year children should make all kinds of prints both as individual art tasks and as group projects. Each time they will be intrigued anew with the surprise that awaits them in the viewing of the final product, and they will discover that the design possibilities in printmaking are unlimited.

Foam Tape

The sequence of printmaking steps are passed through rapidly when the young child uses foam tape. The interest span of the very youngest boy or girl can be maintained since the whole process takes but a few minutes. The child discovers for himself just what is meant by "making a print." He might even be able to relate it to the print his shoe makes in the snow, the pattern a car tire leaves in mud, or even the mark his paint-covered finger makes when he presses it

1. For sources of additional information on relief prints see Bibliography, p. 169.

A. High-density foam strips are easy for small children to cut and arrange on a small scrap of wood.

B. Water-base ink is rolled onto the block with a brayer.

C. Children enjoy repeating their prints many times on a sheet of paper.

on paper. Later on, after this brief and rudimentary beginning, he will be prepared to progress to more complicated printmaking devices.

Self-adhesive foam tape is available in hardware stores and comes in two weights: the all-purpose which is quite porous and spongy; and the high density, which has a smooth surface, is much firmer, and is preferred for printmaking experiences.

While the design possibilities are somewhat limited when the child works with only narrow strips, foam tape offers a fine potential for the very young child's first printmaking activities. He may snip off a few pieces, arrange them to his liking on a small block of wood or piece of cardboard, and then peel off the backing and press them in place. He is then ready to make the print.

With a small brayer, water-base printing ink, and a baking sheet or a piece of Masonite on which to spread the ink, the child rolls the ink on his block and prints it on the paper. It is advisable to use a color of ink and paper that are in marked contrast to each other, i.e., dark blue ink on yellow paper, black on white or light blue, white on green, and so on. The block should be re-inked each time the child prints it. He will delight in printing his block over and over again on a large paper and will better understand the meaning of the terms "repeat print" and "all-over pattern." A very simple design made with only a few bits of tape takes on a new importance and assumes interesting relationships when it is repeated a number of times.

Foam Sheets

Prints made with foam sheet which are available in variety stores and hobby shops are a good follow-up activity for foam strip prints.

These sheets are extremely easy for young children to cut into freely, and the leftover scraps often suggest design motifs for future prints. The picture the child makes may be made up of parts, as the Car and Driver print shown in the photograph above, and these parts may then be adhered with white glue to a piece of corrugated cardboard or a flat board.

A. Sheet foam may be cut easily, and children can make an entire picture by combining and adding parts.

B. Print of Car and Driver was made by brushing tempera on the sheet foam and pressing a piece of paper on top of it.

After the glue is thoroughly dry, the child is ready to print his design. Using a creamy smooth tempera and a flat wide-bristle brush, he applies the paint to the foam shapes as evenly as possible. Some children will take an interest in applying different colors to the various foam shapes in their pictures. Being porous the foam will soak up quite a bit of paint before it is adequately covered to make the first impression. The child may gently press the plate onto a piece of manila or colored paper, or the block may be placed faceup on the table and the paper carefully pressed onto it.

With only a small amount of paint added to the surface of the sponge each time, the child may make a number of prints from one block. He will enjoy discovering how using the same color of paint on different colored paper backgrounds will create a variety of impressions.

Styrofoam Tray Prints

Making a print with a Styrofoam tray is as easy as one—two—three for young children, and they will want to repeat the task a number of times, trying out new images and forms as their concepts expand.

Each child will need a clean Styrofoam tray of the kind that butchers use to pack meat. This tray should have the curved sides trimmed off on a paper cutter.

Then the child draws his picture on it with a pencil, pressing down rather firmly to imprint deep grooves. It is simple to make a line drawing this way, but if the child wishes to make a solid shape, he will need to press down evenly in a whole area. All the lines and places that are pushed down will show up as the color of the paper upon which the plate is printed. All the areas that are left standing will print the color of the ink that is used.

For variety, the children should be encouraged to be innovative with their pencils and create dots, close-together lines, and other textured motifs, as well as thin lines and wide, curved lines and straight, large shapes and small, and so on.

After the drawing has been completed on the Styrofoam, it is ready to be inked and printed. Black or colored water-base inks may be rolled with a brayer onto a baking sheet or a metal or plastic tray. Then the child should use the brayer to cover his Styrofoam tray with ink. A piece of typing paper or colored tissue paper cut a little larger than the Styrofoam should be placed carefully on top of it and gentle pressure applied with the fingers and hands to assure an even printing. The paper is then pulled off, and the finished print is left to dry before being matted for display.

Any number of prints may be made; however, the Styrofoam will need to be re-inked each time it is printed. Children will be interested in seeing the different effects they can create by changing the color of the ink as well as the color of the paper upon which their prints are made.

A. Kindergarten child rolls water-base ink on his Styrofoam tray with a brayer.

B. Tissue paper is carefully placed on top of the tray and rubbed with the fingers to assure an even printing.

C. Tissue paper is pulled off the Styrofoam, and the print appears.

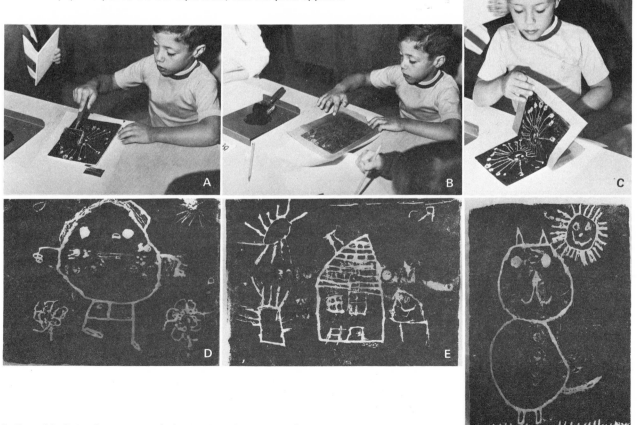

D, E, and F. Since they are mostly linear, Styrofoam prints have a strong appeal for the very young child. They offer avenues for the development of his conceptual symbols.

Card Prints

If young children have had enough experience in cutting paper, they will have developed the skills needed to put together a card print.

Using a five-by-eight-inch file card for the background and another file card, piece of tagboard, or discarded manila folder from which to cut his designs, each child prepares a picture from which a final print will be made.

Parts of an animal such as the ears, wings, legs, and such, may be cut separately and glued down on top of other pieces. The edges of the cutout shapes create a white outline on the finished print. When all the parts of the picture have been cut, the child may wish to rearrange them a bit, add other shapes, or alter some of them before he glues them to the background.

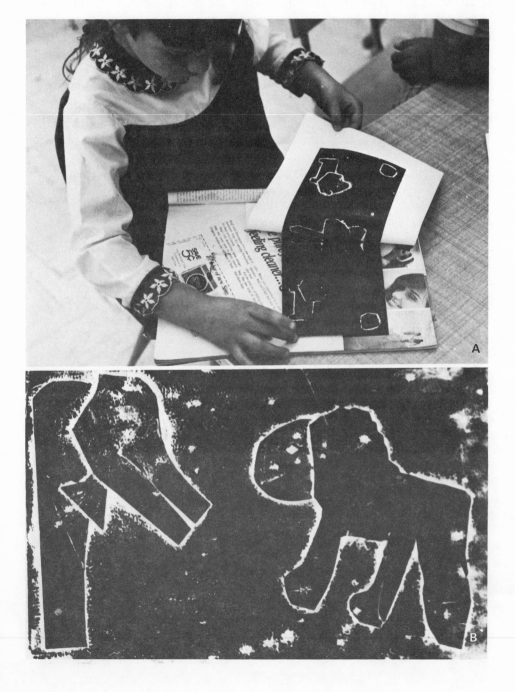

A. Cutting and designing skills as well as the know-how of printing are involved when young children make card prints.

B. Dark and light contrast sharply in card prints. The Elephant and Lion print was made by a five-year-old child.

The printing ink is rolled onto the brayer from the inked tray or sheet, and the card is given a good coating of ink before printing it on colored tissue paper or typing paper. This sort of paper is fairly nonabsorbent, and less ink is needed than would be needed on such porous papers as construction or manila papers.

The print should be rubbed gently with the fingers before pulling it off the card and letting it dry.

Glue-it-on Plus Gadget-Printing

As a starting point and focus for this art task, the children will need an assortment of circles, squares, rectangles, and long strips of colored paper. From these they may choose one or more to glue down to a piece of paper about twelve-by-fifteen inches or so in dimension. When they have made their selection and have chosen where they will place their shape, they are ready to use a printmaking device to complete their compositions.

A long strip of paper may suggest to one child a stem of a flower, or to another child a tree trunk; a rectangle piece might connote the shape of a car, airplane, wagon, torso of a person, or the body of an animal or bird. A circle might help them focus on a plant design, a lady bug, a wheel, a clown's head, a turtle, or a beaming sun face. Whatever the precut geometric shapes suggest is then ready to be enhanced and embellished and made more complete with simple gadget prints.

A few cottage cheese carton lids with sheet sponge cut in circles serve as very functional stamp pads. Creamy tempera should be poured on the sponges, which may later be squeezed and washed clean in running water for future use.

Small blocks and sticks of wood, corks, erasers, jar lids, and edges of cardboard strips are easy-to-handle shapes and offer endless possibilities in design. Gently pressing them on the pad each time before they are stamped makes a neat print on the child's paper. Children will be eager to repeat them and combine them in all sorts of configurations relative to the colored paper shapes.

An extension of this art task lies in the direction of the child's cutting of shapes from colored paper rather than using the simple precut geometric shapes. By snipping out one or two parts for his design idea from colored paper, the child can put together his entire composition by adding a few gadget print motifs.

A. Sheet sponge soaked with tempera makes handy stamp pads for gadget printing.

B. Small blocks of wood, corks, jar lids, erasers, and such, may be printed, repeated, and combined in many ways by the child. Glued-on shape of colored paper serves as focal point.

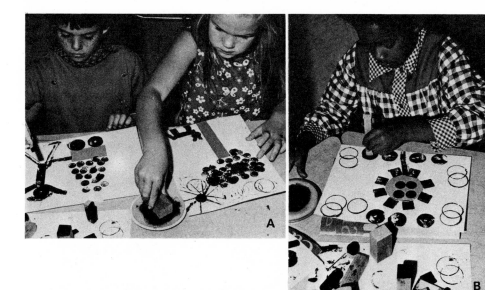

Sun Prints

With light-sensitive Diazo paper and a bit of sunshine, children can make sharply contrasting prints in a few minutes. Making such a dark and light picture fascinates young children, thanks to the mysterious surprise element involved. The picture they have cut out of construction paper appears like magic when the exposed paper that was underneath it is brushed with developer.

To make the frames to hold the sensitive paper, you will need several rectangles of glass 8½-by-12 inches and an equal number of Masonite pieces of the

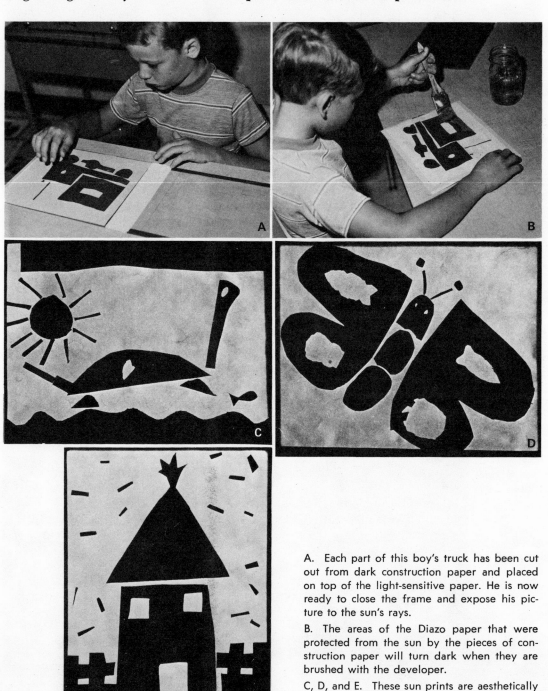

A. Each part of this boy's truck has been cut out from dark construction paper and placed on top of the light-sensitive paper. He is now ready to close the frame and expose his picture to the sun's rays.

B. The areas of the Diazo paper that were protected from the sun by the pieces of construction paper will turn dark when they are brushed with the developer.

C, D, and E. These sun prints are aesthetically related to the shape of the paper. They show a sensitive awareness on the child's part to the contrast of light and dark.

same size. For safety the edges of the glass should be covered with masking tape. These taped edges give the finished print an attractive border. Each rectangle of glass is attached to the Masonite on one side with an adhesive tape hinge on the front and back. This leaves an exposed glass area of 7½-by-10 inches. The fold-up frame enables the child to lay the frame out flat while he places his design on the light-sensitive paper.

Diazo paper and developer are available from supply houses that sell copying materials for office machines. The paper should not be opened out-of-doors. One heaping tablespoon of the powdered developer should be mixed in one cup of 100-degree water and stirred until it is dissolved. It is advisable to mix a fresh batch of developer each time it is used.

If the children are given a blank piece of 8½-by-11-inch white paper, which is the same size as the Diazo paper, they may use it as a working background while they are designing their pictures. With scissors and a piece of dark construction paper, they should cut out the desired shapes and arrange them on this background. They may make the objects in parts, overlapping or leaving spaces between the separate pieces. They may fold the paper and cut out interior shapes for such things as eyes, windows, spots on giraffes, buttons on shirts, and so on. Such holes and cuts in the paper are the only way these details will show up on the finished print. By folding the paper they may cut out several shapes just alike, such as several wheels for a truck, legs for an animal, leaves for a tree, or tail feathers for a bird.

When the child is satisfied with his design, he transfers all the cutout pieces to a sheet of Diazo paper which has been placed sensitive side up on the lower part of the frame. He then lowers the glass in place, creating a sandwich of sorts when he closes the glass top.

Then without letting any of the parts of his picture shift, he holds it in the sunlight for a few seconds. Grasping the frame by the taped edges, he should be careful not to let his thumbs or fingers cover any of the paper. Direct sunlight is not necessary. A cloudy or overcast day provides adequate illumination. The uncovered or exposed parts of the Diazo paper are pale yellow and will turn white during exposure. The covered or protected parts remain yellow until they are brushed with developer which makes them turn a dark gray.

When the child returns to the classroom, he removes the exposed paper from the frame and discards the cut-paper shapes unless he wants to use them again in another print. Then with a two- or three-inch flat brush, he applies the developer to the paper in even horizontal strokes, making the images appear instantly. The prints should be placed to dry on newspapers and pressed flat with an iron later.

Children may use this printmaking experience to develop their evaluation skills as together they view their finished work. They will probably discover some aesthetic concepts that will help them create a more pleasing product the next time they make sun prints. These discoveries might be such as the following: "My print would be better if I cut more shapes or holes inside other shapes to show details." "My print would be more interesting if I repeated one of the same shapes several times, i.e., several kittens drinking milk instead of just one." "I could make my clown look as if he were running by changing the position of his legs." "I could add several smaller objects."

Not only are sun prints worthwhile as a printmaking experience, but the results are attractive for matting and displaying as finished works. They may also be used for program covers, invitations, posters, and for any occasion when a number of the same item are needed. And, too, the child's art vocabulary is increased as he talks about "developer, sensitive to light, exposed to light, and contrast."

Three-Dimensional Prints

Sand casts are relief prints in three dimensions. As such, they open the door to the tactile and gritty experience of manipulating wet sand and found objects, assembling them all in some pleasing order, and casting the arrangement in plaster.

Clean milk cartons cut in half horizontally and taped at the ends should be filled about half full with sand. The sand should be wet enough to retain impressions when objects are pressed into it. After smoothing out the sand, the child makes a simple design by pressing into the surface his finger, wood scraps, and assorted gadgets. These imprints will appear as raised bumps and high places on the cast piece. He may imbed shells, rocks, nails, driftwood, and other found objects into the sand, pushing them partway down and leaving enough of the object projecting up so that the plaster can hold it permanently in place.

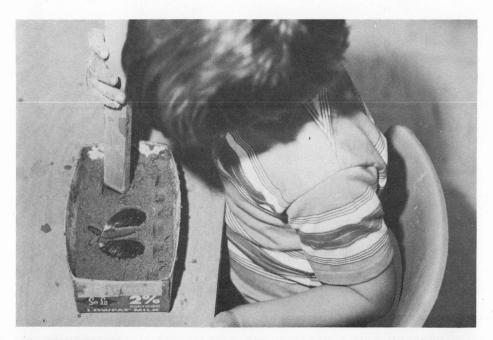

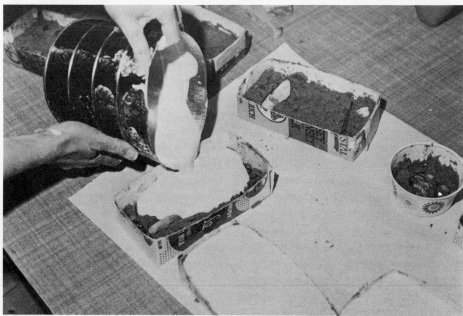

Shells are pressed into the wet sand and will remain in the finished casting. Indentations made by pressing the wood stick into the sand will stand up as in a bas-relief.

Several of the children's cartons may be filled with one batch of plaster. Care must be taken not to pour the plaster too quickly or the imbedded objects will be flooded out of place.

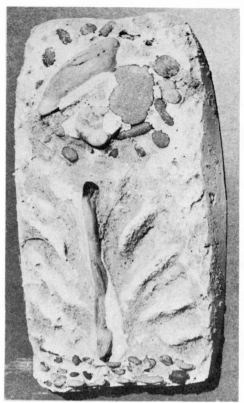

Finished sand casts retain texture of sand and have high and low areas. Pebbles, wood, and shells add pleasant natural accents.

Plaster of paris, or casting plaster as it is sometimes called, is available from building supply firms in hundred-pound bags. Fox mixing it you will need a large disposable can or a plastic bowl or dishpan. You can mix enough plaster at one time to cast several of the children's cartons. Be careful not to pour any plaster down the sink at cleanup time. Hardened plaster easily chips off plastic containers, however.

Fill the container about half full of water and begin sprinkling the plaster into the water without stirring. The plaster will quickly sink to the bottom, and as you sprinkle more in, it will gradually rise to the surface of the water and form small islands. When no more plaster can be absorbed by the water, stop adding the dry plaster to it, and with your hand stir the mixture slowly, squeezing any lumps that may have formed. If you will raise the container an inch or two off the table and let it drop, the air bubbles will be forced to rise to the top. When the plaster is the consistency of pancake batter, gently pour it into the cartons, being careful not to flood out or move any of the objects that have been left half-buried in the sand. Make a layer of plaster about three-fourths- to one-inch thick.

In a few minutes the plaster will begin to harden, and then a hook made from a paper clip or a **U**-shaped wire should be imbedded into the surface to enable the finished sand casting to be hung on a garden or indoor wall.

The next day the plaster will have hardened sufficiently for the children to be able to unfasten the corners of the carton and lift off the casting. By using a small brush and a hose of running water, the child can remove the excess sand without damaging the surface of the plaster print.

Modeling, Shaping, and Constructing 10

The child's world of living, moving, and playing is largely in space, that is, it is three-dimensional, and the task of modeling, shaping, and constructing visual images is a natural channel through which the child's concepts for form become richer, more detailed, and interrelated. If *only* painting and drawing activities are experienced, the child is constantly forced to contrive and translate roundness, depth, spatial relations, and texture into the limitations and confines of a flat plane. This is a complicated and advanced task. However, his representation of form and his conceptual knowledge of three-dimensional forms can more effectively be recreated and dealt with by using three-dimensional materials. In so working, the child uses both hands and, in a more real and true-to-life manner, clarifies and relates all that he knows and feels about natural forms.

When he manipulates a pliable modeling medium, he is able to make changes in his work rapidly, feel the roundness, the depth, the overall wholeness of a figure, head, or animal, and through this tactile intake he can refine, better understand, and communicate his knowledge of physical forms. His drawings and paintings of figures and animals will show improvement if he alternately works with modeling materials and two-dimensional materials. His perpetually increasing knowledge of three-dimensional forms will interact with his two-dimensional drawing skills and prevent the rigid fixation of a stereotyped schema.

Preschool and kindergarten children will probably spend a good deal of time in manipulating any modeling material they are given. They will enjoy pounding, rolling, squeezing, making coils and balls, and imprinting objects into the material. They should not be pushed into making recognizable objects until they are ready to do so naturally; however, if they have many opportunities to play with the material, their growth will proceed rapidly, and representative symbols will begin to emerge.

When children are ready to make use of some techniques, the teacher may show them how to moisten two bits of the material to make them stick together; how to roll out and cut pieces with a dull knife; and how to make textures and pinch out details.

First-graders and older children will enjoy the challenge of a specific motivation or topic after they have passed through the earlier experimental stage of manipulating a modeling material. They can work creatively within a given framework and will benefit from new areas of exploration and expanded ideas.

Two kinds of clay are commonly used in schools—the water-base kind that hardens and is fired in a kiln, and the oil-base or plasticine variety that is reusable and never dries out. While both of these materials have certain advantages, it is felt that other modeling materials can be put to better use for young children.

Water-base clay must be kept in covered containers to keep it just the right consistency. If it is too hard, it is not suitable for modeling. If it is too wet and sticky, it is useless for young children to attempt to handle. After objects are made, they are quite fragile unless they are fired. No wires, sticks, or decorative objects may be imbedded in clay if the object is to be fired. After the clay is fired, it may be painted with tempera, glazed and fired again, or left bisque. If air bubbles are left inside the clay, the object bursts and cracks in the firing. If arms and legs are not properly attached, they fall off. Disappointments for young children are numerous. Pleistocene is suitable for young children to use over and over again if it is soft enough for young fingers to manipulate. The objects are generally tossed back in the bin and not kept by the children.

This section suggests alternative materials to these two kinds of clay. They are soft, pliable, and make satisfying finished projects. They are

1. salt ceramic,
2. baker's dough,
3. food forms—candy clay, cookies, and bread.

All are easy to mix in the classroom, using materials purchased from the grocery store.

Salt ceramic may be colored or left white and painted later. It dries to a rock hardness without any firing. Baker's dough may be left white or colored, also, and needs only to be baked for an hour or so in an oven. Finished objects are inedible and may be brushed or sprayed with a clear glaze after they are dried or baked

A. Bread-dough doll from Ecuador is delicately made with much colorful detailing added. Such examples are made with materials similar to the ones children use, and they are fascinated with seeing work from a faraway land.

B. Clay figures by contemporary artists show much of the decoration and exaggerated forms that young children find easy to relate to and understand.

C. Clay wolf shows seven-year-old child's highly developed skill in handling the material. Teachers need to demonstrate techniques for making arms, legs, feet, and ears adhere.

if a shiny surface is desired. Candy clay needs no cooking or baking—just eating! The cookies must of course be baked, as must the bread dough. All have fine tactile qualities; however, the food forms offer an additional advantage in that they appeal to the child's senses of taste and smell.

Wire, cloves, peppercorns, macaroni, and such, may be imbedded in the salt ceramic and baker's dough, while only edible, nonmelting types of decors may be used in designing the candy, cookies, and bread forms.

To construct means to combine materials in a three-dimensional way. The objects made may or may not be realistic, but the things structured should be joined together in such a way that they are stable and hold together. The pieces may stand on the floor or hang from the ceiling or on the wall. Young children can work with many construction materials and find them challenging and interesting. They can learn to tape and glue. Preschoolers and kindergartners can learn to pound nails and saw small pieces of wood. The children can discover for themselves that such familiar objects as newspapers, boxes, tape, paste, wood scraps, and paint can be manipulated and combined to create all manner of three-dimensional objects. They will need only a minimum of assistance in their work and will often enjoy working in pairs so that one child may hold while the other child tapes or glues.

Young children need to review many times their three-dimensional concepts as their perceptions and knowledge increase and unfold with repeated experiences. The ease and appeal of modeling and constructing activities will route their discoveries toward success-bound avenues.

Recipes

SALT CERAMIC

This recipe may be doubled. Food color (preferably the highly concentrated paste food colors) or liquid tempera may be mixed into the water, or the batch may be left white. Salt is much cheaper if it is purchased in five-pound bags rather than in one-pound boxes.

> 1 cup of salt
> ½ cup of cornstarch
> ¾ cup of water

Stir these three ingredients together in a pan and then cook the mixture over medium heat, stirring constantly with a wooden spoon until it thickens into a big blob. Remove from the heat and place the mixture on a piece of foil. When it cools a bit, knead it thoroughly. If it must be kept a short while before using, it should be kneaded again to make it soft and pliable.

BAKER'S DOUGH

> 1 cup of salt
> 4 cups of flour
> 1½ cups of water

Mix these three ingredients thoroughly with the hands, adding a little more water if necessary. Knead about five minutes until it is soft and pliable. Liquid tempera may be added to the water if colored dough is desired or a single batch may be divided into small balls and different colors added to each. Bake on foil-covered baking sheets in a 350-degree oven till nicely browned and hard all the way through. Thick large pieces will require a longer time than small flat pieces. Colored dough may be left to dry with no baking.

Beads

Children begin very early to roll bits of any modeling material in the palms of their hands to make small balls. They also learn to coordinate hand and eye in stringing all sorts of beads. By combining these two manipulative skills, very young children can make their own necklaces.

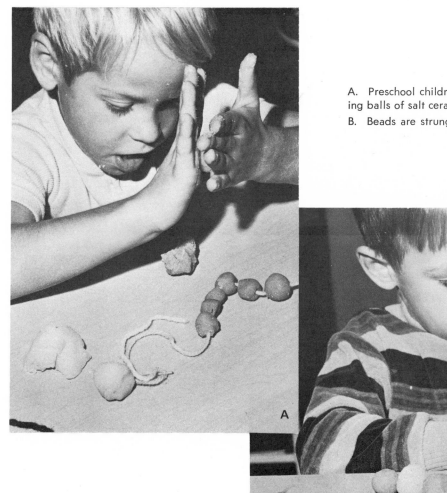

A. Preschool children develop manipulative dexterity in rolling balls of salt ceramic.
B. Beads are strung on soft yarn with a large-eyed needle.

You will need a number of needles with large enough eyes to accommodate soft Orlon yarn. Given a length of this yarn about eighteen inches long, the child pinches off pieces of colored salt ceramic, rolls them in balls, and pushes the needle and yarn gently through the centers. Some children will be interested in the more advanced skill and challenge of alternating colors or sizes of beads—such as one red and then one yellow, or one large and then two small beads. Whatever planned or random combination is made, the necklaces are easy to make and attractive to wear; making them holds the attention of very young children for quite some time.

The finished strings of beads should be placed on foil and dried thoroughly for several days. They should be turned over gently to insure that they dry evenly on all sides. When completely hard, they are ready for the child to wear.

Pendants

Young children will enjoy modeling salt ceramic to create handsome yarn-hung pendants, regardless of whether they themselves wear them or share them with friends.

To make a necklace, each child needs a length of roving (thick yarn) about thirty inches long with a two-inch strip of electric tape folded over in the center of the roving. This tape forms the base upon which the child attaches his pendant. Four or five batches of salt ceramic in strongly contrasting colors will be sufficient for an average class. If white salt ceramic is used, the pieces may be painted by using small brushes with watercolor or tempera when they are dry.

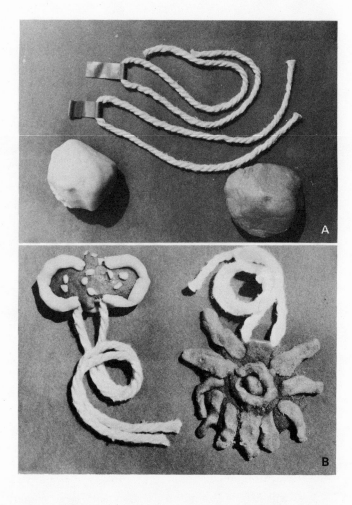

A. Tabs of folded-over tape form the base for attaching modeled salt ceramic pendants.

B. Kindergarten children enjoyed creating these butterfly and flower pendants.

The child may roll coils, small balls, and make pinched and formed shapes to place upon the basic flat shape that he has pressed down on the tape tab. These small decorative bits of salt ceramic may need to be lightly moistened to make them stay in place. If they do fall off in drying, they may be glued back in place later. A pencil and other small tools will be useful in creating small dots and pressed-in textures.

Such simple forms as flowers, bugs, butterflies, turtles, elephants, airplanes, and faces lend themselves well as motifs—or abstract designs may be created.

The pendants will dry hard in a few days. They should be turned frequently in order for them to dry thoroughly and evenly. A clear acrylic glaze gives added shine to the finished pieces.

Fake a Cake

Very small children delight in spreading gooey frosting around on a fake cake. Perhaps the delightful "unbirthday" party in *Alice in Wonderland* has the same fanciful and whimsical appeal to the child's imagination. Certainly the interest and attention span are lengthened in this kind of visual and tactile play task.

A. The tactile appeal of fluffy soapsuds frosting is incentive for preschoolers to swirl, smooth, and make soft peaks on fake cardboard cake.

B. Rectangular box serves as base for macaroni cake. Stick candles add to the cake design as children work with brushes and paint.

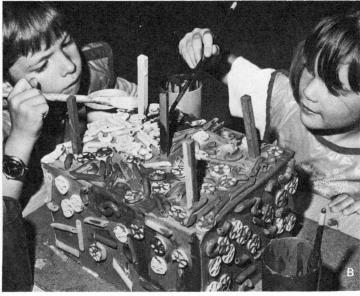

You need a round cardboard ice cream carton, a few short wooden dowel sticks for fake candles, lots of Ivory Snow colored with food coloring and whipped to a thick creamy consistency, and a few small spatulas and table knives for smoothing and spreading the frosting in wavy bumps and peaks. For the cake in the photograph above, the ice cream carton was cut down to a short height before attaching it to a heavy piece of cardboard with glue and masking tape.

Another fake cake that is fun for preschoolers and kindergartners to make is one using macaroni. The use of several different shapes of macaroni aids in the development of visual discrimination skills and gives the teacher an opportunity to talk about which pieces of macaroni are round, which are straight, which are curved, and so on. Some children will find it a challenge to arrange the macaroni in a repeat pattern, such as three straight pieces, two curved ones, and one round one, and then repeating the same arrangement in a border or all-over pattern. When the glued-on macaroni pieces are dry, the children will enjoy painting their "cake."

Some preschools and kindergartens choose one day near the end of the school year to celebrate the birthdays of all the children who will be on summer vacation when their birthdays come around. Having a party and making a fake cake is a fine way to accent this type of pretend birthday provided, of course, that real cake with real frosting is served later!

Modeled Masks

Mask-making has long been a part of the culture and tradition of people the world over. Masks have been and still are worn by people for protection, for appeasing gods, for frightening away evil spirits, for momentarily being another personality, and for just plain fun and celebration.

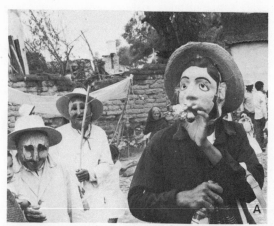

A. Masks are often implements of adornment and ritual. These contemporary Indians are wearing masks while they dance in a churchyard in Atotonilco, Mexico.

B, C, D, and E. Masks may be tools of magic and protection, and they helped primitive man master nature and the mysteries of the spiritual world. These small masks are contemporary folk versions made from clay, papier-mâché, wood, and tin. They depict animal and human forms. Masks bridge differences in cultures, countries, time, and space. Children will benefit from touching and seeing real objects such as these.

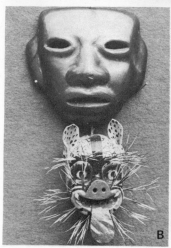
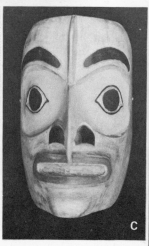
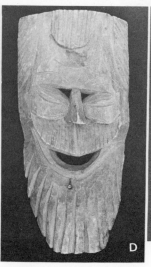
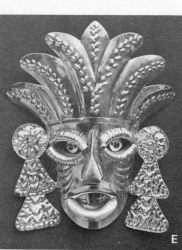

Children today most commonly associate the making and wearing of masks with Halloween, and if masks are to be made by the children at this time of the year, it is wise for them to know that the custom of wearing masks began long ago in ancient Gaul and Britain. The druids and priests thought that witches, demons, and spirits of dead people came back to earth on the last night of October. The druids lit bonfires to drive these bad spirits away and protected themselves by offering them good things to eat and by disguising themselves and wearing masks so that the evil spirits would think that the druids belonged to their own group and thus would not harm them.

The children's concept of face coverings should also include knowledge and appreciation of the many other roles of masks. For instance, in Africa when a boy was accepted as an adult hunter, he wore a mask to scare away evil intruders. Some of these masks covered the head instead of just the face and depicted an animal form such as a buffalo. They were ornamented with feathers and paint and had much stylized, abstract decoration. Indians in the Southwest and Mexico use

masks today as a vital part of their dances, celebrations, and religious rituals. In Japanese Kabuki drama, masks are an integral part of the ceremony.

While they are not thought of as art forms, very functional and utilitarian masks are worn by such familiar people in our own culture as the deep-sea diver, the astronaut, the welder, the surgeon, and even the frosty-nosed skier!

Of course, not all masks are meant to be actually worn on the face or head. Some are made to be an expressive and ornamental art form. Children will find it interesting to look at many kinds of masks in museums, at photographs in reference books, and on films. The teacher should direct their attention to exaggerated features, repetitive design elements, the use of color, feathers, beads, bones, hair, and fur. If possible, actual folk art masks should be in the classroom to be seen and touched, and to aid the children in relating their own feelings to the rich cultures of other civilizations.

 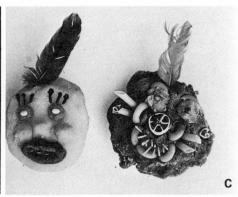

A. Seven-year-old boy is adding wire, jute, and peppercorns to his baker's dough mask.

B. Rope, cloves, and jute were pressed into baker's dough masks before baking them. Features project rather than being drawn flat on the surface. Finished masks were mounted on a felt-covered cardboard.

C. Salt ceramic masks utilize many odds and ends for decorative details since no baking is required. These were made by second-grade children.

Primitive masks are usually symmetrical and often emphasize a mood or spirit through exaggerated and distorted parts. The craftsmen often heighten the all-over effect by using repeated lines and shapes to make the dominant features stand out.

Young children can model small ornamental masks from salt ceramic and baker's dough. A piece of foil or cardboard will keep the modeling material from sticking to the table and will make possible its easy removal later to a drying shelf or the baking oven. Paste food color or liquid tempera may be added to the salt ceramic or baker's dough so that the children may make use of several colors in their mask design. The child will discover that the three-dimensional quality of the face he makes, whether it be human or animal, will be better integrated and will result in a more aesthetic product if the nose, chin, lips, teeth, and eyebrows project and are not simply drawn on the surface of the mask in a flat manner.

The use of feathers, toothpicks, cloves, macaroni, peppercorns, rope, jute, shells, acorns, and such, adds much to the design possibilities. Almost any ornamental material may be pushed into the salt ceramic since the pieces are only air-dried. However, only materials that will not burn or melt at 350 degrees should be used with the baker's dough. A paper clip or hairpin stuck in the top or back of the mask before the material hardens or is baked makes for easy hanging later. The baker's dough masks should be covered with plastic wrap if there must be a delay before they are baked, otherwise the salt will dry first and leave a crusty texture on the surface.

When the masks have dried or have been baked, they may be sprayed or brushed with a clear glaze for added shine and gloss. They may be hung as they are or mounted on a felt or fabric-covered cardboard for an attractive display.

Salt Heads in a Tube

A cardboard tube or an empty frozen juice can and a large lump of salt ceramic are the basic materials for these salt-head figures. In order to keep the figure from being top-heavy, the tube itself should be filled with salt ceramic and the head modeled right on top of it. Each child will need a large lump of salt ceramic and several small pieces of other colors for adding the facial features unless he wishes to paint the head when it is dry.

If the children have used salt ceramic before, they will probably need only be reminded of the necessity for kneading it before they begin work and of how to moisten rolls and balls of the material to make them adhere as facial details. The teacher should point out that exaggerated or oversized features project well from a distance.

After several days the salt heads and the salt ceramic inside the tubes will be dry, and the figures are ready to be finished. By using glue to attach yarn,

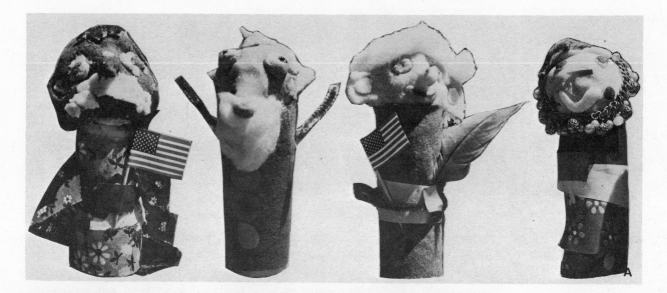

A. Six - year - old children showed much originality and diversity of form when they made these salt-head figures. Colored salt ceramic made it possible for them to model contrasting facial features.

B and C. Young children enjoy the challenge of finding appropriate scraps of materials to use in adorning their figures after the salt heads are hardened. Glue and tape are suitable adhesives.

rope or cotton for hair and beards, felt, colored paper, and fabric for garments, pipe cleaner or sheet sponge for arms, and braid, feathers, and other scrap materials, the salt-head figures may be completed.

Children should be encouraged to make a definite character, perhaps one from a favorite story, or from a television show. It may be real or make-believe, human or animal. Figures may also be used in dioramas.

Figures on a Base

How to make modeled figures that will stand up all by themselves is sometimes a difficult task for young children to do. Salt ceramic opens numerous avenues for young children to explore in creating conceptual images in three dimensions. Through its use they can make figures engaged in a variety of activities such as a boy fishing, a mother with a child, a boy leading a goat, a girl blowing a horn, a cat with kittens, a clown on horseback, a giraffe, a tiger, and many more.

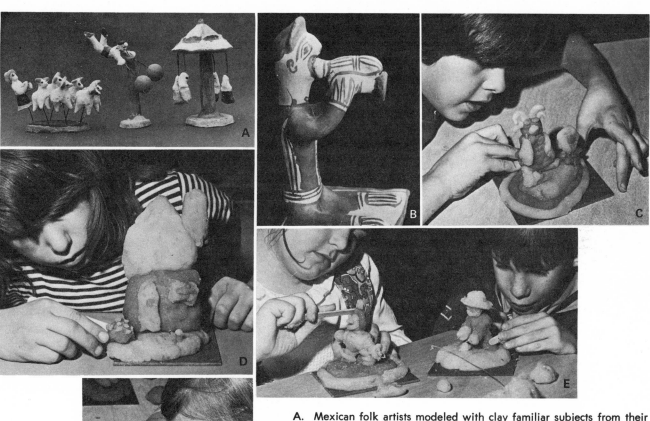

A. Mexican folk artists modeled with clay familiar subjects from their own lives—a sheep herder and carnival performers. In like manner children will model subjects from their own world—things they love to do or things they delight in seeing or imagining.

B. Expressive horn blower sits on a clay base. Primitive Mexican artist brushed on a few repeated decorative details.

C. Ringed base supports horned elf and flower. Wire armature provides interior support.

D. Wire armature gives hidden support to this girl's house.

E. Old Lady and Old Man stand on thick ceramic bases. Wire imbedded in arms makes for flexible positioning.

F. Small bird sits on a nest of salt ceramic. Wooden stick is used to imprint decorative lines.

The reason that salt ceramic lends itself so well to making both single and grouped figures is that galvanized wire and toothpicks may be inserted into bodies, legs, and arms to give them an armature-like strength and shape. A thick, flattened piece of salt ceramic can serve as a substantial base upon which one or several modeled figures may be placed. This provides the child with a platform upon which the feet of his figure may be firmly and permanently planted.

Working on a small piece of thick cardboard or Masonite in order to make it easy to transport the finished piece to a safe place to dry, the children may use a wooden Popsicle stick for modeling and texturing the salt ceramic and for pressing the various parts together. The children may form their figures with several different colors of salt ceramic, or they may choose to work with white only and paint the finished pieces with watercolor or tempera when they are dry. Bits of salt ceramic rolled in balls, thin ropes, and other decorative shapes must be lightly moistened to make them stick to another piece. If these added pieces fall off in drying, they may be reattached easily with white glue when the figure has dried.

People: Spoons, Clothespins, Corncobs, and Salt Boxes

The human form is one of the very first concepts that the child embodies in his art. Whether he draws "Mother" with a circle and lines for legs, whether he cuts out the body parts from colored paper or models it in clay, he is constantly searching for, refining, and enriching his depiction of the human form. On his own, the young craftsman will often pick up found objects such as corks, acorns, and short sticks, and add bits of scrap materials to make small figures which he will keep and treasure for a long time.

In a like manner, folk art figures have their sources in the hearts and day-to-day experiences of the people who make them. These figures, too, are made from indigenous materials—corn husks and clay in Mexico, wood and straw in Denmark, cork in Portugal, silk in China, and ivory and soapstone in Alaska.

A. Corncobs serve as cores for highly individualized figures. Salt ceramic bases enable them to stand alone.

B. Small children need only a few scrap materials to convert wooden spoons and clothespins into funny characters.

C. Clothespin people may adorn bulletin board displays or perform a human role in a diorama. Young children made these to depict characters in a favorite story.

D. No two chunky salt-box people are ever alike when children release their imaginations with collected and discarded materials.

A. Tree ornaments made from dressed-up clothespins are hung by a tiny staple in the top.

B. A short piece of dowel, a spool, and a cork were the cores for these put-together people.

C. Children enjoy seeing folk art figures from many countries and will feel a common bond with the people who made them. This Mexican pair was made from common scrub brushes.

D. Mexican corn husk figures depict characteristic male and female forms.

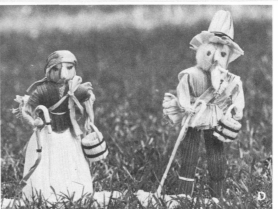

Children can make imaginative and inventive forms and derive much satisfaction from shaping, cutting, and attaching features and clothing to one of the following basic cores:

1. Wooden spoons and clothespins can both be made into tiny doll-like figures by sticking the bottom or feet in a wad of salt ceramic to make them stand upright. Very small children can glue on bits of fabric and yarn for clothing and hair and use a felt pen or small pieces of paper for the eyes and mouth.

2. Dried corncobs also can be stuck into a piece of salt ceramic and fashioned into delightful figures by adding odds and ends of scrap materials. The cobs may be prepared for use—after the kernals have been eaten—by placing them in a warm oven for several hours.

3. Salt boxes filled with sand make fine bookends. They can be wrapped with colored paper, felt, or fabric. Then all sorts of braid, yarn, paper, thumbtacks, buttons, and such, can be attached for the features and clothing. Long strips of felt or other material may be stapled or glued on for dangly arms and legs.

Edible Art

Bread dough, candy clay, and cookie dough as modeling materials will probably find their happiest and most appropriate uses at holiday times. Halloween, Thanksgiving, first day of winter, Christmas, Valentine's Day, first day of spring, and Easter, when made meaningful through cognitive and affective domains, are all occasions when children need to have outlets to express creatively the gaiety of the season. (The section on Celebrations lists a number of exemplary topics which would be suitable for use in stimulating the children's thinking when they begin modeling with any of these three food forms.)

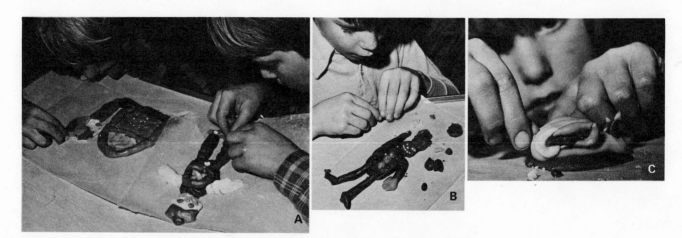

A, B, and C. Candy clay requires no cooking. It is colorful as well as delicious. Several colors of it can be modeled into symbolic representations on festive occasions and decorated with edible decors.

Dark and light cookie dough became a dancing Santa and an elegant reindeer. Beard, hair, and eyebrows were formed from threads of cookie dough that had been pushed through a garlic press.

Cookies and Bread, the Baker's Art by Ilse Johnson and Nika S. Hazelton is a magnificent pictorial collection of work done by both folk artists and contemporary artists from around the world. Children will enjoy looking through this book with the teacher to see what adult artists from many lands have done with a few basic ingredients to embellish and enrich the human experience.

Whichever edible art form is made by the children—whether the modeling material is colored, light, dark, spiced, or plain—bread, candy and cookies are all delightful adjuncts to festive occasions and allow the child inventive ways to say things about the world in which he lives—a very human part of which should be filled with fantasy, fact, and fun!

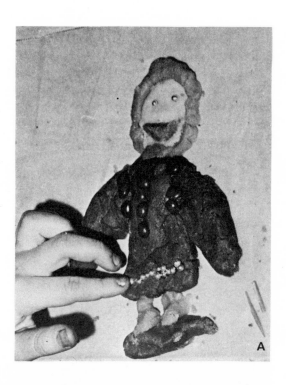

A. Colored cookie dough in the form of an angel has red and silver decors added before baking.

B and C. Bread dough is soft and pliable and is fun to form into skeletons, bats, cats, owls, and witches at Halloween. Any holiday would be an appropriate time to let the children make their own interpretations of characteristic symbols in bread dough. It bakes quickly to a golden crust.

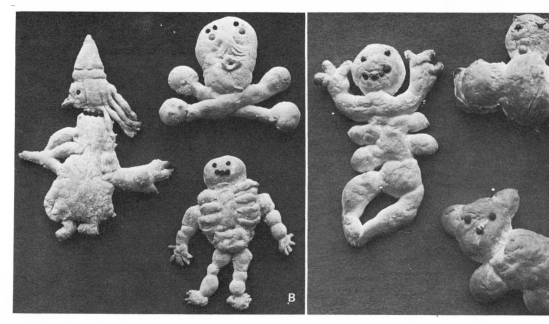

BREAD Bread made from various grains and shaped in an infinite variety of forms has long been a basic element in mankind's diet. Who knows what adult (or child) first thought of shaping decorative forms while kneading, squeezing, or playing with soft, pliable bread dough? Bread has often been a part of symbolic ritual, and many a baker with an artist's sense of three-dimensional form and design has used the unbaked dough to express aspects of the human spirit. A small child responds immediately when handed a small lump of soft bread dough. He senses its plasticity, and his hands respond to its tactile appeal.

Children can derive some understanding of one phase of Mexican culture through modeling bread-dough forms around Halloween time, since there exist parallels and common areas of both serious and humorous feelings at this time. Every year in Mexico, November 2 is celebrated as the Day of the Dead, and it is an occasion for the blending of the Christian All Souls' Day and a pre-Hispanic feast day. Many toys and different kinds of food are made in the shapes of skulls, skeletons, and masks and are sold in the markets. When families gather for a festive meal, they set up an altar with candles and flowers. A special bread called Pan de Muerto (Bread of the Dead) is offered in the belief that the souls of dead people will return and enjoy eating it. The cemeteries at this time are gathering places for families and friends to meet and decorate the graves.

The children should also know a bit of the history and folklore behind some of the symbols we in the United States associate with Halloween because they relate, to some extent, to Mexico's Day of the Dead. They will be interested in learning that long ago the Celtic Druids celebrated, on October 31, a rite that was called the Festival of Samas (who was lord of death). At that time, the souls of all evil-doers who had been condemned to inhabit the bodies of animals were gathered together, the black cat being particularly prominent. Later, Christianity displaced this Festival with a Vigil of All Saints which came to be known as Halloween, or hallowed evening. Through the years people have held this to be a time when evil spirits come out into the open. Witchcraft and returning souls are given equal prominence. The ever-popular jack-o'-lantern is Irish and Scottish in origin. One legend tells that it was named after a man named Jack who was condemned to roam the earth with his lantern after he was barred from heaven for his stinginess and from hell for playing too many practical jokes on the devil. In the 1600s, the Irish peasants decided October 31 would be a good date to celebrate the good works of St. Columba, a missionary who converted Scotland. So they made the rounds seeking donations to buy meat for a feast, prosperity being assured for generous donors and threats being made against stingy ones. Thus, trick-or-treating was born!

With this type of historical and cultural information as a background, the children should be ready to investigate with some understanding the possibilities inherent in bread dough as it relates to Halloween symbols. They may choose to model cats, skulls, bones, skeletons, mummies, jack-o'-lanterns, spiders, witches, broomsticks, pots of magic brew, ghosts, goblins, bats, and so on, from the soft dough. Bodies may be made in several separate parts and a tiny bit of water applied as "glue" if the child has used too much flour to keep his pieces of dough from sticking together. Children will enjoy using whole cloves and peppercorns for eyes, noses, and other small decorative details.

Finished forms should be lifted with a spatula from the child's piece of foil or waxed paper and placed on a baking sheet that has been lightly greased or sprayed with Pam—a vegetable spray-on coating available in grocery stores. The things the children make should be baked immediately, as the yeast in the dough starts rising quickly and will result in overly puffed forms if there is a delay.

Ready-mixed cartons of refrigerated roll dough or dry packaged mixes may be used as an expedient. The odor of the fresh bread baking either in the classroom oven or in the one in the school kitchen is truly memorable! If the school doesn't have such baking facilities, it is an easy matter to arrange with one or two mothers who live near the school to take the baking sheets home, pop them in preheated ovens, and return the baked forms to the children a short time later.

BREAD

1 cup of water
1 teaspoon of sugar
1 tablespoon or 1 package of yeast

Let these three ingredients stand until the yeast softens—two or three minutes. Then stir in one teaspoon of salt and one cup of flour and beat with a large spoon until the mixture is smooth. Then add one tablespoon of oil and one more cup of flour and stir. Turn onto a breadboard and add about one-half to one cup more of flour. Knead until very smooth and elastic. Test it by rolling it into a fat ball and pushing a finger in it. If the impression bounces back, it is about right. Divide this amount into about six portions, giving each child a few spoonfuls of flour to keep his fingers from sticking to the dough and to keep the dough from sticking to the foil or waxed paper.

For a shiny golden glaze, beat an egg with two teaspoons of water and use a pastry brush to coat each modeled form before placing it in the 400° oven. The baking time will vary depending upon the size and thickness of the modeled forms. Probably most of them will be done in fifteen to twenty-five minutes.

CANDY CLAY The happy art task of modeling and shaping with candy clay appeals not only to the child's sweet tooth, but enriches his form concept in that the nature of the material produces a result similar to that of drawing in three dimensions—the products will tend to be somewhat flat. It is inadvisable to try to make animals, people, or plants that stand upright. Paste food colors will dye the candy to bright and irresistible hues, and each child should have wads of several colors so that he may combine and relate the parts and surface decorations to his basic form. A few cinnamon candies, chocolate chips, and silver cake decorations will provide him with finishing design accents.

The children should work with clean hands on freshly scoured desks or table tops. Each item that they make should be formed on a graham cracker or on top of a frosted cupcake.

The recipe for candy clay may be mixed in the classroom by several of the students, or if very young children are using it, an adult or older child may mix it ahead of time and store it in plastic bags. Once mixed it is not sticky on the hands. A small amount goes a long way, and the final products are delicious!

CANDY CLAY RECIPE

⅓ cup of margarine
⅓ cup of light corn syrup
½ teaspoon of salt
1 teaspoon of vanilla
Food coloring

Blend all ingredients and then mix in one pound of powdered sugar. Knead till smooth. Add more powdered sugar if necessary to make a nonsticky, pliable clay.

COOKIES The making of cookies is closely related, from the plasticity stand-point and in range of motivational topics, to what is applicable for use with candy clay. While candy clay is ready to be admired and/or eaten as soon as it is modeled, the cookies require baking in an oven.

The cookies shown on pages 100-101 were rolled, shaped, and decorated by the children on small pieces of waxed paper which were later carefully placed on baking sheets. By using both a dark and light dough as well as some light dough that had been colored with food dyes, the children were able to provide contrast-ing elements for their cookies. By having several garlic presses handy, they could squeeze dough through them for stringy hair, tails, manes, beards, and grass. Cake decors, colored sugar, or any sort of edible nonmelting decorations could be added to the forms and symbols by the child before baking.

Aside from being eaten, cookies can be used for tree decorations, bulletin board displays, and gift-wrap ornaments. Cookies can be mounted on a felt or fabric-covered piece of cardboard and hung on the wall.

DARK COOKY RECIPE

⅛ cup of shortening or margarine | 2 teaspoons of soda
1 cup of packed light brown sugar | 1 teaspoon of salt
1½ cups of light molasses | ½ teaspoon of cinnamon
⅔ cup of water | ¼ teaspoon of nutmeg
6 cups of sifted flour | ¼ teaspoon of ginger

Mix shortening or margarine, sugar, and molasses. Add water and stir. Mix flour, soda, salt, and spices and beat gradually into the wet mixture. Add a little more flour if necessary to make a pliable nonsticky dough. Refrigerate for at least an hour. Bake on waxed paper at 350 degrees for ten to fifteen minutes depending upon thickness and size of cookies.

LIGHT COOKY RECIPE

⅔ cup of margarine | 4 teaspoons of milk
¾ cup of white sugar | 2 cups of sifted flour
1 teaspoon of vanilla | 1½ teaspoons of baking powder
1 egg | ¼ teaspoon of salt

Cream margarine, sugar, and vanilla. Add egg. Beat until light and fluffy. Stir in milk. Sift together flour, baking powder, and salt and blend into creamed mixture. Chill one hour. Divide and knead in paste food colors. Bake on waxed paper at 350 degrees for ten to fifteen minutes depending upon thickness and size of cookies. When cookies have cooled slightly, remove from the baking sheet and cool on wire racks.

Wadded Paper Things

A stack of newspapers, a roll of masking tape, some corks, cutup dowel sticks, cardboard tubes, and some wheat paste are all that is needed to start young imaginations working. The lumpy bumpy creatures shown on page 105 were all brought into being by six-year-old children. The materials are common and inex-pensive, and the process provides channels for a wide range of responses by each individual child.

To make a mammal, bird, fish, or reptile, a large sheet of newspaper is wadded up by the child into an oblong, round, or egg shape. A few strips of masking tape should then be used to hold the wad firmly together. Corks, a short piece of wood,

A. Children use masking tape to fasten corks and cardboard tubes to wadded-up news-papers before covering the en-tire form with newspaper strips that have been soaked in a wheat-paste mixture.

B. Tempera is brushed on the wadded-up animal after it is dry. Pie pans holding paint do not tip over easily and are practical for children to use in experimenting with color-mix-ing.

C. Contrasting colors are add-ed for decoration when the base coat of paint is dry.

D. Q-tips dipped in paint are handy for children to use when making small dots.

E. Yarn, pipe cleaners, felt, feathers, and all sorts of scrap materials may be glued on the animal for final embellish-ment.

F. By cutting cardboard tubes in half lengthwise, a six-year-old girl fashioned tall ears for her wadded-up rabbit.

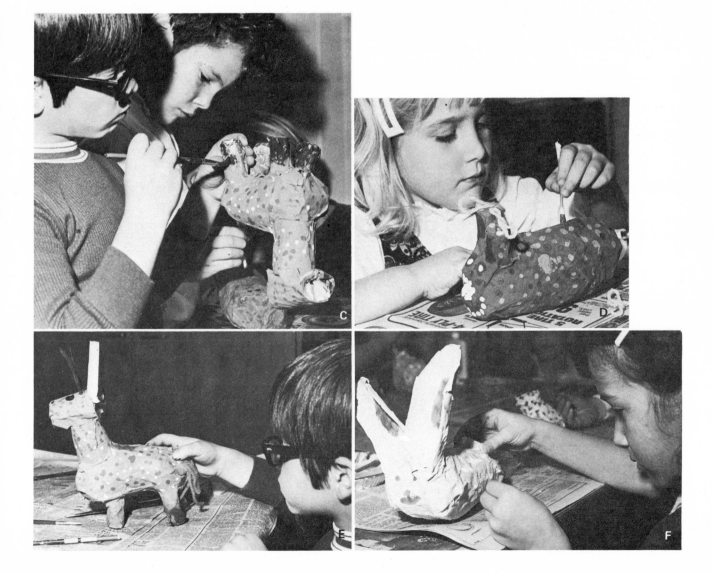

and cutup pieces of cardboard tubes are taped in place for legs, ears, tails, heads, and horns. After all the parts are secured with more masking tape, the whole form is covered with newspaper or paper towel strips and paste.

Wheat paste should be mixed with water to a smooth, thick consistency. Several children can share a pie pan of paste while they are dipping short strips of newspaper in it. The strips may be cut quickly beforehand on the paper cutter (by the teacher) into approximately one-inch widths. The short strips should be thoroughly soaked and covered on both sides with the paste. The excess paste should then be wiped off before applying the strip to cover the animal. A number of strips will be needed to cover up the wadded form completely. The children should be encouraged to smooth out the strips with their fingers until the animal is neat and even on the surface. It is then left to dry thoroughly, probably for several days.

While the animal is drying, the children will enjoy thinking about how they are going to decorate their new friends—what colors of paint they will use and what things they may choose to glue onto them, such as cotton, wool, or feathers. Then, using tempera that is smooth and opaque enough to cover up the print on the paper, the children should paint their animals with a basic color. After this coat is dry, they may add the features and decorative stripes, dots, and so on, with small stiff brushes and cotton-tipped swabs. They may glue on a rope tail, button or thumbtack eyes, a yarn mane or hair, felt or sponge ears. If a shiny glaze is desired, the entire creature may be coated with a clear acrylic spray when it is dry.

Boxy Conveyances

Instead of using wadded-up newspapers as a base, small boxes and cardboard tubes may be combined and fastened together with masking tape. These forms adapt themselves well to becoming cars, fire engines, streetcars, trains, trucks, planes, boats, spaceships, submarines, and the like. Cardboard tubes and thick dowel sticks may be cut up for wheels and smokestacks. Short sticks may be taped on for sailboat masts, propellers, and airplane wings.

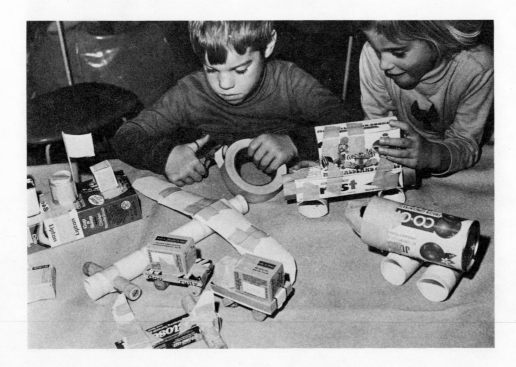

A few small boxes, cardboard containers, and tubes are stacked, combined, and taped together by the children to become cars, gliders, boats, and moon ships.

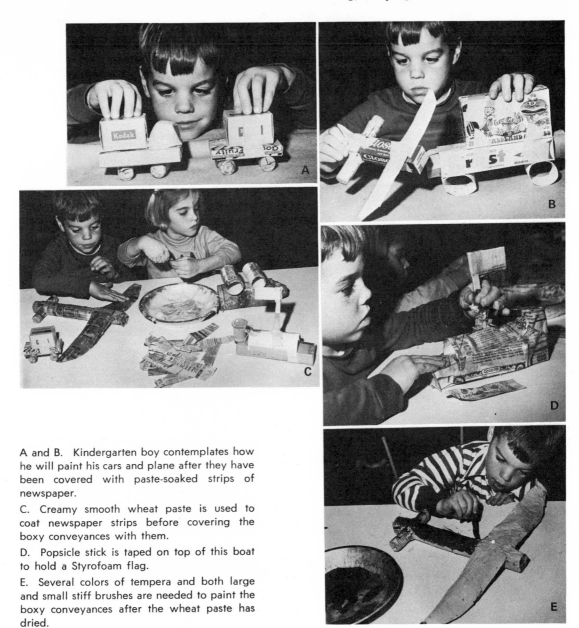

A and B. Kindergarten boy contemplates how he will paint his cars and plane after they have been covered with paste-soaked strips of newspaper.

C. Creamy smooth wheat paste is used to coat newspaper strips before covering the boxy conveyances with them.

D. Popsicle stick is taped on top of this boat to hold a Styrofoam flag.

E. Several colors of tempera and both large and small stiff brushes are needed to paint the boxy conveyances after the wheat paste has dried.

When all the parts are securely taped in place, the entire form is covered with a layer of newspaper or paper towel strips that have been dipped in wheat paste. This serves both to hold all the parts together and to provide a smooth surface for the child to paint upon.

When the vehicle dries, the child is ready to paint it with tempera. After a base coat of color has been applied and has dried, he will want to add windows, doors, wheels, and contrasting trim of all sorts, using small stiff-bristled brushes. Boats will need portholes, cabins, and flags. Planes may have emblems and numbers painted or glued on. Photographs of faces clipped from magazines can be glued onto the windows.

Small boxlike conveyances appeal to young children because their forms are familiar and their size is such that children can cope with them. The concept is three-dimensional design, yet two-dimensional decorative elements also are involved.

Wood Scraps and Glue

If spread on the floor where small hands can poke, pick up, and handle them, wood scraps in a multitude of shapes and sizes will cause the young child to conjure and imagine, to relate and design, and to think in terms of height, width, depth, and weight. What can he make with them by using only glue and tape as adhesives? How can he decorate and finish his work?

Construction projects of this nature offer unending tasks in the world of three dimensions for both boys and girls. Through handling and becoming sensitive to form, the children will find in the wood scraps shapes that may suggest to them the body of a bird, the basic shape for a truck, boat, or plane, the legs or arms for a figure, the trunks for a grove of trees, or the parts for a building or abstract composition.

Cabinet shops and construction companies discard odds and ends of wood scraps. If these pieces are too large for the child to handle easily, they should be cut into smaller odd shapes, triangles, squares, and rectangles. A few flat boards and Masonite sheets will be helpful to use as bases upon which some of the children may glue their constructions.

A. Children should see, feel, and study wood shapes carefully as they make selections for their glued-together constructions.

B. White glue dries quickly if only a small amount is used. During the work process, children learn to relate, balance, differentiate, and compare shapes and sizes of wood scraps.

C. A piece of masking tape is helpful in holding several wood scraps in place until the glue dries.

A. Bird assembled by a kindergarten child was embellished with paint and feathers. Structure is glued to Masonite base.

B. Boat by a kindergarten child had basic form and structure.

In adhering wood pieces, it is advisable to inform the children that a small amount of glue will dry and hold two wood pieces together rather quickly, whereas a large puddle of glue will require a long time to dry. Masking tape will hold them in position while they are drying. When the objects are completed and the glue is dry, the children may wish to paint them and add various kinds of decorations. Bits of fabric, feathers, pipe cleaners, and photographs of faces clipped from magazines may be cut out and glued on the construction.

Bas-reliefs may be made with wood scraps, too. For this art task, a flat piece of Masonite or thin plywood is used for the background, and the wood pieces are glued down flat in an arrangement. The children could be presented with the problem of designing a "Funny Machine" or a "Mechanical Animal." Thick yarn might be used along with the wood pieces if a linear element is needed, and the finished work may be painted with watercolors, tempera, or sprayed all one color.

Play Constructions

The world of play is three-dimensional, and children move actively through and around in space. They dig holes in the ground, pound away at a tree house, pin blankets together for tents, and push and pull cardboard boxes around, imagining them to be houses, tunnels, and trains. The creative child loves to put together his own private environment for play activities.

Capitalizing upon the children's penchant for organizing space, a few adults can foster a highly stimulating and unforgettable episode for young children. Using several large cardboard cartons such as those salvaged from shipping refrigerators, mattresses, and television sets, the children can design all sorts of structures. They can decide with the adults what they want to make and how the adults can help. The adults can, in the making of a "house," for example, provide a helpful hand in cutting out doors and windows with the saber saw, and in joining roofs and things with heavy tape and wire. The teacher should ask the children how they want to cut or change the shapes of the boxes; how they think they might best be fastened together; and how they want to paint and decorate the insides and outsides of the finished play structures.

Several boxes may be lined up and tied together for a long train, with the children painting one for an engine and others for passenger cars, freight cars, and caboose. Several children may share one large box, working together to convert it into a submarine, a steamship, or tugboat complete with portholes, cabins, and

flag. Other boxes may become buses, trucks, or racing cars. An upright box can quickly become a spaceship with a small window added in front and all sorts of knobs and controls placed on an interior panel. Boxes can be igloos, forts, Navajo hogans, Indian pueblos, or African huts.

Thick cardboard tubes from a carpet store can be cut into shorter lengths for chimneys, tunnels, peepholes, periscopes, or any number of things. Cutout windows can be covered with see-through cloth or colored cellophane. All sorts of scrap materials can be collected by the children and glued on the inside and outside of their crawl-in play structures.

Whatever environment is put together depends only upon the dictates of the children's imaginations. All that is needed are boxes, paint, scrap materials, and an assist from a few adults.

A. A child can be both pilot and airplane and move through space in a contraption made from taped-together cardboard.

B. Crawl-through entrance for play structure is being lined with a variety of soft-textured materials.

C. Entry box is wired to peaked house. Plastic pillows are filled with air. Slits in top of walls hold roof in place.

D. Children freely design the exterior walls of their playhouse. Simple flap door provides alternate exit or entry. Many-eyed peephole on left wall of house has been covered with several colors of cellophane.

E. Tape and wire hold this play structure together. Decoration evolves according to individual whimsy and imagination.

F. Several display cases from a grocer's trash bin provided an impetus for this robotlike structure. Cardboard tubes and boxes were glued in place for design accents.

G. Totem poles can be decorated with paint and all sorts of glued-on materials. The one shown here was made from large ice cream cartons and cardboard boxes with several children planning and designing each section to represent such concepts as the weather, the spirit of happiness or anger, and animals and birds. The finished sections were stacked on a long pole so they wouldn't fall over.

H. Head covering is made from an ice cream carton and decorated with bumpy antennae, fanciful braided hair, and projecting lips, ears, and eyes.

Puppet People 11

Puppets are three-dimensional small-scale symbols of people and animals. They are directly controlled by the child's own hand both when he designs them and later when he makes them talk and move as animated creatures. They may even be extensions of his own personality, disguised somewhat in paper, paint, and cloth.[1]

The puppet's origin is somewhat of a mystery. Some people believe that the Egyptians invented puppets, yet some of the first were made along the Ganges River in India. Oriental countries have a long tradition of puppetry, and the ancient Greeks even had puppet theaters. Roman puppet shows were held in homes and public places and traveled as road shows. Italy is well known for its puppetry, and in the Middle Ages Italian puppeteers took their portable theaters to France, Spain, Germany, and England. When young children make puppets they are not only enjoying a playful art activity, but are joining in a long historical line of make-believe, laughter, tears, and high adventure.

Contrived and assembled stages for puppet and marionette shows can be made from corrugated cardboard or plywood. They should be sturdy and large enough to accommodate several children at one time. Youngsters enjoy decorating them and making backdrops. A table turned on its side may be used as a makeshift puppet stage, also.

1. For sources of additional information on puppet making see Bibliography, p. 169.

Paper Puppets: A Four-Way Task

The young child delights in playing with puppets, and when he can make one quickly and easily to suit his own fancy, his pleasure is doubly enhanced. The four types of paper puppets delineated here are functional, attractive, and easy to assemble in a number of ways.

PAPER PLATE PUPPETS These puppets are quite versatile in that they can double as face coverings by cutting eyeholes at the proper places. Paper plates are inexpensive and come in white and a variety of colors. A short, flat stick of wood is stapled and glued to the back side of the plate, and the child is ready to start. Two plates may be used for a two-faced puppet by attaching the stick between the plates. If the group has just enjoyed a favorite fairy tale, the children may wish to create characters to act it out, or they may make a puppet of their own choice, either human or animal in form. A tableful of interesting supplies and scrap materials is a necessity. Such things might include yarn, feathers, buttons, stick-on dots, tape, colored paper, egg carton bumps, paint, cloth, and corrugated paper.

The next three puppet forms are all made by folding colored construction paper in a basic shape and directing the child to add features and clothing in any manner he chooses.

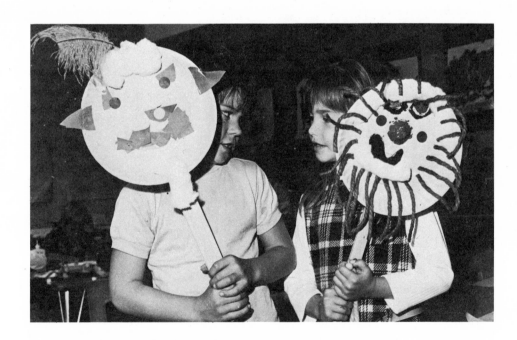

Paper plate faces on sticks can be puppets or face coverings.

FOLD-OVER PUPPET This puppet form is made by folding a piece of nine-by-twelve-inch colored construction paper vertically and stapling the top and open side. The top is folded over about three or four inches, and the child's hand is inserted in the open end of the tube. The child then uses cut paper, yarn, felt pens, or whatever he chooses to create the face and body of his puppet. He should remember to add some hair, ears, or whatever decorative details he may wish, to the back side also.

M-FOLD PUPPET This type of puppet is also made from a folded piece of nine-by-twelve-inch colored paper. This sheet is folded vertically and the open side stapled. Then it is folded in half and the two ends folded back again in an

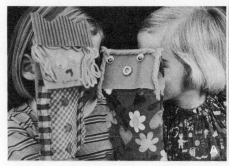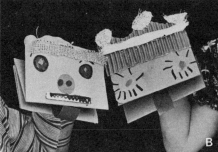

A. Heads bob up and down on fold-over puppets.

B. **M**-fold puppets offer many channels for the resourceful use of scrap materials.

C. Moving, dangling, and projecting parts aid these puppets in being viewed and manipulated.

M-shape. The fingers and thumb are then inserted in the pockets in the back side, and the puppet's mouth opens and closes as the hand moves. Colored-paper eyes, teeth, ears, whiskers, tongue, and so on, are glued and taped and stapled in place.

COOTIE-CATCHER PUPPET To make this puppet, the child starts with a nine- or twelve-inch square of paper. This is folded diagonally twice to find the center and then each corner is folded to the center. The entire piece is then turned over and the corners on the back side folded to the center point. The piece is then folded in half from both directions. By inserting his fingers in the back openings, the child opens and closes the puppet's mouth. The talking mouth may be stapled together to keep it from splitting as the child opens and closes it. Eyes, ears, eyelashes, tongue, teeth, and beards may be attached.

These four puppet forms involve skills in folding, stapling, cutting, gluing, attaching, and overall designing. The puppets are completed quickly and have a very low frustration point for the young child. In a few minutes he is ready to move into the world of fantasy and relate to his new talking friend. The techniques may be repeated often, with every child making a different form of puppet each time.

Stuffed Paper-Bag Puppets

Stuffing a small paper bag with a wad of newspaper and turning it into a delightful puppet by using bits of discarded materials and paint gives the young child a new friend to play with and talk to, and rewards him with a good feeling of personal accomplishment as well. A scrap box filled with all sorts of yarn, fabric, felt, feathers, pipe cleaners, buttons, and such, will prove to be an invaluable aid in generating ideas and approaches in design. Paint, brushes, tape, glue, and staplers should be accessible.

Number-one-size paper bags are available at hardware and variety stores. Being rather small they are easier for small hands to handle than larger bags. First, wad a piece of newspaper around the end of a short wooden stick and wrap pieces of masking tape around the wad in such a way as to hold it firmly in place on the stick. This wad is then inserted into a paper bag, and a piece of masking tape is wound around the base of the bag at the puppet's neck.

Before the children begin to work they should be directed to think in detail about the differences in facial features and the great variety of forms that they may

imagine and create to represent eyes, eyebrows, lashes, noses, mouths, teeth, ears, beards, and such. Hair, hats, crowns, horns, simple clothing, and arms may be cut from colored paper, yarn, and scrap materials. A piece of fabric, tissue, or crepe paper may be gathered up and taped around the stick at the base of the bag to serve as a garment. Arms and legs may be attached with a stapler. Egg carton bumps, fringed paper, and stick-on dots will help the child think in terms of exaggerating and projecting the features and making use of decorative details. Adding things that move, bounce, sparkle, and shine will aid in making the puppet visible from a distance.

The children will enjoy making their puppets talk and move about while performing in an impromptu show, whether the story line they use is taken from a popular story, nursery rhyme, or is one of their own invention.

A. Kindergarten children learn to handle glue, scissors, and all sorts of scrap materials when they make stuffed-bag puppets.

B. Simple materials make for a success-oriented art task, and thick yarn, stick-on dots, and Styrofoam trays are easy for young hands to handle.

C. Paper bowl hat covers this puppet's yarn-covered head.

D. Masking tape wrapped around a scrap of fabric at the neck serves to hold the puppet's garment in place.

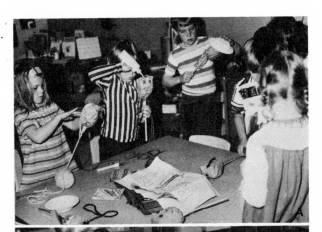

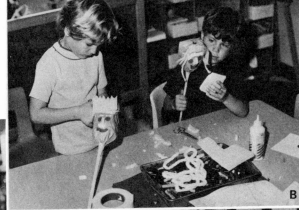

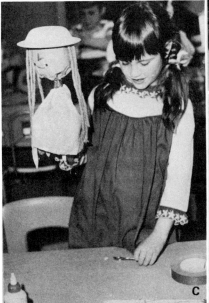

Finger Puppets

Tiniest of all, finger puppets are particularly appealing to the very young child. They are charming and adaptable to all sorts of play activities.

The two materials that work best for these small modeled puppet heads are instant papier-mâché and salt ceramic. Instant papier-mâché comes in pound bags and is a dry, powdery substance that must be mixed with water and kneaded to a pliable consistency.

The child takes a small wad of either of these doughlike materials and sticks his finger inside it to create a hole. This opening enables the child to hold the completed puppet on his finger, and it should be made a little larger than the child's finger actually is, since the cloth garment will be glued inside it and enough space must be left for the child's finger.

The child should model a simple face, pinching out a nose, ears, chin, and such, and adding tiny lumps for other features. He may use a pencil or small tool to impress and imprint details. After several days' drying time, the child paints the head with tempera, giving the entire outside of the head a base coat of one color which is left to dry before painting on top of it and adding features and decorations. Colored salt ceramic requires no paint. Yarn, felt, cotton, wool, or other materials may be glued on for hair, ears, hats, beards, and the like.

The·garment is made from a small circle of cloth upon which the child may draw designs with felt pens and glue on rickrack, buttons, pom-poms, beads, and ribbons.

When the garment and head are both complete, a bit of glue should be dropped in the opening of the puppet's head and the center of the garment poked into it. After the glue is dry, the child may insert his finger into the puppet's head.

A. Ball of instant papier-mâché is formed over the child's finger into a tiny puppet head. Chin, nose, and eyebrows project in an exaggerated manner.

B. Feather was imbedded in salt ceramic bird's head when it was being modeled. Paint is brushed over entire head after it is hardened.

C. Yarn was glued on this painted head to complete the finger-puppet's decoration.

D. Circle of cloth is poked up inside the puppet's head to cover the child's hand.

E. The smallness of finger puppets appeals to children, and they enjoy seeing those made by other people. These woven puppets were made in Ecuador.

Tongue-depressor Puppets

Either baker's dough or salt ceramic is suitable for children to use in forming small heads and attaching them to tongue depressors. If salt ceramic is used, several colors are needed so that the child can create facial features of contrasting colors. If baker's dough is used, the head on the stick must be baked in a 350-degree oven until it is thoroughly hard and lightly browned. If baker's dough is used, it is important that the finished pieces be covered with plastic wrap until they are baked, as the salt tends to dry rapidly, making cracks and leaving a rather unattractive surface.

These puppets, being small, are particularly suitable for the very young children to make. They may add peppercorns and cloves or bits of macaroni for eyes and teeth. Hair, hats, and ears may be attached with a bit of glue when the heads are either dry or baked, and scraps of fabric may be attached to the tongue depressor at the neck by using a short length of masking tape or plastic tape. The availability of a good assortment of scrap materials makes for unique creations. A stapler will come in handy for attaching decorative details to the garment.

Tongue-depressor puppets can be completed quickly so the children will enjoy making several of them. The kindergarten children who created the examples shown below made entire families.

A. Kindergartner adds a flag to the pipe-cleaner arm of her tongue-depressor puppet.

B, C, and D. Tongue-depressor puppets are as different as the five-year-old children who created them.

E. Baker's dough gives crusty wrinkled faces to these two witches. Children added clothing and wool hair after the puppets were baked in an oven.

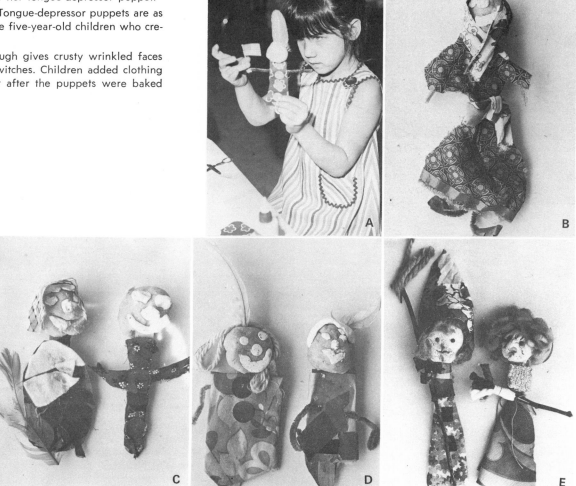

Salt Ceramic on a Stick

Stick puppets with heads modeled of salt ceramic offer young children a wide design latitude and the opportunity of depicting facial features in three dimensions. Each child will need a small lump of salt ceramic for the basic head shape and several small pieces of other colors of the modeling material for details. For instance, the basic head shape might be green, and the child could add a yellow nose, red eyes, and a white beard. While salt ceramic may be painted when it is dry, the use of brightly colored dough eliminates the need for this step. One recipe of the salt ceramic mixture should make enough modeling material for three to four children.

The teacher should demonstrate how to place the salt ceramic on top of the nine- or ten-inch stick of wood. The dough should be kneaded for a few minutes before using it to make it pliable and plastic. The children can pinch it, roll it in coils or into small balls, and use pencils and small gadgets to imprint textures.

Feathers, toothpicks, pipe cleaners, macaroni, buttons, nails, and so on, may be placed in the dough while it is pliable, and rope, yarn, fabric and such may be glued to the dried piece. Several days are required for the heads to dry thoroughly.

A square of fabric may be gathered or pleated and attached to the neck of the puppet with masking tape or colored plastic tape. Braid, lace, rickrack, felt scraps, or ruffles may be attached to the garment with glue or needle and thread.

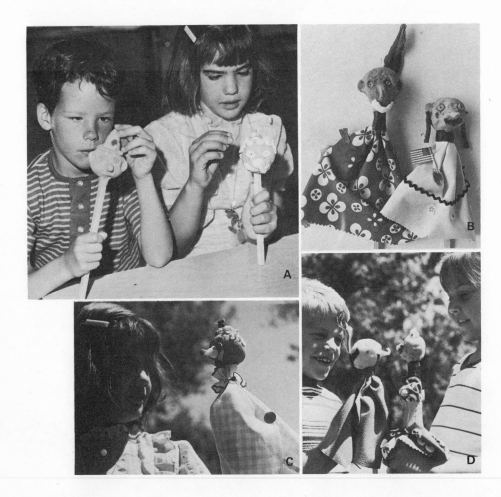

A. Salt ceramic heads are modeled on top of a short stick.

B. Tape is used for attaching wrap-around garments on stick puppets.

C. Contrasting colors of salt ceramic were added by this six-year-old girl to accent the features on her puppet's face.

D. Projecting features make for interesting profiles on these two puppets.

12 Fabric and Fiber

Working with fabric and fiber is a simple direct technique that encourages spontaneity and fosters skills in cutting, gluing, stitching, and designing—both in picture-making activities and in craft objects. Fabric is an exciting tactile material for young children to see and handle. It comes in an endless variety of colors, prints, and textures. It lends itself well to both individual and group projects.

Fabric and felt should be collected and stored in a number of labeled cardboard boxes, cartons, or plastic pans. Pieces may be sorted by color to make it easier for the children to find the kind of scrap they need. Having an iron available to press the fabric before the children begin cutting will make it easier for them to work. In like manner, yarn should be wound loosely into balls from the skeins and kept sorted by color in boxes or cartons.

Good sharp scissors are necessary when working with fabric and felt if children are to be expected to learn to cut with a degree of skill. The ordinary scissors for paper that are usually found in classrooms are inadequate if the child is to have a success-oriented experience.

After the child has spent some time in cutting fabric for the mere sake of cutting, he should begin to demonstrate proficiency in the following ways:

1. He should be able to cut freely into the fabric without using any preliminary paper patterns or drawing his design first.
2. He should develop a feeling for bold masses as opposed to linear concepts as developed and expressed in drawing activities. He should be able to use large shapes to fill the background areas and smaller pieces for interesting details.
3. He should discover and make judgments as to which colors look pleasing close together, and which ones contrast as to light and dark, pattern and plain, rough and smooth, dull and shiny.
4. He should be able to pin his cutout pieces in place and fasten them down after he has made a critical evaluation by moving the shapes around until he has found a pleasing arrangement.
5. He should be aware of using dark background fabric to contrast with light-colored shapes and light-colored background fabric for dark cutout shapes.
6. He should be able to make use of glue or fabric adhesives and should later learn a few simple stitches such as the running stitch, French knot, chain-stitching, and couching to hold his picture together and add decorative embellishments.

In becoming acquainted with fibers, the children should begin to develop a basic knowledge, vocabulary, and understanding of the process of weaving and be able to warp and weave—make simple objects using several different elementary techniques, looms, and yarn.

Banners

Banners are beautiful, bold, and direct, and their production makes for exciting encounters with art for young children. When a group of boys and girls work together on a banner, a large space in which they may organize their visual and emotional experiences is available for them to explore. Each child can actively participate in designing, cutting, pinning, and attaching the parts to the background either with a fabric adhesive or by sewing them with simple running stitches.

Today, banners and flags enjoy a special role in our lives. They are elegant and exciting, adding richness and meaning to many an occasion. Many professional artists are busy designing both of these exciting art forms, and one finds them in gallery exhibits, museums, churches, and at fairs.

When young children make banners, they have a part in carrying on a fine tradition. Great use of banners and wall-hangings was made during the Middle Ages, originating in Rome during the period of military conquest. They were carried into battle to differentiate between military groups. Heraldic flags helped identify a friend or enemy since the metal helmet and armor made recognition impossible. Standards were the personal flags of rulers, and small streamers and long ribbonlike flags were carried by troops. During the Crusades both flags and banners were used by nobles and kings. Standards were used at even an earlier time in Egypt and the Near East. Merchant and craft guilds in the Middle Ages had banners to identify themselves, and of course through the ages countries have used flags.

Banners and flags are in themselves a celebration in design, shape, color, and texture. They may be highly decorative with a unifying theme; they may be a culmination of a group's thoughts and feelings about an idea or an area of life; they may have a message to convey, an emotion to express, a story to tell. Whatever it is the group decides to achieve, a banner should present its message or thought in a clear, effective display that is easily viewed from a distance. The project should utilize shapes, colors, and textures that will contrast and reach out to communicate and delight all who see the finished product. Words and phrases may be used to clarify and enrich the general theme.

The very young child can have a part in designing and cutting the fabric for a banner if good scissors and one of the instant fabric adhesives are used. As a substitute for these adhesives, regular white glue may be used, but it should be noted that it dries stiff and leaves hard spots wherever it is applied. Older children are able to pin their designs together and use a simple running stitch to hold the pieces in place.

Liquid Cloth and Sobo are two fabric adhesives that are suitable for the instant appliqué technique. The iron-on adhesive fabrics available in yardage shops are satisfactory to use also, but their cost makes them almost prohibitive for large projects. Then, too, they are only available in a limited number of colors.

Banners may be made from all sorts of fabrics—in solid colors and in bright stripes and prints. Buttons, beads, lace, rickrack, braid, and tiny mirrors may

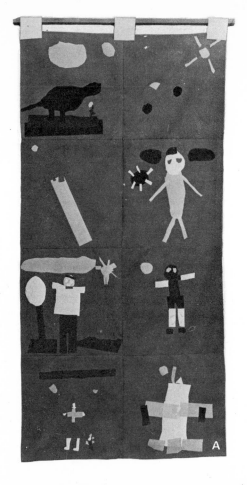

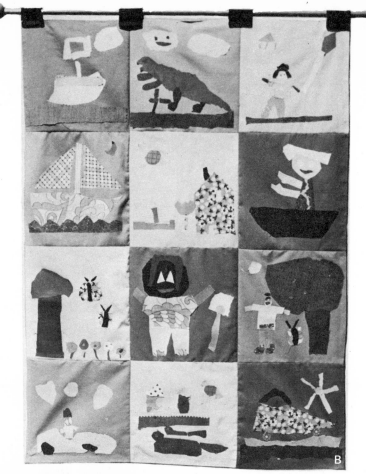

A. Red and purple squares in checkerboard arrangement make up this banner by six-year-old children. Iron-on fabric was used for instant appliqué technique.

B. Appliqué banner made by first-grade children is made of red, yellow, and orange squares. Cutouts were adhered quickly with fabric adhesive.

C. Sixteen third-grade children combined efforts for this large, lined, patchwork banner. Children attached their cut-out shapes with running stitches. Each square represents a favorite book.

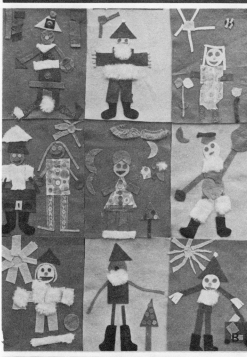

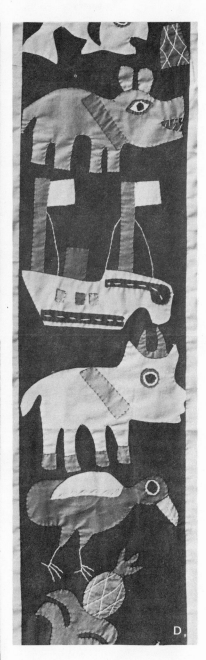

A. Small individual banner made by a five-year-old child is hung by felt tabs from a short dowel stick.

B. Kindergartners made Santa and His Helpers banner using felt on felt and a bit of fake fur for textural emphasis. Banner was later disassembled in order for each child to retain his panel.

C. Preschoolers delight in playing with gay flags they made with felt, fabric scraps, and short sticks of wood.

D. Colorful appliqué banners from Africa are living history books in that they tell of heroic deeds of a powerful dynasty of eleven kings who ruled for many years in what is now Dahomey. They appeal to the eye and heart of the viewer through their simplicity and boldness.

be added to the designs. Yarn is sometimes used along with the fabric for linear details and for writing words. Both sides of felt banners may be used for designs.

Patchwork banners such as the ones shown on pages 121-22 are highly recommended for group projects. Each child makes one square for the all-over configuration, and then all the squares are stitched together or adhered to a large felt or fabric backing. If regular fabric is used, it may be hemmed or bound with tape. No hemming is necessary when felt is used. These banners may hang in the room or school office for a number of weeks and then be dismantled in such a way that each child can retain his individual section.

Young children may need to have someone who will demonstrate a few techniques for using scissors as they begin cutting fabric; e.g., how to hold the scissors; how to fold the fabric to cut out a small opening for an eye or some such small spot; how to fold the fabric to cut several objects of the same shape at once; how to snip fringe; and how to fold and cut a symmetrical shape. They should be encouraged to create figures in parts—by cutting the body, legs, arms, hair, hands, and boots out of separate pieces of fabric. It is always better to have the children cut freely into the material rather than to draw their designs on it with a pencil. As a cut-paper work, spontaneous cutting results in freer shapes that are more natural and uncramped than those that are drawn with a pencil.

After cutting their designs, the children should look at their work and decide on any changes or additions that might be made, any colors or shapes that might be repeated to give unity and interest and accent to the whole design, and any objects that might be modified, rearranged, or enriched with more details.

The top of the banner may be attached to a wooden stick or a metal rod by adding short straps of felt or fabric or by folding over several inches of the top and stitching it in place, leaving a narrow opening for the rod to slip through. Wooden balls or screw-on finials may add adornment to the ends of this supporting pole.

The bottom of the banner may have lead weights attached to make it hang evenly. Lightweight banners may need lining, although this is seldom necessary. Some banners have a rod or stick inserted through a hem in the bottom. A felt banner may be cut in a scallop or other decorative manner with fringe and tassels, or ribbons attached.

Banners may hang flat against the wall, from a ceiling or beam, or be placed in a freestanding holder on the floor. Swinging wall brackets will hold banners out from the wall, and of course banners may be carried in a procession or parade.

Older children will enjoy the challenge of designing a room flag or a school flag containing perhaps the initials or name of their school, their class motto, their team emblem, or some other simple motif. Heavy canvas is a good backing to use for outdoor flags, and the edges should be hemmed before the flag is placed on a pole or holder.

The occasions for making banners and flags are virtually endless. They may be created to welcome parents and friends to an Open House, to say "Thank you" to the PTA for some project they have given to the school, to celebrate a special event or a change of season, to make a school picnic or musical performance more festive, or even to wave in the wind at a school athletic event.

Banners and flags are colorful, graceful, charming, and a joy to have in and around school. Have the children make them and rotate them. Let the banners be a culmination point—tying together new experiences and concepts. Employ banners to motivate and point the way to new learnings. With the instant appliqué technique, banners indeed have become a valuable task for young children. However they function, banners and flags delight the eye with an elegant salute!

Stuffed Stuff

Drawing with felt pens or fabric paint takes on an added dimension when fabric is substituted for paper and the figures are stitched to a fabric backing, turned inside out, and stuffed. The result is a type of soft sculpture. It may be an individual production or an assembled group mural. When this sort of three-dimensional mural is disassembled for the child to keep and take home, the individual parts are complete, and a satisfying feeling of accomplishment is achieved by each child.

Bleached muslin is inexpensive and provides a good base upon which the children may draw. If felt pens are used, the children should have an old magazine or several thicknesses of newspapers to put under the fabric in order to protect the table or desk from ink stains. With each child drawing one or two elements for the total concept, the entire class feels the pride of group effort, yet individual expression is paramount within the whole configuration.

After the children complete their drawings, the figures are placed on another piece of fabric and the two pieces stitched together on the sewing machine with a few inches left open on one edge. It is easier to sew the two pieces together on the right side and then to trim the raw edges with a pinking shears than it is to sew them on the wrong side and have to turn them inside out. The forms will look neater if they are pressed before being stuffed. Polyester, available in pound bags, old nylon stockings, fine sawdust, or plastic bags are suitable stuffing materials. Small children can be taught a simple running stitch to use in sewing up the openings or a sewing machine may be used.

It is advisable to have the children work with a fairly small piece of fabric. In the case of the caterpillar on page 125, each child was given a circle approximately seven inches in diameter, except for one child who received a ten-inch circle with which he designed the head. The children decided to add pointed pieces of felt to each segment. Pipe cleaners and feathers were added to the face for antennae.

The first-grade children who drew themselves for the Balloon Parade had their choice of several sizes of fabric pieces. They were urged to use the entire height of the material for their figures. The stuffed figures were assembled on colored paper, and then a bit of bright yarn with a name balloon was attached to the hand of each figure.

The Butterfly Tree was done by a group of six-year-old children using felt pens. The variety in the all-over designs and colors used is seen in each child's unique shapes and decorative details. The children perched their stuffed butterflies in a colorful swarm on a many-branched tree.

The City Skyline mural was drawn and assembled by seven-year-old children who had just completed a unit on City Neighborhoods and had studied the many kinds of buildings that make up a city. They had looked in detail at the shapes, sizes, and kinds of architecture—churches, factories, schools, apartment buildings, offices, and so on. The fabric paint that they used comes in a tube with a ball-point tip and is called Tri-Chem. The tubes must be held upright rather than slanted and a slight pressure exerted to make the paint flow. Each time the tubes are used the tips must be dipped in the solvent to dissolve the paint seal that forms over the tip; the paint then flows easily onto the fabric as the tube is moved slowly around. A gentle squeeze on the bottom of the tube each time it is used pushes the paint forward and insures a good flow of color. A plastic outer tubing encircles the lower portion of the tube to prevent the user from squeezing it too tightly. A magazine should be placed under the fabric when the child is drawing. The paint

dries to the touch quickly, but one should wait forty-eight hours before pressing it with an iron to make it permanent. The fabric paint comes in many colors, and each tube lasts a long time.

This type of soft sculpture offers a rich potential of creative tasks for young children. Backgrounds for murals may be made from cut paper, burlap, felt, chalk, or paint. Children will enjoy exploring the following topics for Stuffed Stuff murals:

Birds in a bush	Easter eggs hidden in the flowers
An airport	Dancing around the Maypole
A boat harbor	The first Thanksgiving
Houses on a hill	Children flying kites
On our playground	Below the waves
Witches and spooks	Zoo parade

A. Caterpillar is made of individual circles of fabric and colored with oil pastels. Each child designed one section.

B. Kindergarten children introduced themselves for Open House by drawing figures with felt pens and assembling the stuffed forms with name balloons on colored-paper background.

C. Butterfly Tree was made by first-grade children with felt pens on white fabric. When it was disassembled, each child retained his own contribution.

D. Six-year-old girl draws butterfly freely on fabric, and fills in areas with felt pens.

E. City Skyline is seven feet long and culminated a study of urban architecture. Buildings show great diversity of shape and exterior ornamentation. Car, plane, sun, and clouds unify all-over design.

Pillow Dolls

Pillow dolls are a delight for young children to make, to love, and to keep for many years. Each doll has a bit of its creator's personality and consists only of cloth, trimming, stuffing, imagination, and an awareness of human qualities.

As a folk art tradition, doll-making holds a time-honored position the world over because it is done for pleasure, delights our senses, and expresses character traits that have a universal appeal.

As in the drawings of small children, "correct" anatomical proportions are of lesser importance than are sincerity, spontaneity, and honesty of expression. Children give their dolls, whether they are human or animal, characteristics that are valued and understood. The results are intriguing, whimsical, humorous portraits in fabric. Children will naturally exaggerate some features as they do in their two-dimensional work—the eyes, the nose, or perhaps the wildly flowing hair, to mention but a few.

The making of pillow dolls is a pleasant and easy art task. Any kind of white or colored cotton fabric will serve as a base on which the children can begin. Some boys and girls will prefer to draw their dolls on a piece of material with felt pens, sewing on buttons and beads for details, and adding bits of contrasting fabric for clothing, mounted on with glue or a fabric adhesive. Older children will enjoy using a needle and embroidery floss to create mouths, eyebrows, or other details. A running stitch, chain stitch, and French knots are three very simple stitches.

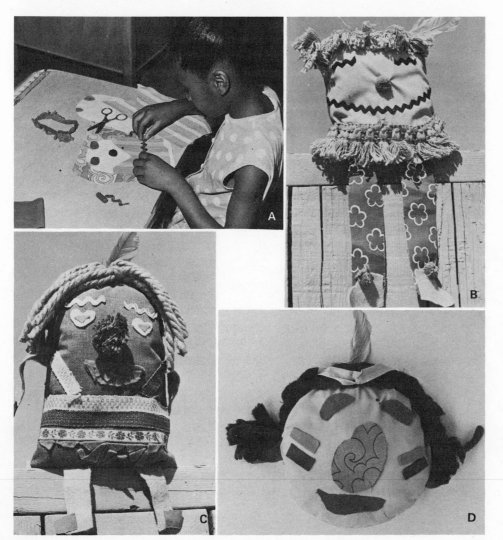

A. Pillow doll has its beginning when child cuts bits of fabric and braid and arranges them on the basic shape.

B, C, and D. Seven-year-old children designed their doll forms with simple arch, rectangle, and circle shapes, adding trim and cut-out eyes and mouths. Hair, legs, and arms are stitched and glued on later.

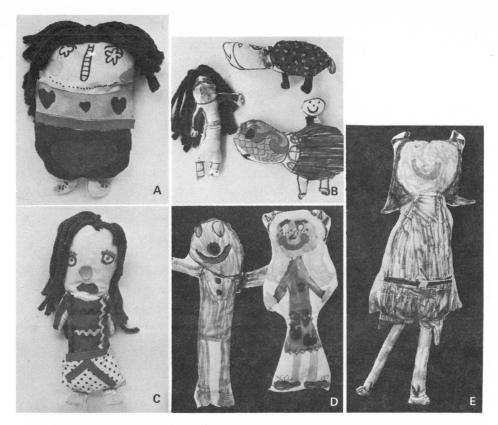

A, B, C, and D. These pillow dolls were drawn with felt pens. Some fabric pieces were added for decoration. Yarn hair was sewed on after they were turned inside out and stuffed.

E. This two-foot-tall pillow doll was drawn with felt pens by a seven-year-old girl. Back of doll was made by drawing outline on front side on another piece and reversing it and adding details before sewing the two pieces together.

When drawing doll forms, children should be cautioned against making very narrow legs, arms, or small details that will present a problem when it comes to trying to turn these elements inside out after stitching. Curves should be clipped and an opening left so that the doll may be stuffed with Dacron, old nylon stockings, or shredded plastic bags. This two- or three-inch opening should be left on the straightest part of the doll to make it easier to stuff and sew up.

It is sometimes fun and challenging for the children to have a basic precut piece of fabric such as an arch, circle, rectangle, or triangle. These shapes provide the basic form for the doll, while the arms, legs, or feet are made separately by the child and inserted in the seam when it is sewed on the machine. A tableful of colorful fabric scraps, ball fringe, rickrack, braid, lace, bias tape, and bits of iron-on fabric will provide a stimulating array for the child to have at his disposal in designing his doll. The doll's facial features and clothing should all be cut and put in position by the child before he attaches them to his basic shape. While it is not necessary to decorate the back of the doll, some children may want to do so to make their projects look more complete.

Boys should share in doll-making since they are equally involved in the creative use of materials, in imaginative play, and in arriving at their own understanding of all things human. Some children will value their dolls as toys, while other children will utilize this medium to communicate a personal statement in a sculptural form.

Weaving on Vinyl and Cardboard Looms

Weaving is the process by which fibers—yarn, string, and thread—are inter-laced. It is an ancient craft, the basic principles of which have not changed through the ages. As long as 30,000 years ago cavemen mastered the weaving of simple baskets with straw, reed, and other natural materials. Later these prehistoric people wove with fibers and made cloth.

Young children can use a number of simple looms to create woven items for both utilitarian and decorative purposes. They will find the over-and-under process fascinating and will be delighted with their new skills. Even the youngest children are able to learn the terminology of weaving, and their finger muscles will develop dexterity and control as they become sensitive to color, texture, and the elements of design.

Through examining the woven artifacts of other times and cultures as well as the works of contemporary craftsmen, young children will come to value woven forms as genuine creative expressions.

Probably the easiest device to use as an introductory weaving task in the preschool and kindergarten is the vinyl loom. Vinyl fabric comes by the yard and is available in bright colors at yardage shops. The looms illustrated below are six-by-eight inches and have ten vertical slashes cut one-half inch apart. Slightly wider borders on the right and left sides help the vinyl lie flat as the child weaves.

Supplied with a number of ten-inch-long pieces of thick yarn or one-half-inch-wide strips of felt, the child is ready to begin. The ends of the thick yarn should be dipped in white glue or wrapped with tape to keep them from fraying and make them easier to handle. These precut pieces of yarn or felt strips are called "wefts" or "weavers" and may be compared, when talking with children, to inch-

A. Vinyl looms with yarn and felt wefts are reusable and make it easy for very young children to grasp the over-and-under process that is called weaving.

B. Cardboard loom is strung with warp string on the front side, and short pieces of yarn are woven back and forth with the fingers.

C. Striped mats were made on card-board looms by eight-year-old chil-dren and stitched together for a wall-hanging.

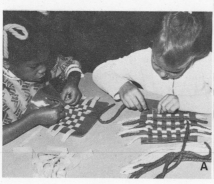

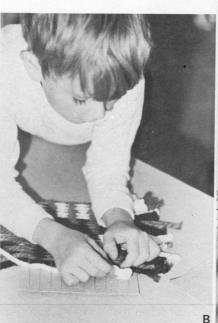

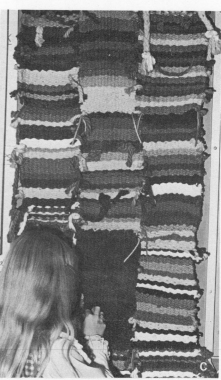

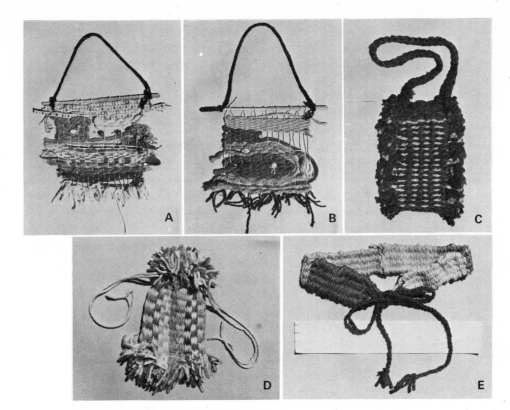

A and B. Straw, braid, and lichen as well as yarn were woven into the warp strings on cardboard looms by six-year-old children. Fringe tied on the bottom and a dowel through the top added finishing details.

C and D. Second-grade children fashioned purses from the mats they wove on their cardboard looms.

E. Long, narrow cardboard loom was used by seven-year-old boy when he wove this belt. Braided strings enable it to be tied in front.

worms that are crawling over and under, over and under the warp slashes in the loom. After one weft has been woven across the loom, the second one is put in place by going under and over alternating warps to create the checkerboard woven effect.

Since the weaving process is difficult in the beginning for the preschooler to grasp, he will need to make a few trial-and-error attempts before he understands what weaving is all about.

Mistakes on the vinyl loom are easy to correct by simply pulling out the weft. The looms are reusable and serve only as a learning device, not as a finished product. Having once mastered the over-and-under technique, children will be eager to create patterns with contrasting colors of yarn, and they will be ready to go to a more complicated kind of loom.

A cardboard loom is easy to make, warp, and weave upon. The attractive mats, wall-hangings, belt, and purses in the photographs were all made on small cardboard looms of various dimensions. About six-by-nine or seven-by-ten inches is a workable size for the child's first experience with this type of loom. Small slits about one-half inch apart should be cut along the top and bottom. Then warp string should be wound back and forth on the front side of the loom with tape holding the beginning and end of the string on the back of the cardboard.

For the young child's first experience in weaving on a seven-by-ten-inch loom, he will find it helpful for the weft yarn to be cut in lengths of about nine inches. This makes it possible for him to weave across his loom and take a new piece of yarn and weave across again without having to go back and forth with a shuttle or long piece of yarn. These precut wefts leave an attractive fringe on the sides of the mat; and when it is removed from the loom, those sides can be stitched on the sewing machine by an adult to make the mat more secure.

When the child is ready to weave back and forth with a long piece of yarn, a small cardboard shuttle with the yarn wound around it may be used, or the child may find it easier to use either a large-eyed needle or his fingers to work the yarn over and under the warps. A ruler is sometimes used as a pickup stick to lift alternating warps and create a shed through which the shuttle may be quickly passed. The child should be cautioned not to pull the weft too tightly on the right and left edges as this results in the mat having an hourglass curve on the sides.

The children will soon discover that they can originate many different woven patterns by repeating colors in some kind of order, and they will find that different thicknesses of yarn contribute to the design created by the weft.

A weft may be woven partway across the warp strings and then back again, or it may be woven around in a simple shape with additional pieces of yarn used to fill in unwoven areas. In other words, it is not necessary always to weave horizontally. Interesting tapestry-like designs may be created in this manner.

When the child has finished weaving his mat, he may either ease the warp strings out of the slits, or he may first tie fringe along the bottom of the warps. A dowel, chopstick, twig, or metal rod slipped through the top warp loops will facilitate hanging the finished piece.

Spool Weaving

Spool weaving is an old craft with limitless possibilities and endless fascination. Many of us remember, as children, using an old wooden spool, a few nails, a needle, and yarn to knit long cords. Young children can find satisfaction and enjoyment while developing manipulative skills and discovering new uses for these hollow cords and tubes.

The size of the woven cord is determined by the size of the hole in the loom, the number of nails, and the thickness of the yarn. Any acrylic, Orlon, or wool yarn may be used. Cotton and rayon yarns lack the stretchiness needed to loop the yarn over the nails. Variegated yarn produces horizontally striped coils, and children are entranced watching the designs develop as they weave.

The looms may be made from empty spools, but then you are limited to creating a cord about one-third of an inch wide. Any size hole may be drilled and then sawed into a scrap of wood—from about one inch up to eight inches or so. Use a square piece of wood and draw diagonal lines with a ruler and pencil and bore a hole with a brace and bit where the lines cross. A coping saw blade may be inserted in the hole and the desired size circle cut. With a pencil, mark the points where the finishing nails will be placed. These marks should be about one-half inch apart around the opening as shown in the photographs on page 131. They should be spaced far enough away from the hole to keep from splitting the wood. Two small pieces of wood on either end of the loom can serve as legs and make for easier handling. The rough edges of the wood should be sanded.

Whether the child uses a spool with only four or five nails or works with a larger loom with fifteen or twenty nails, the basic process is the same. To begin, the end of the yarn is dropped through the hole from the top and the yarn is wrapped around each nail from the right to left, that is, in a clockwise direction, bringing the yarn to the left of the first nail, wrapping around it once and then moving to the next nail on the left, coming behind it, wrapping around it and moving on to the next nail as shown in the photograph on page 131. When all the nails have been wrapped once, the yarn is placed in front of the first nail above the wrapped loop. Then with a large blunt needle, nail, or crochet hook, the child places the bottom loop over the yarn and over the top of the nail, creating a single loop on each nail. Weaving should progress in this fashion from right to left, with

A. End of yarn is dropped down through hole of spool loom and then wound clockwise around the loom, encircling each nail from behind.

B. Blunt needle is used to pick up loop on each nail, stretch it out, and lift it over the yarn and top of the nail.

C. Spool looms may be almost any size, and the woven tube or cord will vary according to the size of the opening.

D and E. Snakes may have wire inside or be stuffed with cotton. Variegated yarn creates its own scalelike pattern.

F. Two lengths of cording were woven on small spools and stitched together for this attractive belt. Beads and fringe were added later.

G. Cording for round mat was stitched around and around and the circle sewed to a felt backing before fringe was tied at the outer edge.

H. Finger puppets made on small spool looms are trimmed with felt and yarn and have arms and legs made from tiny woven cords.

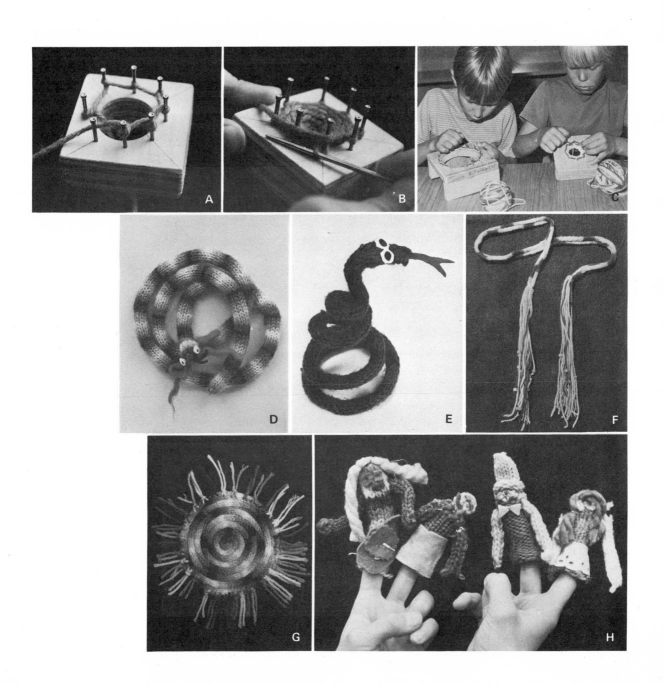

the child giving an occasional tug to the end of the yarn to pull the cord down through the hole. Left-handed children may prefer to weave in the opposite direction.

The loops should be kept loose as the child weaves or he will have difficulty in stretching the loops over the tops of the nails. He will find it much easier if he will reach behind each nail and stretch out the loop before he tries to place that loop over the nail.

When the desired length of coil or tube is finished, the loops on the nails should be bound off. This is done by cutting the yarn, leaving a piece several inches long, and then pulling this yarn through each loop and drawing it up tightly to close the top opening of the tube. The tube is then pulled down out of the loom, and the child is ready to use the finished length in creating an object. Any number of attractive items may be made from these coils and tubes. A few of these are listed here, and children will undoubtedly invent other things when given a little encouragement.

1. Coiled mats with or without fringe tied on the edges. Three yards of cord will make a seven-inch circle. Mats will lie flat if they are stitched to a felt backing.

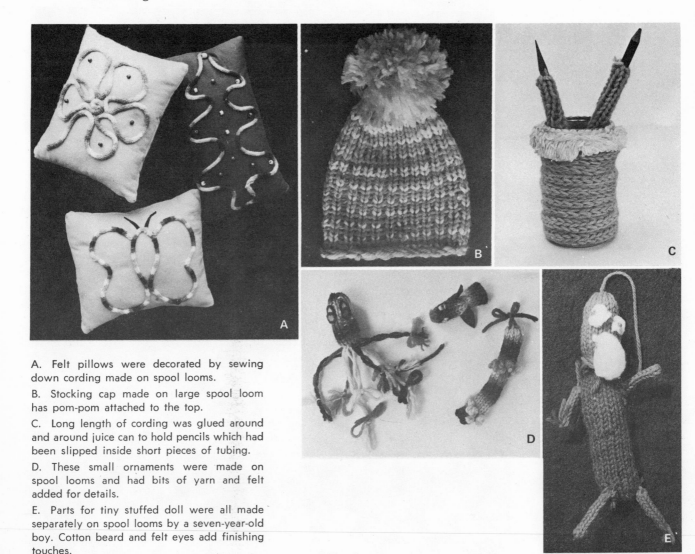

A. Felt pillows were decorated by sewing down cording made on spool looms.

B. Stocking cap made on large spool loom has pom-pom attached to the top.

C. Long length of cording was glued around and around juice can to hold pencils which had been slipped inside short pieces of tubing.

D. These small ornaments were made on spool looms and had bits of yarn and felt added for details.

E. Parts for tiny stuffed doll were all made separately on spool looms by a seven-year-old boy. Cotton beard and felt eyes add finishing touches.

Felt-covered panels are texture pictures in that they are made of glued-down cording, felt, and rickrack.

2. Pillow tops made from a coiled mat and sewed to a circle, square, or triangle of felt or soft fabric.

3. Pillow tops made by stitching down a long coil to a piece of felt in a simple linear design and adding a few beads for accents.

4. Pictures created by drawing or writing with the coil on felt and then adding bits of braid, felt, and rickrack for details.

5. Pencil cup made from a frozen juice can with a length of tubing glued around and around it. Each pencil wrapper is made from a single narrow tube.

6. Small stuffed animals, birds, fish, etc. These may be used for Christmas tree ornaments and are made from several short tubes of different sizes. They are stuffed with bits of cotton, tied with yarn, and have bits of felt, beads, and buttons added.

7. Small stuffed dolls. The body, head, arms, and legs are made on several different sizes of looms. The parts are stuffed separately and sewed together.

8. Finger puppets. These are made on looms with a one-inch hole with nails arranged in a two-inch circle. They should be woven about 4½ or 5 inches long. Yarn, felt, braid, lace, and beads may be added for faces and garments. Arms, ears, and such, may be woven on the tiny four- or five-nail loom and sewed onto the body.

9. Snakes, ever-popular and much loved by their creators, may or may not be stuffed. Some children enjoy inserting a wire in their snakes and coiling them in a striking position.

10. Stocking caps and even heel-less stockings may be made on the spool loom. A loom with a hole about nine inches in diameter is needed to create a cap that will fit the average child's head, while a five-inch loom makes a sock.

11. Purses may be made from the large looms. A tassel or pom-pom may be placed at the bottom and a drawstring at the top.

12. Purses may be made by winding the smallest size coil as for a mat or pillow top. One side of the purse could be made of felt, and the two sides could then be stitched together, leaving a top opening which could be closed with a button or snap. A short length of tubing could be used for a handle.

13. Belts and chokers may be made and fringes and beads added.

Slot Looms

The slot loom is a device which produces a flat length of woven material very similar in appearance to knitting. It is much easier to weave on a slot loom than it is to knit, and the work progresses more rapidly.

To make the loom you will need two pieces of wood two inches wide and about twelve inches long. You will also need two smaller pieces about 2-by-2½ inches. The two long pieces should be nailed to the small pieces as shown in the photograph below—leaving a ⅜-inch-wide slot or narrow opening. With a pencil and ruler mark the points for the finishing nails to be driven. They should be placed one-half inch apart and about one-eighth inch from the edge of the wood and should stand up about one-half inch or more. The loom may be any length, but a twelve-inch size is convenient to use. It isn't necessary to use the entire length if you wish to weave a narrower panel.

After winding the yarn around the nails as shown in the photographs below, the child should use a large blunt needle or crochet hook to lift the lower loop up and over the upper loop and nail, leaving a single loop on each nail. He should repeat this step on each nail. Then he is ready to rewrap the nails as he did when he first started, winding the yarn down to the other end of the loom

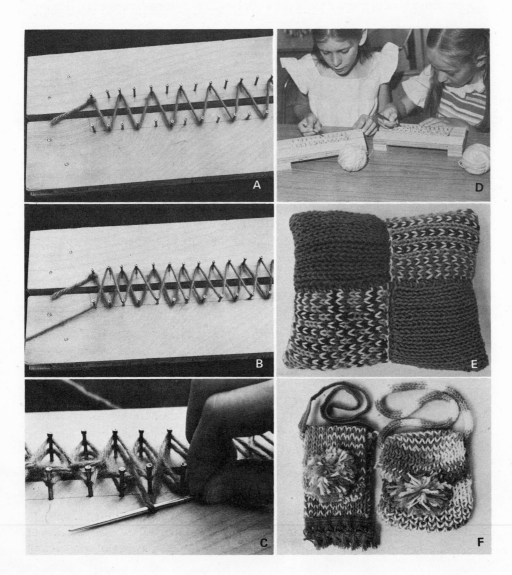

A. Yarn is tied to the corner nail on the slot loom and wound in a zigzag fashion all the way to the other end.

B. Yarn returns to where it began by crisscrossing it on top of the first zigzag winding.

C. Yarn is wrapped again in the same fashion as shown in A and B. Then the lower loop is picked up by a needle and stretched up and over the yarn and the nail.

D. Small slot looms are placed flat on the table and are easy for young children to handle.

E. Pillow top by eight-year-old child was made by stitching together four squares that had been woven separately. The top was then stitched to a felt backing and stuffed.

F. Slot-loom purses by eight-year-old children were folded and stitched on the sides, leaving a pocket and flap. Pompoms, braid, and straps were added.

Scarf woven on slot loom was made by tying second color of yarn onto the first color half-way through the weaving.

and back again, making the **X**-pattern with the yarn. Then he should lift the loops up and over each nail again as he did before. After a few rows, the woven fabric will begin to appear below the slot opening, and the weaver may continue until the desired length is completed.

The woven piece must then be bound off. This is done by using a crochet hook and starting at the opposite end away from the end of the yarn. The first loop is hooked through the loop on the opposite side, and then that loop is hooked through the loop on the opposite side till the end is reached and the yarn is cut and pulled through the last loop.

Hungarian Weaving

While woven pieces made on the Hungarian loom look rather complicated, the appearance is deceiving. Children find that it is fascinating and satisfying to make the loom, attach the warps, and weave. Small children will be able to cope with a small-size loom. They can make mats, hot-plate holders, door-knockers, and wall-hangings, or they may choose to sew several mats together to make a pillow top or a small purse with a button or snap attached to the top opening.

While belts may be made on a narrow loom by lifting the weaving off the nails as it progresses and replacing it higher up and continuing weaving, it is not suggested as a task until the children have had more experience with weaving, as the long warp strings may become tangled and present the child with a frustrating situation.

Hungarian looms are made from a flat piece of wood and may be any proportion and size. The one shown here is seven-by-seven inches. Lines should be drawn along three sides an inch from the edges and marked off at one-half-inch intervals. Then finishing nails should be hammered in place, all at the same height.

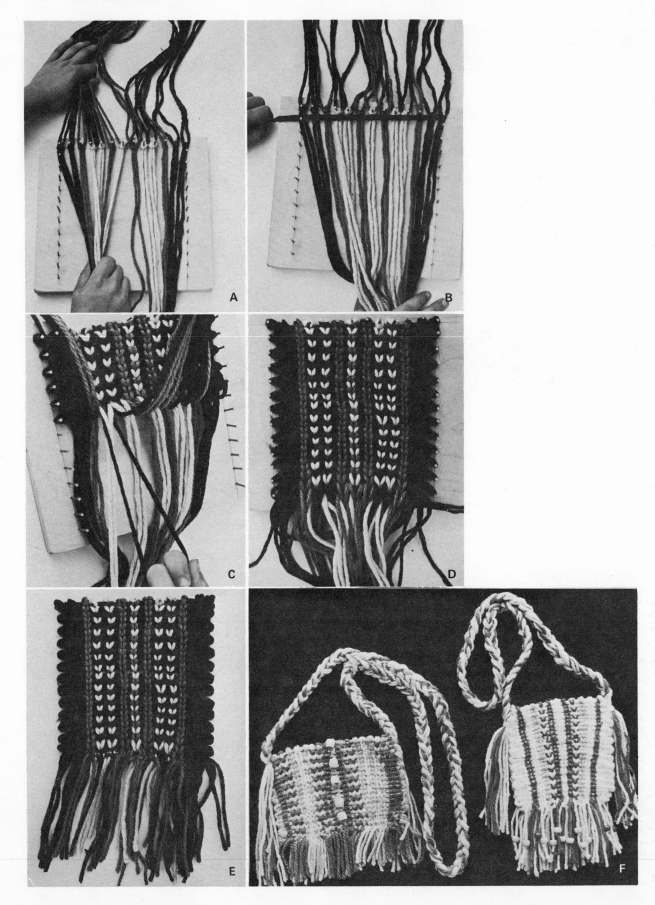

A. Thirteen nails run along the top of this loom, requiring a total of twenty-six pieces of yarn, each piece of yarn being about eighteen or twenty inches long. Two warp strings are attached to each nail in the following manner: Find the centers of both warp strings and loop them together to form a knot. Then press this knot down onto the nail with two ends stretched out above the nail and two ends laid down below the nail.

B. A six-inch-square mat requires a piece of yarn about eight yards long for the weft or weaver. Double this yarn and loop the middle of it over one of the top corner nails. Pull this doubled weft yarn across the warps horizontally and place it snugly down behind the corner nail on the other side, securing it on the side of the loom with a piece of masking tape. The weft is now lying in the open shed, and you will weave by moving the upper double warp strings from the first nail, holding them together and placing them down on the loom between the matching two warp strings that are fastened to the same nail. These bottom warps are then lifted up and placed above the nail at the top of the loom. Continue exchanging positions of the warp strings along each nail all the way across the loom, always keeping the TWO TOP warps together and spreading apart the TWO BOTTOM warps when you reverse their positions. When you have done this on each nail, lift up the masking tape and place the weaver back across the loom, going above the nail on the opposite side and reattaching it with masking tape. Do not skip any nails as you progress back and forth with the weft in this zigzag fashion.

C. Each time you weave across the loom you create a new shed, and you will repeat the same weaving process of exchanging the positions of the upper and lower warps. If you run out of the weft, tie more yarn to the ends and tuck the knots out of sight on the reverse side and continue weaving.

D. When you reach the bottom of the loom, make fringe by tying one top warp with its matching bottom warp. This holds the last weft in place. If you are making a woven piece that does not call for fringe, tie the matching warps in a knot and use a large-eyed needle to weave each one into the reverse side of the mat so that it doesn't show.

E. The finished mat may be lifted off the nails and made into a wall-hanging, purse, pillow, or whatever object the child may choose to use it for.

F. Two purses were made on Hungarian looms by eight-year-old children. Braided handles, beads, and tassles were added.

G. Door knocker by eight-year-old boy has a bell and beads and hangs from a supporting rod by a braided strap.

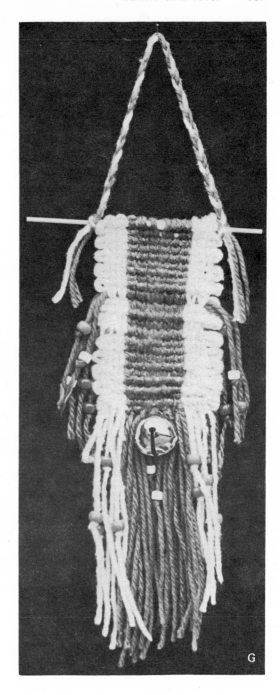

G

Rug yarn in an assortment of colors should be wound from skeins to balls and be ready for the children to use. They should select about three or four colors for their warp strings—the strings that will be attached to the top nails. The length of these warps should always be twice the length of the loom (or the finished product) plus about six inches for take-up and fringe. You will need two lengths of yarn for each top nail. If both pieces of warp strings on the same nail are the same color, a solid vertical line will appear in the finished product. If the two pieces of warp string are of contrasting colors, a **V**-shaped design will be repeated vertically. By arranging solid lines and **V**-shapes, the young craftsman can create his own combination of up-and-down patterns.

Needlepoint

Young children may be introduced to creating with yarn on canvas mesh or on the new plastic perforated screen. They enjoy working out their own designs prior to working the stitches with wool, Orlon, or acrylic yarn. Both mesh and screen are available in yarn and knitting departments.

A small piece of mesh or screen about three-by-four inches is approximately the right size for enabling the child to complete his piece before he tires of it. The children who created the needlepoint examples (below) drew around their mesh or screen onto a piece of paper and then worked out several ideas with felt pens to fit that size and shape. Then they taped the mesh or screen on top of the drawing they liked best, and used waterproof felt pens to draw it onto the mesh. The use of waterproof pens was a precautionary measure taken to avoid the possibility of damp hands causing the design to rub off later as they worked with needles and yarn.

Then they were ready to begin stitching, using a blunt large-eyed needle and the colors of yarn designated by their felt pen drawing. Each child needed to learn to thread his needle by flattening the yarn between thumb and finger and then pushing the needle between them. A small overhand knot was tied in the other end. When he finished using a piece of yarn, the needle was run through several stitches on the back side to hold it in place before the yarn was cut off.

While more advanced students and adults are challenged by using complicated and traditional stitches such as the continental or tent stitch, the basket weave, and such, the very young needlepointer will find enjoyment and challenge enough in filling in the mesh in his own manner. In creating the examples shown below, no rules were set down as to how to make the stitches. The children were encouraged to fill in the mesh as solidly as possible and to try to go back into

A. Long horizontal stitches were used to fill in the background by the eight-year-old child who created this needlepoint duck.

B. Short, tightly packed stitches were made by the child who designed this snail. Small needlepoint squares may be framed or made into pincushions.

C. Plastic mesh enables children to work rapidly and use all sorts of stitches. This fire truck was designed by a seven-year-old boy.

each opening that their yarn had come out of in order to cover up the mesh as much as possible. Short stitches and long were used and horizontal, vertical, and diagonal ones. The fire engine, duck, and snail illustrated on page 138 show quite a number of variations created by the children as they worked to fill in the color areas.

Once they are started, children find it fun to keep their needlepoint in their desks and work on it in their spare time.

Rug Pictures

Two traditional rug-making techniques lend themselves well to invention and exploration for very young children. A minimum of space and equipment is required, the results are beautiful, and the process quickly learned. Making a large rug picture is a sustained task for a group of children since it will take a number of weeks for them to complete it. Several children at a time may work on it, and each child will enjoy seeing his efforts add to the color patterns appearing in the cut pile.

Canvas mesh or scrim may be purchased for the backing in most department stores and yarn shops. It comes in widths of about thirty-six inches and should have 3½ or 4 holes to the inch. A realistic and appropriate length to buy for a class project would be about three-fourths of a yard or so. It should be covered on the cut edges with masking tape to keep it from coming undone as the work progresses. Either acrylic, Orlon, or rayon-cotton blended rug yarns may be used for rug pictures. These are inexpensive and available in a wide range of colors. The skeins should be loosely wound in balls to prevent them from becoming tangled.

In talking with the children as they work on design ideas for a rug picture, teachers should point out that the motif should be kept bold and simple without too many small details due to the nature of the yarn and pile.

Two techniques are recommended in transferring the child's design to the canvas backing. In the first technique, each child paints a picture with tempera or draws one with Rich art colors on paper the same size and shape as the canvas. The class may vote upon its choice, and the picture is then placed on a table with the mesh on top of it. Then several children draw the outline on the mesh with felt pens of matching colors. When the different areas are filled in with felt pens, the children will know where to hook or tie knots with the different colors of yarn.

The second method for transferring a design to canvas is to have each child make a small drawing. These drawings are then placed one at a time in an opaque projector and viewed on a piece of white paper that is the exact size of the piece of canvas mesh. By moving the projector back and forth the teacher can reduce or enlarge the image as desired to make it fit the shape of the paper. The class may then decide which design it will choose, or perhaps they may select parts of several different drawings to combine within one composition. The mesh should then be taped over the paper, and several children may draw the design on it with felt pens, being careful not to stand in the way of the beams of light coming from the projector.

Two ways of filling in the areas with pile are described here, and small groups of children may be instructed at one time in how to use either the latch hook or how to tie rya knots. These children may in turn teach their peers until all the class has learned the technique. Hooking and knotting are no more complicated for young children to learn than shoelace tying.

Latch hooks may be purchased in department stores or yarn shops for about one dollar each. A latch hook is a small tool with a hinged latch that opens and

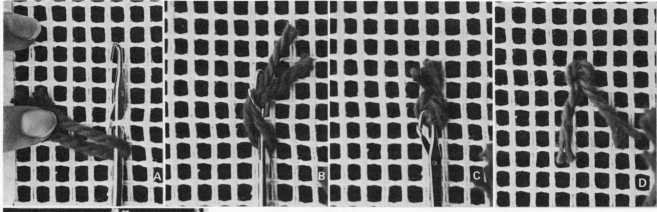

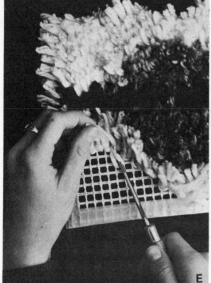

A. Fold a piece of cut yarn in half behind the latch. Then push the hook down through the first hole, under the horizontal threads of the canvas, and up through the hole directly above. The hinged latch will fall open.

B. Then holding both ends of the yarn in the fingers, pull them around in front of the latch under the hook. Then pull the hook toward you until the latch closes. Then let go of the loose ends.

C. Continue pulling the hook until the loose ends have passed through the looped yarn, thus completing the knot.

D. Give the ends of the yarn a tug to tighten the knot.

E. Each child may make a small square, hooking or tying the yarn in a simple design of his own creation. When all the squares are completed, they may be whipped together on the reverse side to make a large patchwork rug picture.

F. A small drawing of Cat with Flowers is being enlarged in an opaque projector while a six-year-old girl traces the images on the canvas mesh with felt pens.

G. Canvas mesh may be placed on top of a child's drawing or painting and the picture drawn on it with felt pens.

H. Six-year-old children enjoy the challenge of latch-hooking and delight in seeing their individual work contribute to the group production.

I. The entire class of first-grade children worked on this two-by-three-foot rug picture.

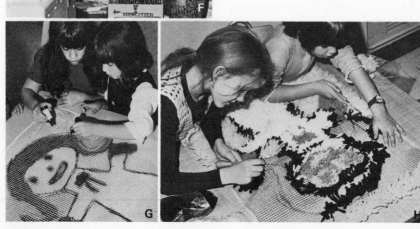

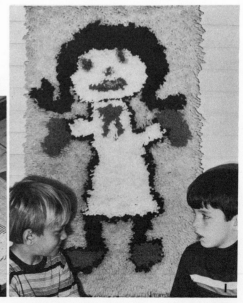

closes to hold and pull the yarn before releasing it in a neat knot. The yarn is cut before it is used, and the cut length determines the height of the pile. Usually about 2½ inches is a workable length for finishing up with a pile about one inch high.

To make the precut pieces of yarn, wrap the yarn a number of times, without stretching it, around a piece of cardboard 2½ inches wide. Then wrap a rubber band around the middle of the cardboard to hold the yarn in place; snip along the top and bottom with a scissors. These short pieces should be kept sorted by color in boxes or plastic bags. The children should work on a table and try to hook across the canvas, starting at the bottom and working up so that the pile will fall evenly. However, they may enjoy filling in areas of the rug solidly in one color and filling in the background later.

The rya knot is formed like the Ghiordes knot that is used in Oriental rugs, and the resulting short pile that it makes is called *flossa*, which is Scandinavian in origin. It is tied with a large-eyed needle. When a row of knots is completed, the row above it should be tied in every other hole to those knots of the preceding row. It is better to work from the bottom up so that the knots are all tied in the same direction and the pile falls evenly.

When the rug picture is finished, a narrow flat piece of wood may be attached to the top to make it easy to hang. A class might like to present the finished work to the school office for all the children and teachers to enjoy.

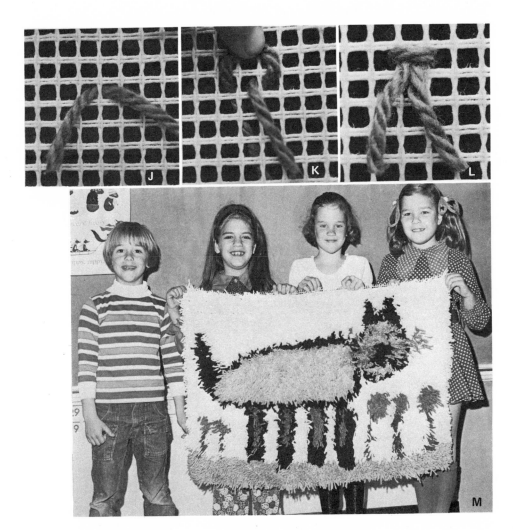

J. For the rya knot, a length of yarn about two feet long should be cut and threaded through the eye of the needle. Then the needle is poked down through a hole in the mesh, leaving a one-inch tail of yarn sticking up. A short piece of inch-wide cardboard will be helpful in measuring the length of this tail.

K. Then holding onto this tail with the left hand, poke the needle back through the mesh immediately to the right of the hole where the tail is sticking out. Pull the yarn up. Then poke the needle down in the hole immediately to the left of the hole where the tail is, leaving a loop about as big as your finger.

L. Now poke the needle up through the same hole where the tail is, coming out below that loop you just left. Pull both tails to the same one-inch length as measured against the cardboard and snip them with a scissors.

M. Six-year-old youngsters are justifiably proud of their rya knotted rug picture.

Liquid Colors 13

The cognitive tools of the child artist include the working elements of design, one of the most important of which is color since it also incorporates and reflects much of the affective domain in the child's growth and attitudes. Children live in a world of color. They see it in flowers, in clothing, in cars, in rain puddles on oil-slick streets, in animals' fur and birds' feathers, in sunsets, in paintings, and in people's eyes and hair. Color can make us feel happy or sad, warm or cool, and the colors children use in their paintings and drawings often reflect this quality.

We usually think of a color in association with familiar things, and as very young children begin to paint and draw, they slowly develop this color-object relationship. Since fire is red and yellow, these colors are thought of as warm. Sky and water are blue and are usually thought of as cool colors. Children like to have favorite colors, and they usually choose bright intense ones.

If children compare the green leaves of the budding willow tree with the green leaves of the stalwart oak, if they look at the blue summer sky mirrored in a lake and the blue-gray sky above city buildings, they develop a more refined awareness of color's delicate or intense differences.

While very young children find an academic study of color wheels and color theories beyond their interest and understanding, many of the principles of color mixing, blending, and naming and association can become meaningful entities if children are given a number of encounters with color in its liquid form. Liquid colors move, swirl, blend, are absorbed by paper and fibers, and are pleasurable for young children to observe. Experiments with pigments come alive when children see red and yellow magically merge into orange; blue and orange become gray; and red, blue, and violet all blend from one hue to the next.

Throughout their lives, individuals make color choices that make their surroundings more pleasant. Children can become more sensitive to color's intricate and subtle relationships, to its differences and similarities when they work with color in its liquid form.

Dip and Dye: Decorating Paper

Very young children are captivated by the old Japanese technique of folding and dipping paper in dye. They will want to make several sheets of this decorative paper because no two ever come out of the dye baths looking exactly alike. Two and three dips in the dye baths create merged and blended tones, while the pleasing repetition of colored shapes results from the way in which the paper was folded before it was dipped in the dye.

A. Preschooler folds Dippity Dye paper in triangular accordion fold prior to dipping it in diluted food color.

B. Corners or entire sides of the folded paper may be immersed in dye and removed when the desired amount of color has been absorbed. Paper should be blotted between newspapers before dipping it in a second color.

C. Magic moment comes when child unfolds his paper and discovers the lovely pattern he has created.

D. Paper may be folded in several ways before dipping and redipping it in dye baths.

The paper should be folded in an accordion-like manner as illustrated above, and the resulting packet should not be too thick or the dyes won't penetrate to the center. A paper folded very small will produce small patterns, while a larger fold will create larger patterns. If a stiffer paper is desired, add a little plain gelatin to the dye water. Special paper called Dippity Dye is available from art supply sources. This paper is absorbent and has a rice paper appearance, but is quite inexpensive.

Dye baths may be made from paste food colors since these colors come in an enormous assortment of tones and are highly concentrated. The paste should be mixed with a small amount of water in a small bowl, sour cream carton, or tuna can. The color should be rather intense since the wet paper dries to a lighter tint or shade.

The folded packet of paper should be dipped in the dye bath one corner or side at a time and lifted out when the desired amount of color has been absorbed by the paper. Children will quickly learn how to control the spread of the color by the length of time they leave it in the dye. The dyed packet should then be squeezed and then placed between several layers of paper towels or newspapers to blot out the excess color and force it evenly through the layers of paper. The packet is then dipped in another color which should be darker than the first— either by dunking a corner or side that was not dipped before, or by redipping the tip of a corner or edge that was dipped before and removing it before the dye completely covers the first color. After the packet is blotted between papers again, it may be carefully unfolded and placed on newspapers to dry.

The brightly patterned paper may be pressed with an iron and used for gift wraps, stationery trims, program covers, greeting cards, or for covering cartons, boxes, cans, books, and notebooks.

Tie-Dye

The art of tying knots in fabric and dipping it in dye is over three thousand years old, so this new way of decorating material is actually one of the oldest. Young children enjoy the surprise achieved in creating the blurry-edged patterns resulting from a process that is actually an updated version of an ancient process called *bandhnu* in India.

Tie-dye is inexpensive in that old clothes and pieces of cotton and nylon fabric can be used—but given a new and personal touch. The main purchase is the dye itself. The instant all-purpose or cold-water dyes are easy to work with since no simmering is required. White or light-colored blouses and shirts, T-shirts, handkerchiefs, and pillow slips are some of the ready-made items that children might bring to school for a dye-in. Or, some project might be decided upon such as having each child tie and dye a length of muslin which will later be gathered and stitched on a band for an apron.

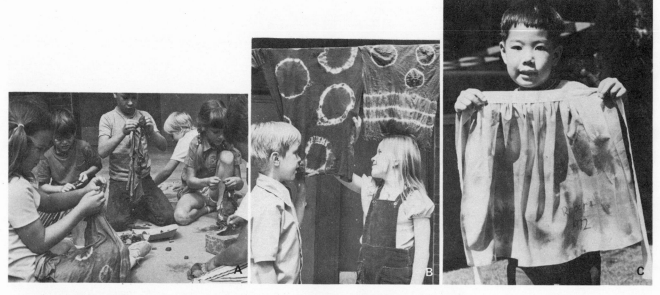

A. Young tie-dye artists remove small pebbles, strings, and rubber bands from shirts and pieces of materials that have been dyed.

B. Circles and stripes appear on fabric in areas that were tied with string. These shirts will dry quickly on an outdoor clothesline.

C. Kindergarten boy is proud of apron made from fabric that he tie-dyed.

The designs created are determined by the manner in which the material is folded or tied. The color doesn't penetrate the tied portions. Experimenting with tying and then soaking the fabric in the dye bath results in a delightful uncertainty. While it is possible to predict with some degree of accuracy the pattern you will create with certain folds and ties, young children will need to be instructed in only a few basic ones.

Circles, both large and small, regular and irregular, can be tied in several ways. Tiny ones are made by pinching up bits of the fabric and winding a thread or narrow rubber band about them. Slightly larger circles can be tied over beads or marbles. A grouping of a number of small circles makes a pleasant arrangement.

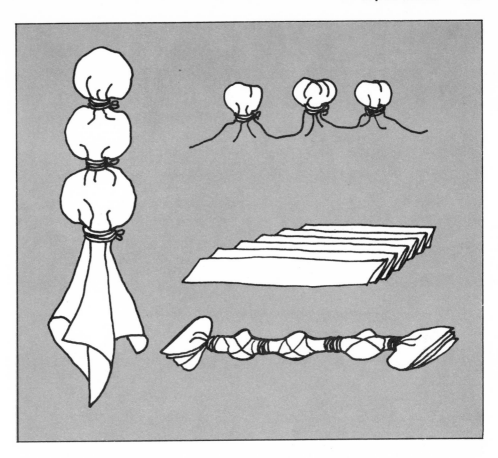

Fabric should be wet, squeezed out, and tied in any of several ways before it is soaked in dye bath.

Large circles are created by picking up bigger loops of the material. Concentric circles are made by tying in a series of marbles or golf balls. Where the cloth is tied between the marbles, there is a very definite edge to the ring. By tying in cubes, pebbles, beans, spools, clothespins, walnuts, and little sticks, an infinite variety of rings may be made. Fabric may be pleated and the pleats tied together leaving gaps between the string. This will produce an all-over cobweb effect.

The garment or fabric should be dipped in water and squeezed before the child begins to tie knots. Strong white string is best for tying. Thread may be used for fine circles and narrow tape for wide bands. If very young children have difficulty in tying string, rubber bands may be used instead.

Children may find it easier to work with a partner when they are tying their knots. They should be shown how to leave a loose end of string when they begin winding so that they will have two ends to come together for tying when they finish. They should tie a bow or slipknot so that it will be easy to untie when they are through, as string sometimes shrinks and the knots become quite tight.

You will need a large pot for each color of dye you use. One bottle of Rit will dye up to two pounds of dry material, and one package of Putnam will dye one pound or three yards of dry material. The dye should be diluted or dissolved according to the directions on the bottle or package, using less water for more intense colors. The wet article should be put in the dye bath and stirred for about ten minutes. The colors become lighter when the fabric dries. Simmering the dye bath will result in darker colors also. When the item is removed from the dye, it should be squeezed out and rinsed thoroughly in cool water.

You will probably find it advisable to schedule your dye-in for a pleasant day and do the work outdoors, stringing up clotheslines for the finished pieces to dry on.

Pied Paper

Because no two sheets of swirling pied paper are ever alike, young children will want to make more and more of them, each time seeing new images and relationships in the flowing color patterns.

You will need a fairly large pan (such as a cake pan, roaster, or dishpan) to hold the warm water, some oil paint, and some turpentine. Paint thinner will be necessary for cleaning up.

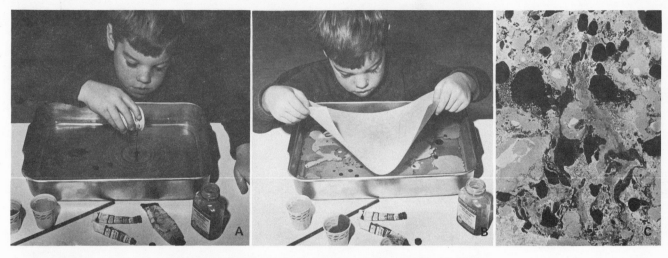

A. Rapt interest in color is reflected in this kindergarten boy's face as he pours oil paint that has been thinned with turpentine onto the surface of the water in preparation for making pied paper.

B. Oil and water don't mix, and this principle enables the very young child to encounter the richness of color patterns and associations.

C. Swirling colors are bright and beautiful, and the child finds fascination in seeing them transferred from the water's surface to white paper.

The children should mix small amounts of oil paint with a little turpentine and pour or drip the mixture on the surface of the water. They should use several colors for each piece of paper, adding more paint and trying new combinations each time. A pencil or stick will be useful in swirling the colors around on the surface of the water. Then they should take a piece of white paper, hold it by the sides, and carefully lower it onto the surface of the water. The colors will adhere immediately to the paper, which may then be placed to dry for several hours on newspapers.

This attractive paper may be used as matted pictures, as program and invitation covers, and as coverings for cans, boxes, and such.

Nature's Secret Colors

The plant world has a colorful secret waiting for young children to discover. Many very common plants that grow around us will work wonders as dyes for fleece or skeins of white wool yarn, and children can encounter an age-old natural process right in the classroom. They can learn not only about a number of plants, but about sheep, wool, shearing, and how long, long ago people learned how to enrich their fabrics for clothing and blankets by adding nature's colors to the fibers. They will look with fresh eyes at brilliantly hued flowers, at bark, and at roots and weeds and wonder what magic color may be hidden within each.

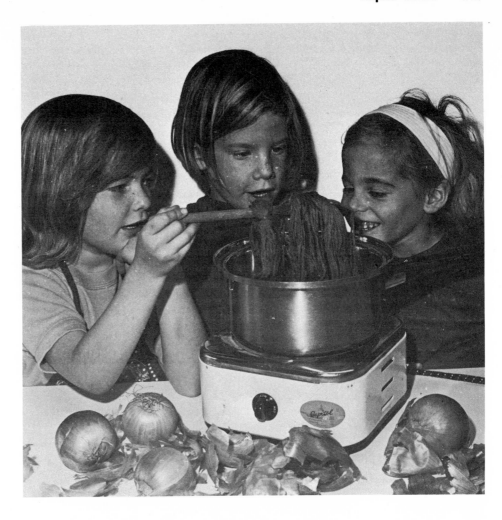

Kindergarten children enjoy checking the onionskin dye bath and watching the yarn become darker the longer it simmers.

It is interesting to know a little about the history of dyeing now that this ancient art is being rediscovered. With a greater interest in ecology and wildlife as well as in crafts, people are once again finding that such natural things as flowers, lichens, roots, berries, seeds, herbs, oak galls, a kind of shellfish, and even cochineal insects are sources for beautiful earth-toned colors. The methods used for dyeing were kept carefully guarded for many, many years, and in the sixteenth century the dyers' guilds started to make written records. It is from these records that we have information as to how dyeing has been done for fifteen hundred years. Traders brought dyes from India and the New World to Europe. Our colonists experimented with many indigenous plants, but purchasing dyed materials was generally considered too much of a luxury for the typical self-sufficient family. Most dyeing was done by master dyers by the early 1800s, and the fabric mills continued to use natural dyes to a large extent even after coal tar dyes were invented in 1856.

White wool yarn should be purchased for classroom dyeing tasks—it takes dyes better than cotton or synthetic yarns. A four-ounce skein should be rewound in small skeins and each one tied loosely in about four places to keep it from becoming tangled in the dye pot. The small skeins may then be simmered in different dye baths for an assortment of colors.

If a bag of fleece can be obtained from a weaving supply house or a rancher or farmer, the children can see it progress from a shaggy pile of tangled fibers to a clean white fluff, and then from the dye bath to the spindle. Fleece should first

be rinsed in a pot of hot tap water by gently moving it around without squeezing it or rubbing it. Hot or even simmering water does not harm wool. What does hurt it is rapid movement at the boiling point, sharp changes of temperature, and being wrung or twisted. After it is rinsed it should be placed in water of the same temperature supplemented by Ivory soap, Fels Naptha, or some mild liquid detergent containing no enzymes. Then the wool should be rinsed in hot water, lifted out with a slotted spoon, and allowed to drain before being placed on a clean absorbent towel to dry.

Another natural dye source is found in the outer hulls of black walnuts. These should be broken up and soaked in water, then boiled and the liquid strained off for the dye bath. Or, the hulls may be placed inside a nylon stocking and simmered along with the wool. Leave the wool to cool in the dye bath, then rinse it, drain it, and leave it to dry.

For a delightful woodsy odor and a fresh yellow-green color, gather some lichen for a dye bath. Lichen is the greenish moss that grows on trees in the woods. Remember that it is illegal to gather any plant material on public property and be sure to obtain the property owner's permission before gathering it on private land. Take only a small amount and leave enough to avoid any possibility of depleting the source. The lichen should be torn apart and tied in a nylon stocking to keep the bits and pieces from becoming entangled in the fleece or yarn. Simmer it very slowly until the desired color is reached. Wet colors always tend to lighten on drying. Then leave it to cool, rinse in clean water, drain, and dry.

Gray, bronze, and blackish tones may be created by using an old iron pot that will hold two quarts of water. Into this place three or four handfuls of rusty nails or rusty steel wool pads and one cup of unused black tea leaves. This mixture should be boiled for an hour or two, then strained and enough water added to make up for the amount that vaporized in the process. Then add two ounces of wetted washed wool or yarn and simmer one hour. Let it stand overnight and rinse and dry it the next day.

Young children will find sufficient thrill and surprises in working with substantive dyes only—those dyes that do not require a mordant.[1] Later on they will want to know about the wider range of shades that may be obtained from plants if the wool has first been treated before it is placed in the dye bath. The word *mordant* means "to bite" in French because the chemicals used cause the dye to bite into the wool. Early dyers found that the same dye bath would make different colors depending upon whether it was placed in an iron pot, a copper pot, or a tin pot. Today craftsmen treat wool with mordants in the form of metal salts or other prepared solutions, the most common being alum, chrome, tin, and iron.

Nature has indeed been lavish with colors, and children will reap a rich harvest of sensory and conceptual experiences when they unlock the lovely earth tones of plants and release them into wool.

1. For a complete explanation of the mordanting process that is necessary when using elderberries, mistletoe, wild mustard, marigolds, spinach, birch bark, etc., see Robert and Christine Thresh, *An Introduction to Natural Dyeing* (Santa Rosa, Calif.: Threshold, 1972); Mary Frances Davidson, *The Dye Pot* (published by author, Rt. 1, Gatlinburg, Tenn., 1971); and the handbook *Dye Plants and Dyeing* (Brooklyn: Brooklyn Botanic Garden, 1964).

14 Gift Time

Throughout the school year there are a number of occasions when children want to give a present to a relative or friend. If the objects made at such a time do not make a unique contribution to the child's aesthetic development, they have no place in the curriculum. If they are cut from an adult-conceived pattern, if they are poured in a commercially made mold, if they are copied and assembled from a prototype, they are nonart and have no place in the child's life. Using art materials does not necessarily mean that the child is having an art experience, or that the product he makes has anything to do with art.

Teachers who ordinarily encourage creative expression and individual effort on the part of the children will risk having their work undone, and they will find it increasingly hard to stimulate the children to think for themselves and be resourceful if they fall back on patterns and copying at gift time. To do so fosters dishonesty, dependent thinking, and nullifies the child's dignity and diminishes his desire and ability to think, feel, and do for himself.

With the foregoing philosophy as background, the following tasks are presented for gift time. All of them are designed to result in an aesthetic product that is conceived and designed by the child to incorporate his skills of drawing, modeling, cutting, and assembling.

Calendars

A happy and colorful drawing, painting, or cut-paper picture that a child has made and of which he is particularly proud, or perhaps one that he especially creates for the occasion, may be mounted and made into an enchanting and useful calendar. Such calendars are a suitable gift project for preschoolers as well as older children because the art work itself depends entirely upon the imagination and maturity of the individual child.

The child's picture should be attached to a contrasting piece of construction paper or colored tag or poster board. Rubber cement is a good adhesive to use since it leaves no bumps or spots on the surface of the paper. Small printed calendars are available in stationery stores and variety shops. They are inexpensive and have a gummed backing, making it easy for the young child to stick one onto the bottom of the frame or mat he is working with.

The child may wish to replace the picture he had made on his parents' calendar during the year, changing it to one that will fit the season or tell about an event happening that month. In such an instance the teacher may see fit to stack eleven sheets of paper of the same size under the top picture and staple them all to the backing, and as the months pass the child may create a new picture for each of the eleven sheets.

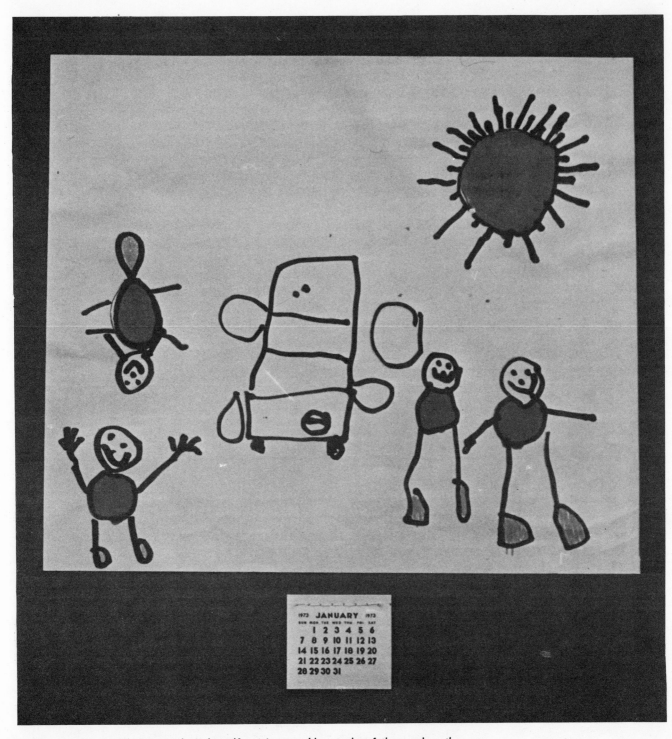

1973 JANUARY 1973
SUN MON TUE WED THU FRI SAT
 1 2 3 4 5 6
 7 8 9 10 11 12 13
14 15 16 17 18 19 20
21 22 23 24 25 26 27
28 29 30 31

In this calendar picture, Francie drew herself waving good-bye to her father and mother as they left in the car.

By thus putting the child's art on permanent display, adults show their evaluation and appreciation of the child's own ideas. Since the art work is original with each child, no two gift calendars will ever be alike.

Bookmarks

Useful and decorative, bookmarks involve drawing, or cutting and gluing, with felt and fabric. Burlap stripping may be purchased by the yard in hobby and craft stores, and felt and pellon are available in fabric shops. Felt and pellon should be cut in strips two or three inches wide and seven or eight inches long.

Children may snip out designs from assorted scraps of felt and fabric and use glue or fabric adhesive to attach the pieces to the burlap or felt background strips. They may choose to make a realistic representation or an abstract design. Before they begin cutting, the children will benefit from thinking about what things they know about that are tall, long, or thin that would fit the narrow shape of a bookmark. Such suggestions might include a long-necked bird, a clown on stilts, an alligator, a fish, a mermaid, a tall building, a train, a skinny man or woman, a girl jumping rope, or a boy holding a balloon. The children should be encouraged to think in terms of adapting their design motif to the narrow shape.

The bottom of felt or burlap may be slashed diagonally, cut pointed, curved, fringed, or finished in whatever manner the child may choose. A hole punch may be used to make openings to tie on yarn loops for fringe.

A. Giraffe with fringed mane and a beady-eyed bird were designed by six-year-old child to fit a long, narrow felt bookmark.

B. These bookmarks were made by four- and five-year-old children who cut out felt shapes and glued them to burlap strips.

C. Tri-Chem and pellon were used for these drawn bookmarks.

Another type of bookmark is one that is drawn on pellon with tubes of fabric paint. Working on an old magazine provides a cushiony backing and protects the table or desk. The child should be instructed to hold the tube of paint in a vertical position and draw freely. After forty-eight hours the pellon should be pressed with a warm iron.

Pincushions

Given a small piece of white or light-colored cotton fabric such as bleached or unbleached muslin, and either tubes of fabric paint or felt pens, the young child can make his own drawing to adorn a pincushion. The piece of fabric should be taped down on four sides to an old magazine. Not only does this hold the material firmly to a cushiony base and protect the table top, but when the tape is removed a neat margin has been left in which the seams may be stitched.

The children should be encouraged to draw whatever motif they wish on their piece of fabric. While some of the younger children may well be content with a simple schematic drawing or even a scribble, slightly older children will be fascinated with the bright colors as they flow from the tube or pen onto the fabric, and they will wish to fill in large areas solidly, as in the butterfly and train pincushions illustrated below.

After forty-eight hours the fabric should be pressed with a hot iron if Tri-Chem was used. The teacher should then stitch it to a felt or fabric backing on the sewing machine, leaving about an inch open on one side. The little pillow is then ready to be turned inside out and the corners poked out with the eraser end of a pencil. The pincushion should then be filled with fine sawdust. This is best accomplished with a spoon or a small funnel. When it is tightly packed the child should use a running stitch to close the open edges.

This same technique could be used for making small beanbags, using birdseed, small beans, or rice for the filling.

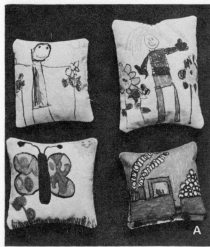

A. These tiny pincushions with designs drawn on them with tubes of fabric paint make attractive and unique gifts.

B. A small funnel is helpful in filling pincushions with fine sawdust. Side opening is then stitched together, and the pincushion is finished.

C. Paint flows easily from tip onto fabric if the tube is held upright.

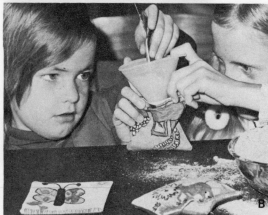

Weed and Candle Holders

Young children love to work with baker's dough, rolling it in balls, coils, squeezing, poking, and imprinting it with any small gadget that is handy. A natural outgrowth of this play activity is the making of dried weed and candle holders. Children may gather small dried weeds on a nature walk, or a small bunch of straw flowers may be purchased. These come in earth tones and bright colors and contrast nicely with the soft tan and gold shades produced when the baker's dough comes out of the oven.

The child should model and work with his holder on a small piece of aluminum foil. This makes it easy to lift the finished piece onto a baking sheet and place it in the oven. Cloves and peppercorns make good design motifs for the young child to use to imbed in a linear or grouped arrangement. The candles and stems of the flowers may be stuck into the dough while it is being modeled, the flowers remaining through the baking process and the candles being removed beforehand and glued back in place later.

The lump of baker's dough that the child uses for his holder should be about four or five inches in diameter and will require a slow baking period until it is thoroughly hard and dry all the way through. This may take several hours at 300 or 325 degrees.

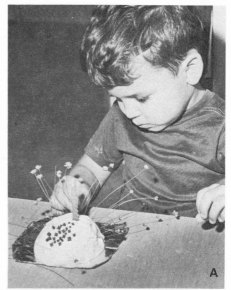

A. Preschool boy finds it intriguing to imbed dried flower stems into baker's dough. Very young children enjoy participating in this art task and are proud of their products.

B and C. Small balls and coils of dough as well as cloves, candles, and straw flowers are combined by young children for these attractive table ornaments.

Mounted Baker's Dough Pictures

After young children have had several experiences with baker's dough, they should be ready to make a bas-relief picture. Small pieces of plywood or hardboard may be utilized as backgrounds for these three-dimensional arrangements. Since baker's dough lends itself to flat things rather than to stand-up sculpture, the animals, birds, or whatever the child makes are quite adaptable to this art task.

While the child is modeling his dough he should think in terms of the total arrangement, grouping and relating two or three forms on his board. In working with baker's dough, the usual nonmelting materials such as macaroni, toothpicks, peppercorns, and beads may be imbedded into the dough for details and contrast. Also, pencils, screws, spoons, and small gadgets may be used to imprint texture and details. A garlic press will produce stringy threads of dough which may be used for hair, manes, clothing details, grass, and so on.

The modeled pieces should be baked at 350 degrees on the pieces of wood, or small pieces may be baked on foil and later glued to wood or felt-covered corrugated cardboard. The child may add bits of moss, dried flowers, weeds, and such, to unify and relate the modeled parts. A piece of jute or heavy yarn wrapped around the edges of the board makes an attractive frame. Small ring-hanging devices are available in hardware and variety stores, and these should be glued to the back of the wood piece before it is gift wrapped and taken home.

A. Smiling Lion by seven-year-old child has shaggy mane and stands in a flower bed of lichen and dried weeds.

B. Cat and Mouse by second-grade youngster makes use of toothpicks, macaroni, and cloves.

C. Happy Angel is mounted on calico-covered cardboard and has a red ribbon tied on top of its head.

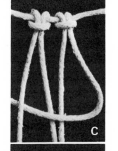

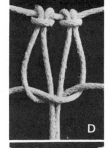

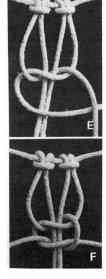

Macramé Key Rings

Utilizing only a square knot—which is less complicated to tie than the shoelace bow knot—young children can make sturdy, attractive key holders with notebook rings. The materials are inexpensive, and the entire task can be completed in one art period. Cotton seine cable cord or jute is available in craft shops and hardware stores. Beads and small bells can be bought in import stores as well as in hobby and craft houses. Note this word of caution in selecting beads to be used with this type of heavy cord: Be sure the holes in the beads easily accommodate two cords.

Children may work on tables or desks with a thick cardboard panel propped on their laps, or the notebook ring may be fastened to their desk tops with a piece of masking tape. Each child will need two or four cords, each about eight times the length desired for the finished product. Each cord is doubled and tied onto the notebook ring with a lark's head knot as shown in the photographs.

By threading beads onto the cords between knots, by tying either half or full square knots, and by using contrasting colors of cords, the children can achieve many different designs. The end of the key holder should be left fringed with possibly a few overhand knots tied to keep the cords in place.

A. Cord is tied in a lark's head knot over a holding cord or on a notebook ring.

B. Ends of cord are pulled snugly in place.

C. Cord on right is brought over the two middle cords and under the cord on the far left.

D. Cord on left is then brought over the two middle cords and up through the opening created by the traversing right-hand cord.

E. The second half of a square knot is the reverse of the first half; that is, the cord on the left is brought across the two middle cords, and the cord on the right is placed on top of it.

F. The cord on the right is brought to the left and up through the opening on the left, and the full square knot is completed. By repeating the complete square knot over and over, a flat sinnet is formed. By repeating the first half over and over, a spiral sinnet is formed.

G. A group of children may all be instructed at one time in how to tie a square knot if the teacher uses thick cords pinned to a vertical panel.

H. Six-year-old boy uses notebook ring as holder for his cords. He has strung two beads on the cords and has alternated the sinnets in designing his key ring.

I. Several kinds of cords and different arrangements of half and full square knots make for a multitude of key ring designs.

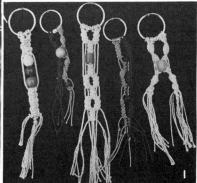

Cardboard Key Holders

To make cardboard key holders you will need to cut up some corrugated cardboard into pieces of assorted shapes and sizes—about three-by-four inches—and some newspapers or paper towels into inch-wide strips about five or six inches long.

Sturdy and colorful, these cardboard key holders were made by four- and five-year-old children.

The children should each dip a strip of paper into a wheat paste and water mixture, wiping off the excess and wrapping the soaked strip around the cardboard. They should continue doing this until the cardboard is covered smoothly on both sides and on all the edges. Then they should prop it up on a piece of foil or waxed paper to dry.

When it is dry, an ice pick should be used by the teacher to poke a hole in it for the beaded chain or notebook ring to pass through. The child should paint his cardboard with either tempera or acrylic colors, giving it an all-over base coat and then painting his own design on top of it with small stiff brushes when the coat is dry. A clear coat of acrylic will keep the paint from coming off on clothing or on moist hands and will give the key holder a long-wearing glazed surface.

Weaving for Wearing

Cardboard weaving in miniature produces handsome pendant necklaces for gift time. Using the technique described for cardboard looms in chapter twelve on "Fabric and Fiber," the child cuts tiny slits one-fourth of an inch apart along the top and bottom of a small piece of cardboard that is about 2½ by 3½ inches in size. String or yarn is then warped up and down on the cardboard and the two ends of the warp string are fastened on the back side with masking tape. These ends may be woven into the necklace later with a needle.

Then using a large-eyed needle and short lengths of yarn, the child weaves in and out and back and forth to create any pattern and color arrangement that he may desire. He may weave all the way across the warp strings several times to achieve a solid stripe, or he may choose to weave only partway and then weave back and forth over these warps to create a narrow woven strip. He may let the weft yarn hang down on either side for a decorative effect. If he does not want the

loose ends of yarn to hang on the sides, he may weave the point of a large-eyed needle in and out of the finished woven piece, thread it with a loose end of yarn, and slip it inconspicuously inside the weaving.

Short pieces of yarn may be tied on to the bottom warps for fringe. Beads may be added. When the weaving is all filled in, the child may insert a tiny stick such as a meat skewer in through the top of the warp strings. This helps the piece lie flat and retain its shape. Yarn may be braided and attached to the pendant for tying it around the neck.

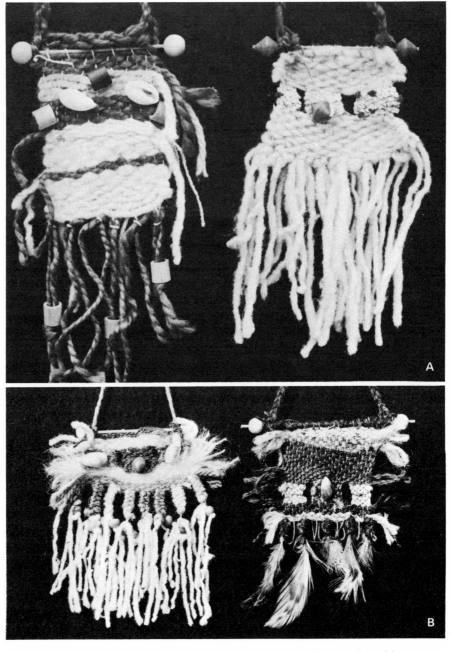

A. All sorts of yarn scraps may be utilized to weave necklaces on tiny cardboard looms.

B. Older children enjoy creating intricate designs. Feathers and beads were added to these necklaces.

Nature Frame-ups

While the final product in this task is a highly decorative and individually designed gift item for young children to make, the process involved in planning it and putting it together encompasses not only perceptual and designing episodes, but mathematics, science, and language arts experience. Children must measure the wood and learn about the natural objects they have collected. Later they may describe or write poems about the items that they have used for their frame-ups.

Several weeks ahead of time, the class should begin collecting objects such as feathers, shells, seed pods, beans, driftwood, sticks, dried flowers and leaves, small rough or polished rocks, beans, rice, etc. The children will become more sensitive to color, line, texture, and size and shape in nature as a result of looking closely, handling, and arranging the items that they selected.

Each child will need a plywood or pressboard base for his frame-up. This background board may be painted, covered with cloth, or left natural. It may be either square or rectangle, depending upon what size of scraps are available. The children will also need some flat one-inch sticks of wood for the outer frames and a number of one-half-inch sticks for marking off the interior areas. This sort of wood may often be found in the trash bins of cabinet shops.

Before working with the wood itself the children should be given a number of strips of tagboard cut in one-half-inch widths. They should snip these and make their overall arrangement on the background, changing and adding until they have arrived at a pleasing composition that will accommodate a variety of the natural forms. They may then mark their one-half-inch wood sticks to correspond to the paper strips and saw them to the same lengths. Then the children should tack them in place with small hammers and finishing nails and use white glue to mount the items they have selected.

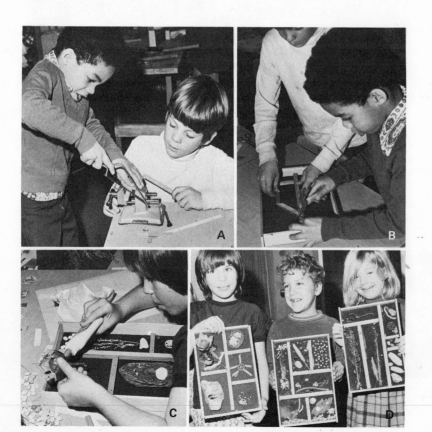

A. A small vise is helpful when children saw wooden sticks.

B. Outer and interior framework is tacked in place by children in their own prearranged designs.

C. In handling found natural objects, children become more sensitive to detail, to likenesses and differences, and to relating colors, shapes, and textures.

D. Proud of their accomplishments, these seven-year-old children have found new beauty in nature by framing a few of its many forms.

15 Celebrations

Seasons and holidays throughout the year offer exciting art-experience opportunities for young children; however, the celebration concept can be abused by an insensitive teacher who thinks of it only as a time to decorate the classroom with thirty tired look-alike turkeys, Santa Clauses, cupids, or Easter bunnies. Patterns and copy work rob the child of the chance to spill forth his own feelings and thoughts in unique ways. They squelch his self-confidence and destroy his ability to respond imaginatively, joyously, and flexibly in a new situation.

The human need to celebrate and make an event festive is universal and has been perpetuated and fostered throughout all eras of history by both young and old. For children it can manifest itself in a variety of creative activities. Their feelings about celebrations and their awareness of each holiday's meaning can be proclaimed when they draw, paint, cut, model, and construct with art materials. Four approaches to stamping out stereotyped depictions of holiday subjects, while at the same time encouraging children to celebrate special days with original and unique art expression are suggested.

Familiar with a New Twist

Placing holiday subjects in personalized settings or giving them an incongruous or humorous activity will humanize a holiday or tickle the child's sense of humor and cause his imagination to rush in a new direction.

The following list of topics for painting, drawing, cutting and gluing, printmaking, modeling, and constructing, incorporates familiar cultural symbols for the month of December and is typical of this specific method of encouraging both imaginative and cognitive/affective responses:

A very fancy winter sun, snowflake, or star
Cherub rocking on a crescent moon or riding on a comet
Santa dancing, skiing, or playing a violin
Elf with a goat or riding a sled
Boy with a dreydl
Reindeer with bells on his antlers
Lighting candles on our Menorah
Angel dancing or playing a guitar, banjo, trumpet
Rocking horse, rocking lion, or rocking reindeer
Boy or girl drummer
Toy soldier blowing a horn
Mouse with holly

Elephant with a horn
My dove of peace
Quails in a bush
King or queen with a glorious crown
Alligator with a Christmas bird on his back
Raggedy Ann or Andy with a balloon

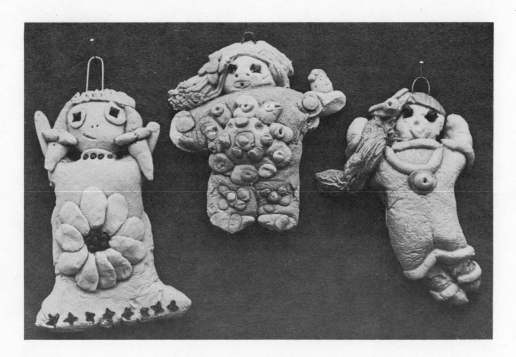

Dancing Angels are modeled of baker's dough for holiday decorations.

Backgrounds and Origins

Delving into resource material for the historical background and origins of a holiday will give children insight and a fresh approach to incorporate in their visual imagery.

The following description of how Valentine's Day came to be gives us a number of motivations for art tasks. Real people long ago felt, loved, and thought the same as we do, and children find it easy to identify with these human drives and emotions and to make aesthetic responses.

It is believed that Valentine's Day had its beginnings in a Roman festival called Lupercalia when the men wore hearts pinned to their sleeves on which were the names of girls who would be their partners during the celebration. Sometimes the couple exchanged presents—gloves or jewelry. In later times, a day honoring Saint Valentine preserved some of the old customs. Seventeenth-century maidens ate hard-boiled eggs and pinned five bay leaves to their pillows before going to sleep on Valentine's Eve in the belief that this would make them dream of their future husband.

In 1415 the Duke of Orleans was imprisoned in the Tower of London. He wrote love poems or "valentines" to his wife in France, and it is believed that these were the first valentines. Sweethearts in the seventeenth and eighteenth centuries exchanged handmade cards trimmed with paper hearts and real lace. During the Civil War valentine cards bcame popular in the United States. Satin ribbons, mother-of-pearl ornaments, and spun glass trimmed these elaborate cards.

Here is a list of themes for valentine art tasks. These topics will stimulate original and personal art productions incorporating historical and sometimes whimsical comments about February 14.

Roman men wearing hearts on their sleeves
Seventeenth-century maiden dreaming of her future husband
The Duke of Orleans in the Tower of London
Civil War soldier giving a valentine to his sweetheart
Cupid shooting a bow and heart-tipped arrows
Mermaid with a loving heart
Lion with a heart of gold
A house made of hearts and flowers
An automobile with heart-shaped tires
Valentine bugs and butterflies in a valentine flower garden
The most beautiful and loving heart in the world
Love birds and love bugs
Cupid with a daisy
The Queen or King of Hearts

Festivals and Processions

Preparing for and participating in an elaborate ceremony will have much meaning and memorable enjoyment for the children when the focal activities are related to a particular holiday or event.

A typical one is the celebration of the Vernal Equinox or the Coming of Spring. This special day heralds a new season, and it can be made resplendent with the combined participation and efforts of several grade levels by having a procession and a short program complete with banners, simple costumes and headgear, flags, music, dances, food, poems, and stories.

In keeping with the spirit of spring, children can embellish long cardboard tubes for pretend horns and trumpets. Paper plates may be gaily painted and mounted on sticks with crepe-paper streamers attached to trail in the breeze. Short cardboard tubes with waxed paper wrapped around the ends become kazoos for the children to decorate and hum into. Aluminum pie pans taped together with pebbles inside make a satisfying rattling noise. Narrow strips of fabric or crepe paper tied to the ends of sticks serve as streamers to wave. Large felt banners to celebrate the four spring months can be mounted and carried on poles and can incorporate symbols and words that have to do with the customs and historical proclamations of spring.

An impromptu Maypole dance can be staged around a tether pole or around a long stick imbedded in a bucket of sand. Long crepe-paper or fabric streamers should be attached to the top of the pole with each child grasping the end of one strip. Each child then faces another child, and they walk around the pole, going over and under and carrying their streamers in what becomes a woven wrapping at the top of the pole. The very young children will enjoy the simpler version— holding a streamer and walking around and around the pole in follow-the-leader fashion.

Paper-bag costumes, folded paper hats and crowns, crepe-paper headbands and sashes can be made and worn by the children for the procession. They will enjoy singing a few songs about spring and perhaps hearing a poem written by several of the older children in honor of the First Day of Spring. The children will of course be eager to eat cookies, candy, or bread that they have made in symbolic spring forms.

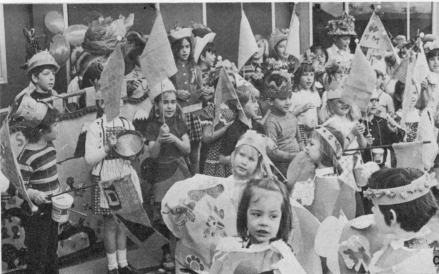

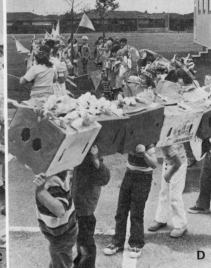

A. Pennants, crowns, and a Maypole made colorful additions to the Coming of Spring festivities in which preschoolers through third-graders participated.

B. Felt banners incorporating springtime activities were draped on a pole and carried in lead positions in the procession.

C. Imaginative musical instruments, individually designed hats, balloons, and paper butterfly costumes contributed to an awareness of the changing season and the warm sunny days to come.

D. Kindergartners designed a many-legged caterpillar with cardboard boxes to represent the concept of new life in the springtime.

In designing banners and in making special drawings and paintings for an art exhibit, the children will need to know the story of spring. Such information from books and films as the following will provide helpful resource data for all sorts of stimulating art productions.

First day of spring, March 21, is the date on which day and night are both twelve hours long all over the world. March was named after the Roman god of war, Mars. The astrological sign Aries, the Ram, extends from March 21 to April

19. Wild geese in **V**-formation streak northwards; robins appear, daffodils bloom, hibernating animals awake. "In like a lion, out like a lamb" refers to windy weather —a time for kites.

April is named for Aphrodite, the Greek goddess of love. Greeks called spring "the opening." The astrological sign Taurus, the Bull, extends from April 20 to May 20. April Fool's Day, Palm Sunday, Easter, and Passover are celebrated. Snow melts; early flowers such as the daisy, primrose, lily, and forsythia bloom. Fruit trees blossom, and there are rain showers. Snakes shed skins; birds return to build nests and lay eggs. Newborn animals take their first steps. It is a time to plant, clean house, and open the baseball season.

May was named after the Roman goddess of spring (Maia Majesta). It was dedicated to Ceres, goddess of grain, with corn being her favorite grain. Navajo Indians called May the month of tiny and tall leaves. The ancient Romans celebrated the first day of May by honoring Flora, goddess of flowers, who was wreathed in garlands. A procession of singers and dancers carried her statue past a sacred blossom-decked tree. Later these festivals spread to other parts of Europe, reaching their height in the Middle Ages. On May Day English villagers awakened at daybreak and gathered blossoms. A Maypole made of a tall birch tree was set up on the village green and decorated with bright flowers. Pipers played and villagers danced and sang. The fairest maiden was Queen of the May. Children today hang baskets of flowers on doors.

June was named in honor of the Roman goddess Juno, patroness of women, marriage, and home. It is the month of roses, weddings, and perfumed air. The astrological sign is Gemini, the Twins, and it rules from May 21 to June 20. Nature wears her loveliest dress. Spring ends June 21.

Mini-celebrations

Considering some not-so-familiar days as possible vehicles for mini-celebrations opens all sorts of doors for creative merrymaking and significant festivities. An interesting story or film about some historical first or important event will bring forth from the children wellsprings of ideas for all sorts of art tasks—muralmaking, paintings, cookies, dioramas, living pictures, construction activities, kite making, and puppet shows, to name but a few. In like manner, when birthdays of famous people are solemnized or celebrated at school, children are able to identify more closely with and appreciate those men and women who made important contributions to our lives.

Here is a sampling of events and noteworthy birthdays that are on the level of a young child's understanding:

Oct. 21 —Thomas Edison invented the electric light, 1879
Oct. 25 —Birthday of Pablo Picasso, Spanish artist, 1881
Oct. 27 —Navy Day
Oct. 28 —Birthday of Jonas Salk, 1914

Nov. 2 —Birthday of Daniel Boone, 1734
Nov. 15 —Zebulon Pike discovered Pikes Peak, 1806
Nov. 22 —First trans-Pacific airmail flight, 1935
Nov. 30 —Mark Twain's birthday, 1835

Dec. 5 —Walt Disney's birthday, 1901
Dec. 6 —St. Nicholas Day in Europe
Dec. 16 —Beethoven's birthday, 1770

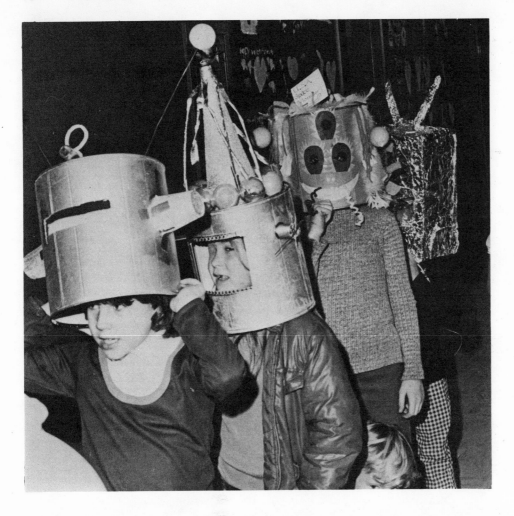

Space Day was celebrated by all the second-grade classes after they had studied the planetary system and man's explorations into space. A special space-food luncheon was prepared, and each child created his own helmet for the afternoon parade which was held to honor the brave men who were the first explorers in spaceships.

Dec. 17 —Orville Wright made first successful airplane flight at Kitty Hawk, 1903

Jan. 1 —Birthday of Betsy Ross, maker of first American flag, 1752
Jan. 4 —Birthday of Jacob Grimm, German author of fairy tales, 1785
Jan. 24 —Gold discovered in California, 1848

Feb. 2 —Ground Hog Day
Chinese New Year's Day—date varies
Feb. 6 —Babe Ruth's birthday, 1895
Susan B. Anthony's birthday, 1820
Feb. 26 —Buffalo Bill's birthday, 1846

March 2—First round-the-world nonstop airplane flight, 1949
March 3—Girls' Doll Festival in Japan
March 7—Alexander Graham Bell patented the telephone, 1876

April 2 —Hans Christian Andersen's birthday, 1805
April 3 —Pony Express began, 1860
April 5 —Booker T. Washington's birthday, 1856
April 18 —Paul Revere's ride, 1775

May 6 —First postage stamp, the "penny black," issued in England, 1840
May 10 —First transcontinental railroad in U.S. completed in Utah, 1869
May 21 —Clara Barton founded the American Red Cross, 1881

Bibliography

The following lists include books for teachers and books for teachers to share with children.

Art Education and Philosophy

ALSCHULER, ROSE H., and HATTWICK, LA BERTA W. *Painting and Personality.* Chicago: University of Chicago Press, 1947.

Art Education: Elementary. Washington, D.C.: National Art Education Association, 1972.

Art Education Framework for California Public Schools, Kindergarten Through Grade Twelve. Sacramento: California State Board of Education, 1971.

BLAND, JANE C. *Art of the Young Child.* Greenwich, Conn.: New York Graphic Society, 1968.

CONRAD, GEORGE. *The Process of Art Education in the Elementary School.* Englewood Cliffs, N.J.: Prentice-Hall, Inc., 1964.

EISNER, ELLIOTT W. *Educating Artistic Vision.* New York: Macmillan Co., 1972.

FELDMAN, EDMUND BURKE. *Becoming Human Through Art: Aesthetic Experience in the School.* Englewood Cliffs, N.J.: Prentice-Hall, Inc., 1970.

GAITSKELL, CHARLES D., and HURWITZ, AL. *Children and Their Art.* 2nd ed. New York: Harcourt, Brace and World, Inc., 1970.

HARRIS, DALE B. *Children's Drawings as Measures of Intellectual Maturity.* New York: Harcourt, Brace and World, Inc., 1963.

HERBERHOLZ, DONALD, and HERBERHOLZ, BARBARA. *A Child's Pursuit of Art.* Dubuque, Ia.: Wm. C. Brown Company Publishers, 1967.

JAMESON, KENNETH. *Art and the Young Child.* New York: Viking Press, 1970.

KELLOGG, RHODA. *Analyzing Children's Art.* Palo Alto, Calif.: National Press Books, 1969.

LANSING, KENNETH M. *Art, Artists, and Art Education.* New York: McGraw-Hill Book Co., 1969.

LARK-HOROVITZ, BETTY; LEWIS, HILDA; and LUCA, MARK. *Understanding Children's Art for Better Teaching.* Columbus, Ohio: Charles E. Merrill Books, Inc., 1967.

LEFRANCOIS, GUY. *Of Children: An Introduction to Child Development.* Belmont, Calif.: Wadsworth Publishing Co., 1973.

LEWIS, HILDA P., ed. *Art for the Preprimary Child.* Washington, D.C.: National Art Education Association, 1972.

LINDERMAN, EARL W., and HEBERHOLZ, DONALD W. *Developing Artistic and Perceptual Awareness.* 3rd ed. Dubuque, Ia.: Wm. C. Brown Company Publishers, 1974.

LINDERMAN, MARLENE. *Art in the Elementary School: Drawing, Painting, and Creating for the Classroom.* Dubuque, Ia.: Wm C. Brown Company Publishers, 1974.

LORTON, MARY BARATTA. *Workjobs: Activity-Centered Learning for Early Childhood.* Menlo Park, Calif.: Addison-Wesley Publishing Co., 1972.

LOWENFELD, VIKTOR. *Your Child and His Art.* New York: Macmillan Co., 1965.

———, and BRITTAIN, W. LAMBERT. *Creative and Mental Growth.* 5th rev. ed. New York: Macmillan Co., 1970.

PARNES, SIDNEY J., and HARDING, HAROLD F., eds. *A Source Book for Creative Thinking.* New York: Charles Scribner's Sons, 1962.

PIAGET, JEAN. *The Language and Thought of the Child.* New York: Meridian Books, 1955.

PICKERING, JOHN M. *Visual Education in the Primary School*. New York: Watson-Guptill Publications, 1971.

TORRANCE, E. PAUL. *Rewarding Creative Behavior: Experiments in Classroom Creativity*. Englewood Cliffs, N.J.: Prentice-Hall, Inc., 1965.

UHLIN, DONALD. *Art for Exceptional Children*. Dubuque, Ia.: Wm. C. Brown Company Publishers, 1972.

WACHOWIAK, FRANK, and RAMSAY, THEODORE. *Emphasis: Art*. Scranton, Penn.: International Textbook Co., 1965.

Art Heritage, Aesthetic Judgment and Valuing of Art

ABISCH, ROZ, and KAPAN, BOCHE. *Art Is for You*. New York: David McKay Co., Inc., 1967.

About Us: The 1973 Childcraft Annual. Chicago: Field Enterprises Educational Corp., 1973.

AITCHISON, DOROTHY. *Great Artists*. Ladybird Books, Series on Rubens, Rembrandt, Vermeer, Leonardo, Raphael, Michelangelo, and others. Loughborough, England: Wells and Hepworth Ltd., 1970.

ALDEN, CARALLA. *From Early American Paintbrushes: Colony to New Frontier*. New York: Parents' Magazine Press, 1971.

———. *Sunrise Island: A Story of Japan and Its Arts*. New York: Parents' Magazine Press, 1971.

ATWOOD, ANN. *New Moon Cove*. New York: Charles Scribner's Sons, 1969.

BAHTI, TOM. *Southwestern Indian Tribes*. Las Vegas, Nev.: KC Publications, 1971.

BAIRD, BIL. *The Art of the Puppet*. New York: Macmillan Co., 1965.

BARREN, BERYL. *Wonders, Warriors, and Beasts Abounding*. Garden City, N.Y.: Doubleday and Co., Inc., 1967.

BAYLOR, BYRD. *Before You Came This Way*. New York: E. P. Dutton and Co., Inc., 1969.

BELVÉS, PIERRE, and MATHEY, FRANCOIS. *Enjoying the World of Art*. New York: Lion Press, 1966.

———. *How Artists Work: An Introduction to Techniques of Art*. New York: Lion Press, 1967.

BERGER, RENE. *Discovery of Painting*. New York: Viking Press, 1963.

BORRESON, MARY JO. *Let's Go to an Art Museum*. New York: G. P. Putnam's Sons, 1960.

BORTEN, HELEN. *A Picture Has a Special Look*. New York: Abelard-Schuman, 1961.

———. *Do You See What I See?* New York: Abelard-Schuman, 1959.

CADY, ARTHUR. *The Art Buff's Book: What Artists Do and How They Do It*. Washington, D.C.: Robert B. Luce, Inc., 1965.

CAMPBELL, ANN. *Paintings: How to Look at Great Art*. New York: Franklin Watts, Inc., 1970.

CANADAY, JOHN. *Mainstreams of Modern Art: David to Picasso*. New York: Simon and Schuster, 1959.

CHASE, ALICE ELIZABETH. *Looking at Art*. New York: Thomas Y. Crowell Co., 1966.

———. *Famous Paintings: An Introduction to Art for Young Readers*. New York: Platt and Munk, 1969.

Childcraft Annual: Look Again. Chicago: Field Enterprises Educational Corp., 1968.

COEN, K., and COEN, G. *Musical Instruments in Art*. Minneapolis, Minn.: Lerner Publications Co., 1965.

CORNELIUS, CHASE, and CORNELIUS, SUE. *The City in Art*. Minneapolis, Minn.: Lerner Publications Co., 1965.

DE LA CROIX, HORST, and TANSEY, RICHARD. *Art Through the Ages*. 5th ed. New York: Harcourt, Brace and World, Inc., 1970.

DEVLIN, HARRY. *What Kind of House Is That?* New York: Parents' Magazine Press, 1969.

Discovering Art Series. *Nineteenth Century Art, Chinese and Oriental Art, Greek and Roman Art, Seventeenth and Eighteenth Century Art, Art of the Early Renaissance, Art of the High Renaissance, Prehistoric Art*, and *Ancient Art of the Near East*. New York: McGraw-Hill Book Co.

DOUGLAS, FREDERIC, and D'HARNONCOURT, RENE. *Indian Art of the United States*. New York: Museum of Modern Art (distributed by Simon and Schuster), 1941.

DOVER, CEDRIC. *American Negro Art*. Greenwich, Conn.: New York Graphic Society, 1969.

DOWNER, MARION. *Children in the World's Art*. New York: Lothrop, Lee and Shepard Co., Inc., 1970.

———. *Roofs Over America.* New York: Lothrop, Lee and Shepard Co., Inc., 1967.

———. *The Story of Design.* New York: Lothrop, Lee and Shepard Co., Inc., 1968.

FISHER, LEONARD E., series. *The Weavers. The Cabinet Makers. The Architects. Glass-makers. Papermakers. Potters. Silversmiths.* New York: Franklin Watts, Inc.

FORTE, NANCY. *The Warrior in Art.* Minneapolis, Minn.: Lerner Publications Co., 1965.

FRANC, HELEN M. *An Invitation to See: 125 Paintings from the Museum of Modern Art.* New York: Museum of Modern Art, 1973.

FRASER, KATHLEEN. *Stilts, Somersaults, and Headstands: Game Poems Based on a Painting by Peter Bruegel.* New York: Atheneum Publishers, 1968.

FREEDGOOD, LILLIAN. *Great Artists of America.* New York: Thomas Y. Crowell Co., 1963.

GETTINGS, FRED. *The Meaning and Wonder of Art.* New York: Golden Press, 1963.

———. *You Are an Artist: A Practical Approach to Art.* Middlesex, England: Paul Hamlyn, 1965.

GLUBOK, SHIRLEY. *Art Books for Young Readers, The Art of the Southwest Indians, The Art of Ancient Egypt, The Art of the Lands in the Bible, The Art of Ancient Greece, The Art of the North American Indian, The Art of the Eskimo, The Art of Ancient Rome, The Art of Africa, Art and Archaeology, The Art of Ancient Peru, The Art of the Etruscans, The Art of Ancient Mexico, Art of India, Art of Japan, Art of Colonial America, The Fall of the Aztecs, The Fall of the Incas, Discovering Tut Ankh Amen's Tomb, Discovering the Royal Tombs at Ur, Digging in Assyria, Home and Child Life in Colonial Days, Art of the Spanish in The United States and Puerto Rico.*

GREGOR, ARTHUR S. *How the World's Cities Began.* New York: E. P. Dutton and Co., Inc.

HAFTMANN, WERNER. *Painting in the Twentieth Century.* New York: Frederick A. Praeger, 1966.

HART, TONY. *The Young Designer.* New York: Frederick Warne & Co., Inc., 1968.

HOLLMANN, CLIDE. *Five Artists of the Old West.* New York: Hastings House, 1965.

HOLM, BILL. *Crooked Beak of Heaven: Masks and Other Ceremonial Art of the Northwest Coast.* Seattle, Wash.: University of Washington Press, 1972.

HOLME, BRYAN. *Drawings to Live With.* New York: Viking Press, 1967.

HUNT, KARI, and CARLSON, BERNICE W. *Masks and Mask Makers.* New York: Abingdon Press, 1961.

JANSON, H. W., and JANSON, DORA. *The Story of Painting for Young People from Cave Painting to Modern Times.* New York: Harry N. Abrams, Inc., 1962.

JANSON, H. W. *History of Art for Young People.* New York: American Book Co., 1971.

JOHNSON, ILSE, and HAZELTON, NIKA S. *Cookies and Breads: The Baker's Art.* New York: Reinhold Publishing Corp., 1967.

KAHANE, P. P. *Ancient and Classical Art.* New York: Dell Publishing Co., Inc., 1967.

KAINZ, LUISE C., and RILEY, OLIVE L. *Understanding Art: Portraits, Personalities, and Ideas.* New York: Harry N. Abrams, Inc., 1967.

KOHN, BERNICE. *Everything Has a Shape and Everything Has a Size.* Englewood Cliffs, N.J.: Prentice-Hall, Inc., 1964.

LA FARGE, OLIVER. *The American Indian.* Special Edition for Young Readers. New York: Golden Press, 1973.

LALIBERTE, NORMAN, and McILHANY, STERLING. *Banners and Hangings: Design and Construction.* New York: Van Nostrand Reinhold Co., 1966.

LALIBERTE, NORMAN, and MOGELON, ALEX. *Masks, Face Coverings, and Headgear.* New York: Van Nostrand Reinhold Co.

MacAGY, DOUGLAS, and MacAGY, ELIZABETH. *Going for a Walk with a Line: A Step into the World of Modern Art.* Garden City, N.Y.: Doubleday and Co., Inc. 1959.

MADIAN, JON. *Beautiful Junk: A Story of the Watts Towers.* Boston: Little, Brown and Co., 1968.

MEDLIN, FAITH. *Centuries of Owls in Art and the Written Word.* Norwalk, Conn.: Silvermine Publishers, Inc., 1967.

MOORE, JANE GAYLOR. *The Many Ways of Seeing: An Introduction to the Pleasures of Art.* Cleveland and New York: World Publishing Co., 1968.

MOORE, LAMONT, series. *The First Book of Painting, The Sculptured Image,* and *The First Book of Architecture.* New York: Franklin Watts, Inc.

MORMAN, JEAN M. *Wonder Under Your Feet: Making the World of Art Your Own.* New York: Harper and Row Publishers, Inc., 1973.

O'NEILL, MARY. *Hailstones and Halibut Bones: Adventures in Color.* Garden City, N.Y.: Doubleday and Co., Inc., 1961.

PAINE, J. *Looking at Sculpture.* New York: Lothrop, Lee and Shepard Co., Inc., 1968.

PAUL, LOUIS. *The Way Art Happens.* New York: Ives Washburn, Inc., 1963.

PEARE, CATHERINE O. *Rosa Bonheur: Her Life.* New York: Henry Holt and Co., 1956.

Praeger Encyclopedia of Art. New York: Frederick A. Praeger, 1971.

PREBLE, DUANE. *Man Creates Art Creates Man*. San Francisco: Canfield Press, 1973.

PRICE, CHRISTINE. *Made in the Middle Ages*. New York: E. P. Dutton and Co., Inc., 1961.

RABOFF, ERNEST. Art for Children Series. *Marc Chagall, Paul Klee, Pablo Picasso*, and others. Garden City, N.Y.: Doubleday and Co., Inc.

ROBBIN, IRVING. *The How and Why Book of Caves to Skyscrapers*. New York: Wonder Books, 1963.

SCHWARTZ, ALVIN. *Old Cities and New Towns: The Changing Face of the Nation*. New York: E. P. Dutton and Co., Inc. 1968.

SHAY, RIEGER. *Gargoyles, Monsters, and Other Beasts*. New York: Lothrop, Lee and Shepard Co., Inc., 1972.

SMITH, BRADLEY. *Mexico: A History in Art*. Garden City, N.Y.: Doubleday and Co., Inc., 1968.

TAYLOR, BARBARA HOWLAND. *Mexico: Her Daily and Festive Breads*. Claremont, Calif.: Creative Press, 1969.

The Book of Art. 10 vol., New York: Grolier Educational Corp., 1966.

TISON, ANNETTE, and TAYLOR, TALUS. *The Adventures of Three Colors*. New York and Cleveland: World Publishing Co., 1971.

WILLARD, CHARLOTTE. *Famous Modern Artists from Cezanne to Pop Art*. New York: Platt and Munk, 1971.

WOLF, THOMAS H. *The Magic of Color*. New York: Odyssey Press, 1964.

ZUELKE, RUTH. *The Horse in Art*. Minneapolis, Minn.: Lerner Publications Co., 1965.

Art Expression and Techniques

BAYLOR, BYRD. *When Clay Sings*. New York: Charles Scribner's Sons, 1972.

BENDICK, JEANNE. *The Human Senses: Science Experiments*. New York: Franklin Watts, Inc., 1968.

BETTS, VICTORIA B. *Exploring Papier-Mâché*. Worcester, Mass.: Davis Publications, Inc.

CANEY, STEVEN. *Toy Book*. New York: Workman Publishing Co., 1972.

CATALDO, JOHN W. *Words and Calligraphy for Children*. New York: Van Nostrand Reinhold Co., 1969.

Crayon Resist Techniques. Worcester, Mass.: Davis Publications, Inc.

GREENBERG, PEARL. *Art and Ideas for Young People*. New York: Van Nostrand Reinhold Co., 1970.

HELFMAN, HARRY. *Making Your Own Sculpture*. New York: Wm. Morrow and Co., 1971.

HONEYWOOD, MARY. *Making Pictures in Paper and Fabric*. New York: Watson-Guptill Publications, 1968.

HOOVER, F. LOUIS. *Art Activities for the Very Young*. Worcester, Mass.: Davis Publications, 1961.

HOPPER, GRIZELLA. *Puppet Making Through the Grades*. Worcester, Mass.: Davis Publications.

HORN, GEORGE F. *Experiencing Art in Kindergarten*. Worcester, Mass.: Davis Publications, 1971.

———. and SMITH, GRACE S. *Experiencing Art in the Elementary School*. Worcester, Mass.: Davis Publications, 1971.

———. *Tissue Paper Activities*. Worcester, Mass.: Davis Publications, Inc., 1971.

KAMPMANN, LOTHAR. *Creating with Poster Paints*. New York: Van Nostrand Reinhold Co., 1967.

———. *The Children's Book of Painting*. New York: Van Nostrand Reinhold Co., 1971.

KRINSKY, R. *Art for City Children*. New York: Van Nostrand Reinhold Co.

LAURY, JEAN R. *Appliqué Stitchery*. New York: Van Nostrand Reinhold Co., 1966.

LEE, RUTH. *Exploring the World of Pottery*. Chicago: Children's Press, 1967.

LEYH, B. *Children Make Sculpture*. New York: Van Nostrand Reinhold Co., 1972.

LIDSTONE, JOHN. *Building With Cardboard*. Princeton, N.J.: D. Van Nostrand Co., Inc., 1968.

LORRIMAR, BETTY. *Creative Papier-Mâché*. Cincinnati, Ohio: Watson-Guptill Publications, 1972.

MATTIL, ED. *Meaning in Crafts*. Englewood Cliffs, N.J.: Prentice-Hall, Inc., 1971.

PATTEMORE, ARNEL. *Printmaking Activities for the Classroom*. Worcester, Mass.: Davis Publications, Inc., 1969.

PLUCKROSE, HENRY, ed. Starting Points Books. *Let's Paint, Let's Crayon, Let's Print, Let's Make a Picture, Let's Model, Let's Make Soft Toys, Let's Draw, Let's Make Puppets.* New York: Van Nostrand Reinhold Co., 1971.

RAINEY, SARITA. *Weaving Without a Loom.* Worcester, Mass.: Davis Publications, Inc., 1966.

———. and PATTEMORE, ARNEL. *Ways with Paper.* Worcester, Mass.: Davis Publications.

SEIDELMAN, JAMES E., and MINTONYE, GRACE. *Creating with Paint.* New York: Crowell-Collier Press, 1967.

———. *The Rub Book.* New York: Crowell-Collier Press, 1968

TRITTEN, GOTTFRIED. *Art Techniques for Children.* New York: Van Nostrand Reinhold Co., 1965.

WANKELMAN, WILLARD F.; WIGG, PHILIP; and WIGG, MARIETTA. *A Handbook of Arts and Crafts for Elementary and Junior High School Teachers.* 3rd ed. Dubuque, Ia.: Wm. C. Brown Company Publishers, 1974.

WEISS, HARVEY. *Lens and Shutter: An Introduction to Photography.* Reading, Mass.: Young Scott Books, 1971.

WILSON, JEAN. *Weaving Is Creative* (1972); *Weaving Is Fun* (1970); and *Weaving Is for Anyone* (1966). New York: Van Nostrand Reinhold Co.

Relief Prints

Making Relief Prints. Eight Super 8mm silent film loops. Color. "Found Objects," "Carving Soft Materials," "Styrofoam," "Monoprints," "Torn and Cut Paper," "Dried Glue," "Collograph," "Combining Techniques." Aim Instructional Media Services, Inc., P.O. Box 1010, Hollywood, Calif.

Exploring Relief Printmaking. A Motivational Art Films Production. 12 min. Film Associates of Calif.

Puppet Making

Exploring Puppet Making. Ten Super 8mm silent film loops. Color. "Bag Puppets," "Bag Puppets with Strings," "Sack and Cloth Puppets," "Flat Puppets," "Tubular Puppets," "Folded Paper Puppets," "Papier-Mâché Puppets," "Puppets with Moving Parts," "Puppets with Strings," "Staging the Puppet Show." Bailey-Film Associates, 2211 Michigan Ave., Santa Monica, Calif.

Index

Italicized page numbers indicate pages on which illustrations appear.